Put any picture you want on any state book cover. Makes a great gift. Go to www.america24-7.com/customcover

NASHUA
After returning from a winter in Florida, snowbird Leo Pomerleau paints a decorative windmill in his front yard.
Photo by Don Himsel, The Telegraph

New Hampshire 24/7 is the sequel to *The New York Times* bestseller *America 24/7* shot by tens of thousands of digital photographers across America over the course of a single week. We would like to thank the following sponsors, the wonderful people of New Hampshire, and the talented photojournalists who made this book possible.

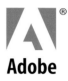
Adobe

OLYMPUS

LEXAR *Media*

snapfish

jetBlue AIRWAYS

WEBWARE

Google

DIGITAL POND

ebaY

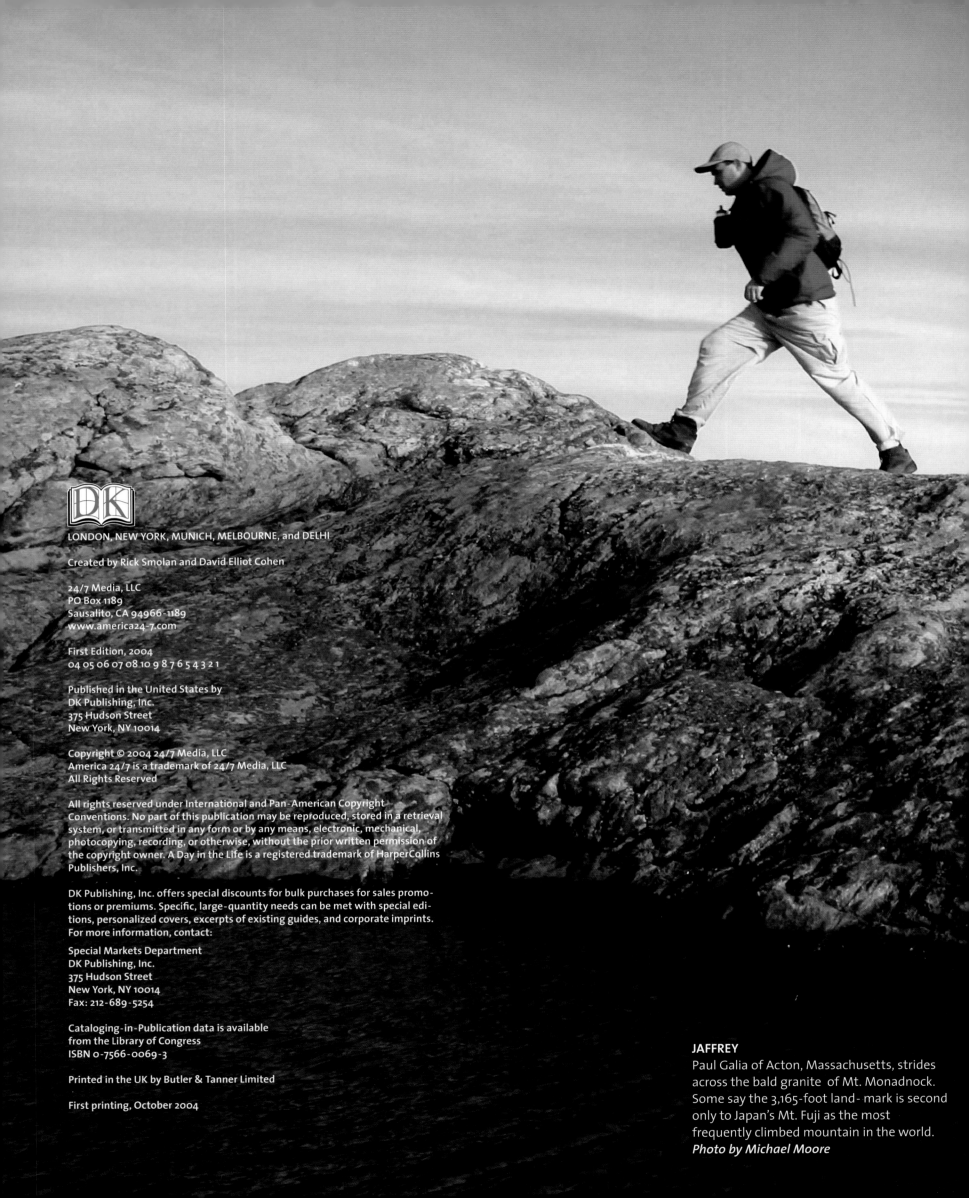

DK

LONDON, NEW YORK, MUNICH, MELBOURNE, and DELHI

Created by Rick Smolan and David Elliot Cohen

24/7 Media, LLC
PO Box 1189
Sausalito, CA 94966-1189
www.america24-7.com

First Edition, 2004
04 05 06 07 08 10 9 8 7 6 5 4 3 2 1

Published in the United States by
DK Publishing, Inc.
375 Hudson Street
New York, NY 10014

DK Publishing, Inc. offers special discounts for bulk purchases for sales promo-
tions or premiums. Specific, large-quantity needs can be met with special edi-
tions, personalized covers, excerpts of existing guides, and corporate imprints.
For more information, contact:

Special Markets Department
DK Publishing, Inc.
375 Hudson Street
New York, NY 10014
Fax: 212-689-5254

Cataloging-in-Publication data is available
from the Library of Congress
ISBN 0-7566-0069-3

Printed in the UK by Butler & Tanner Limited

First printing, October 2004

JAFFREY
Paul Galia of Acton, Massachusetts, strides
across the bald granite of Mt. Monadnock.
Some say the 3,165-foot land-mark is second
only to Japan's Mt. Fuji as the most
frequently climbed mountain in the world.
Photo by Michael Moore

NEW HAMPSHIRE 24/7

24 Hours. 7 Days.
Extraordinary Images of
One Week in New Hampshire.

Created by Rick Smolan and David Elliot Cohen

DK Publishing

About the America 24/7 Project

A hundred years hence, historians may pose questions such as: What was America like at the beginning of the third millennium? How did life change after 9/11 and the ensuing war on terrorism? How was America affected by its corporate scandals and the high-tech boom and bust? Could Americans still express themselves freely?

To address these questions, we created *America 24/7*, the largest collaborative photography event in history. We invited Americans to tell their stories with digital pictures. We asked them to shoot a visual memoir of their lives, families, and communities.

During one week in May 2003, more than 25,000 professionals and amateurs shot more than a million pictures. These images, sent to us via the Internet, compose a panoramic yet highly intimate view of Americans in celebration and sadness; in action and contemplation; at work, home, and school. The best of these photographs, more than 6,000, are collected in 51 volumes that make up the *America 24/7* series: the landmark national volume *America 24/7*, published to critical acclaim in 2003, and the 50 state books published in 2004.

Our decision to make *America 24/7* an all-digital project was prompted by the fact that in 2003 digital camera sales overtook film camera sales. This techno-logical evolution allowed us to extend the project to a huge pool of photographers. We were thrilled by the response to our challenge and moved by the insight offered into American life. Sometimes, the amateurs outshot the pros—even the Pulitzer Prize winners.

The exuberant democracy of images visible throughout these books is a revela-tion. The message that emerges is that now, more than ever, America is a supersized idea. A dreamspace, where individuals and families from around the world are free to govern themselves, worship, read, and speak as they wish. Within its wide margins, the polyglot American nation manages to encompass an inexplicably complex yet workable whole. The pictures in this book are dedicated to that idea.

—*Rick Smolan and David Elliot Cohen*

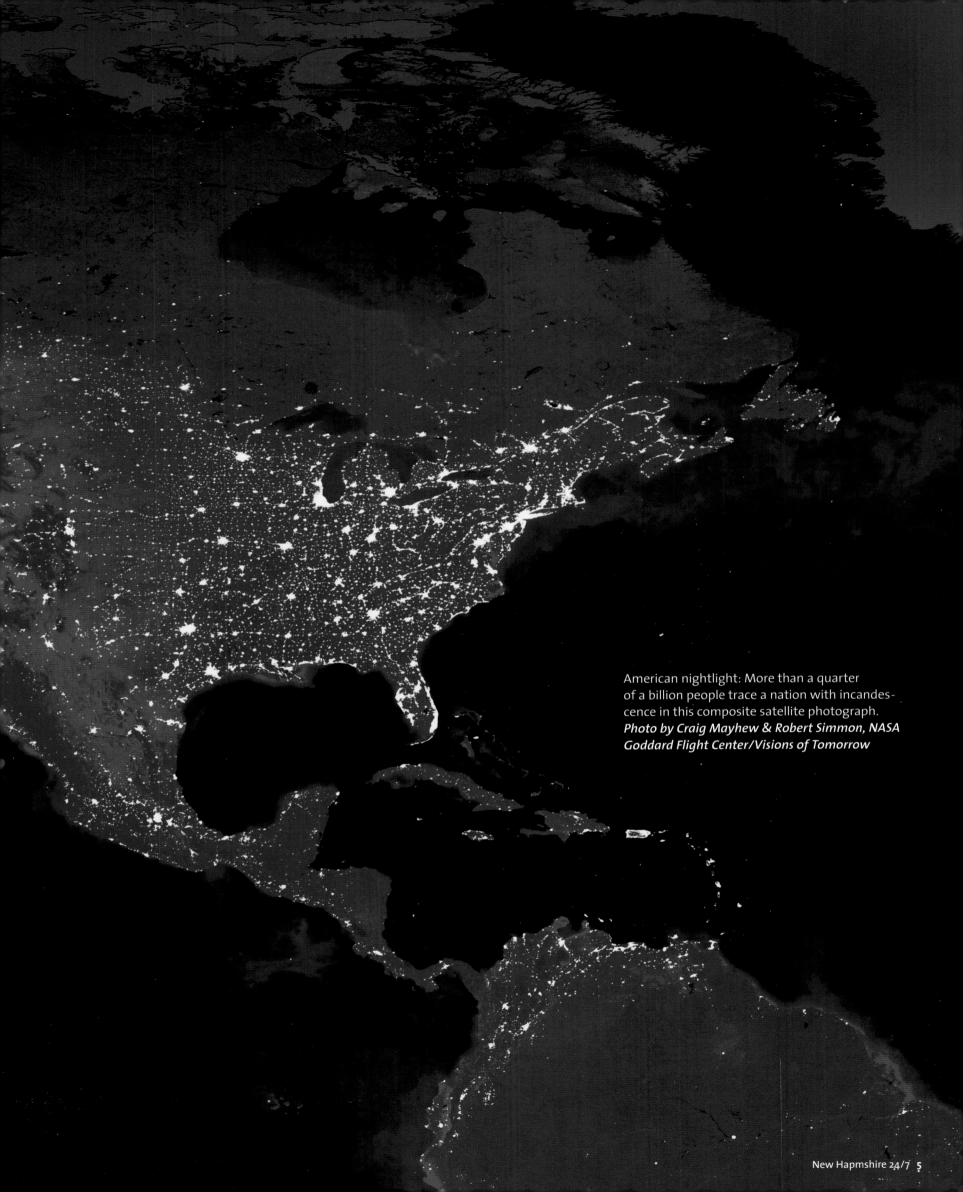

American nightlight: More than a quarter
of a billion people trace a nation with incandes-
cence in this composite satellite photograph.
Photo by Craig Mayhew & Robert Simmon, NASA
Goddard Flight Center/Visions of Tomorrow

The New Hampshire Way

By Felice Belman

High above New Hampshire, before there even *was* New Hampshire, the craggy profile of an old man gazed out across the White Mountains. Carved by nature out of a windswept outcrop on Cannon Mountain, the Old Man of the Mountain was a stalwart friend to Abenakis and Penacooks, to European settlers, to hikers and snowboarders and all manner of tourists. So iconic was he that his visage is on our license plates. To New Hampshire, the Old Man was a steady presence, reflecting the very personality of the state: flinty, reliable, starkly beautiful, unflinching in the face of modernity. That is, until May 2003, when he crumbled into dust.

To outsiders, the notion of mourning a collapsed rock face was puzzling, quirky—even hilarious. In New Hampshire, it was serious business. "Goodbye, Old Man," cried the oversized headlines. "What now?" residents asked themselves. The obliteration of the Old Man had, with a jolt, exposed the fragility and dynamism of life in New Hampshire.

In the early years of the new century, the Old Man is not the only thing that's changed. New Hampshire is the fastest-growing state in New England—new houses, new strip malls, new cul-de-sacs where fields once stood, new cell phone towers hidden none-too-artfully among the granite hills. French and Irish immigrants have been replaced with newcomers from Central America, Asia, and Africa, challenging old communities in new ways. And traffic! The state's few highways are clogged with transplanted Bostonians commuting to high-tech jobs. Should we widen the roads for them? How wide? How fast? Does our town really need its first stoplight, its first McDonald's?

ALTON
The view north from 1,780-foot Mt. Major takes in Lake Winnipesauke and the White Mountains' southern flank. Winnipesauke, the largest lake in New Hampshire, is a venerable summertime destination. Belknap and Carroll counties double their popula-

These are the anxious debates of New Hampshire town meetings, an old-timey tradition in which natives and newcomers vote together on fire truck purchases and teacher contracts—and nurture the sense of community that brought and keeps them all here. Except, of course, in the growing number of towns that have killed off the town meeting altogether. Five hours on folding chairs on a Saturday afternoon? There's got to be a better way, they assure themselves. Tradition be damned!

New Hampshire, in the shorthand of the national media, is among the most conservative states in the country: no sales tax, no income tax, a penny-pinching commitment to public schools. And yet, New Hampshire elected the world's first openly gay Episcopal bishop. It swoons over maverick politicians like John McCain and Howard Dean. New Hampshire cares deeply about the environment. And it has refrained from using its death penalty statute for more than 60 years. Even a small, old-fashioned state can be a place of complexity and contradiction.

When the Old Man of the Mountain fell from its peak, the governor quickly established a "revitalization" task force. Far-out ideas blew in from around the globe: Carve a new Old Man out of plastic and stick him right back up there! Create a better-than-new version by beaming a computerized image onto the cliff! What about a laser light show? Eventually, though, the space-age thinking gave way to more New Hampshire—style solutions: songs, poems, and some modest memorial markers. Time stands still for no man, the Old Man instructed, but let's not go crazy.

FELICE BELMAN *is Sunday editor of the* Concord Monitor *and co-editor of* The New Hampshire Century, *a collection of 100 profiles of 20th-century figures*

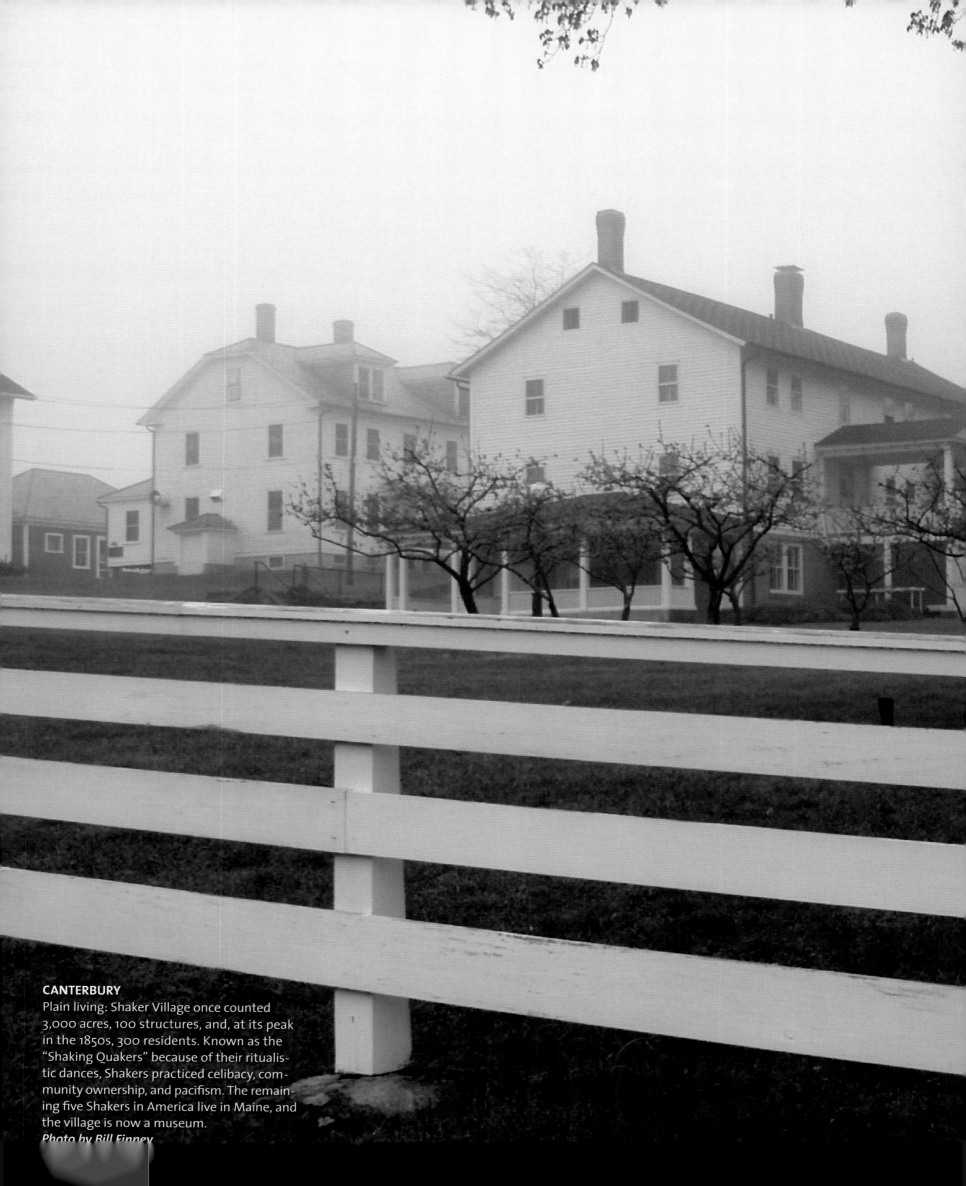

CANTERBURY
Plain living: Shaker Village once counted 3,000 acres, 100 structures, and, at its peak in the 1850s, 300 residents. Known as the "Shaking Quakers" because of their ritualistic dances, Shakers practiced celibacy, community ownership, and pacifism. The remaining five Shakers in America live in Maine, and the village is now a museum.
Photo by Bill Finney

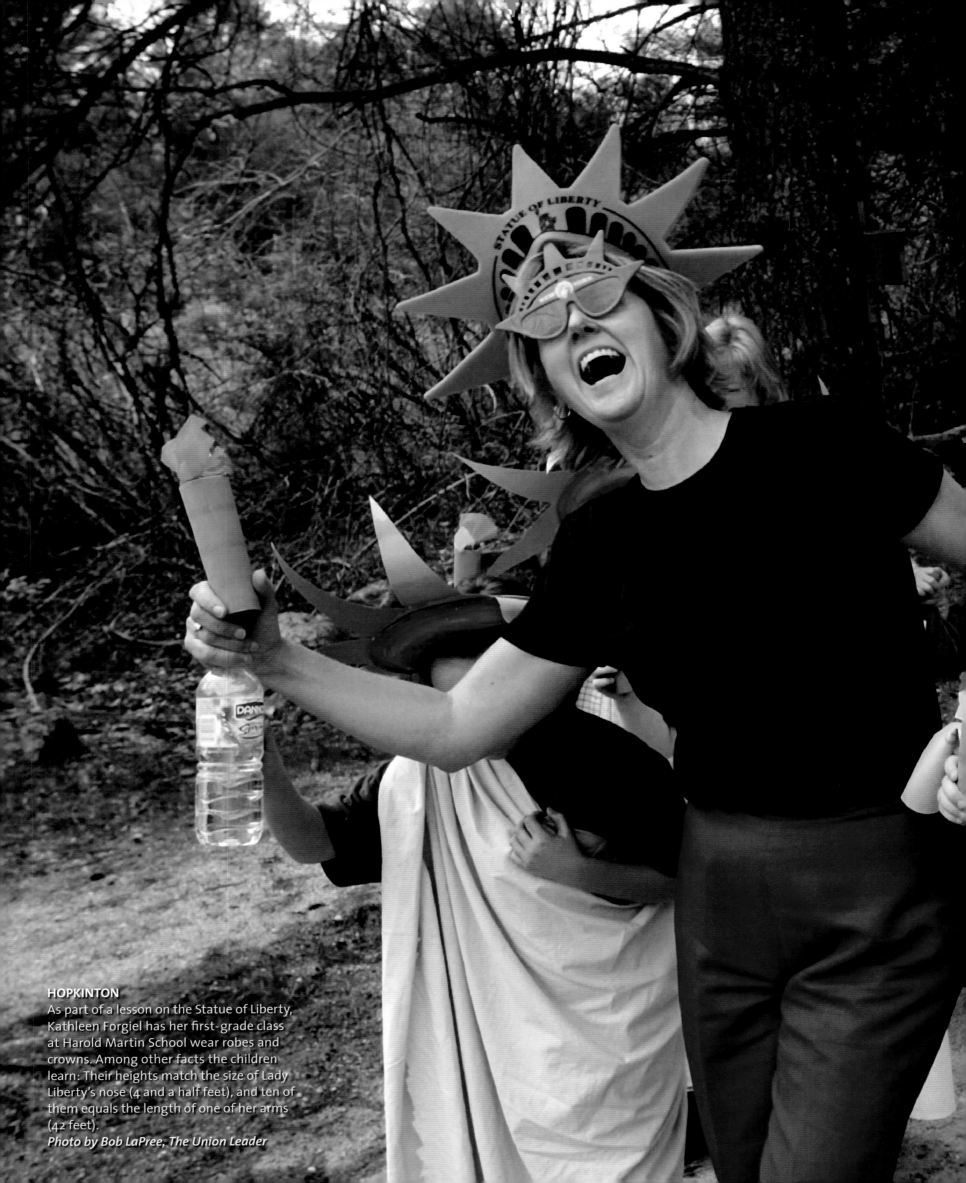

HOPKINTON

As part of a lesson on the Statue of Liberty, Kathleen Forgiel has her first-grade class at Harold Martin School wear robes and crowns. Among other facts the children learn: Their heights match the size of Lady Liberty's nose (4 and a half feet), and ten of them equals the length of one of her arms (42 feet).

Photo by Bob LaPree, The Union Leader

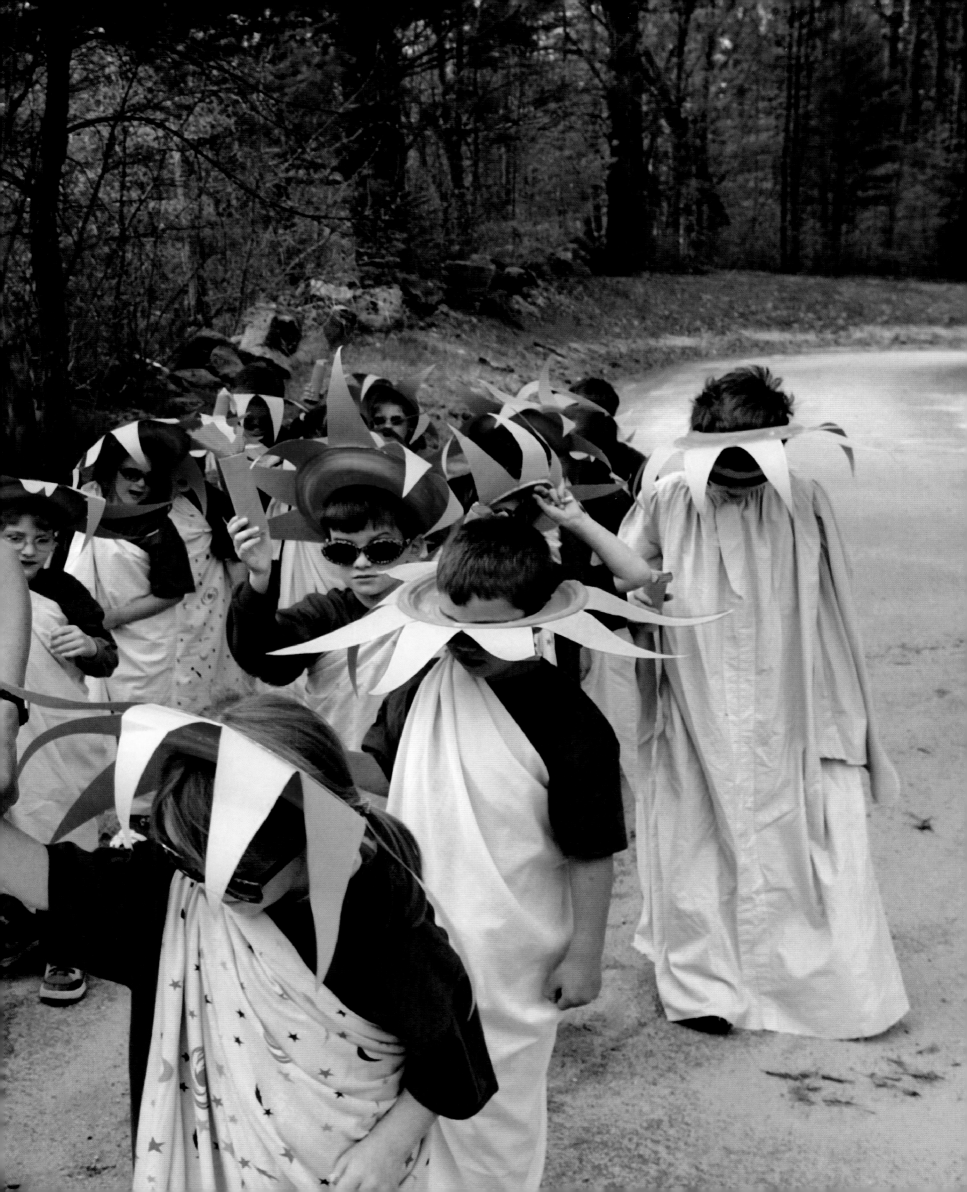

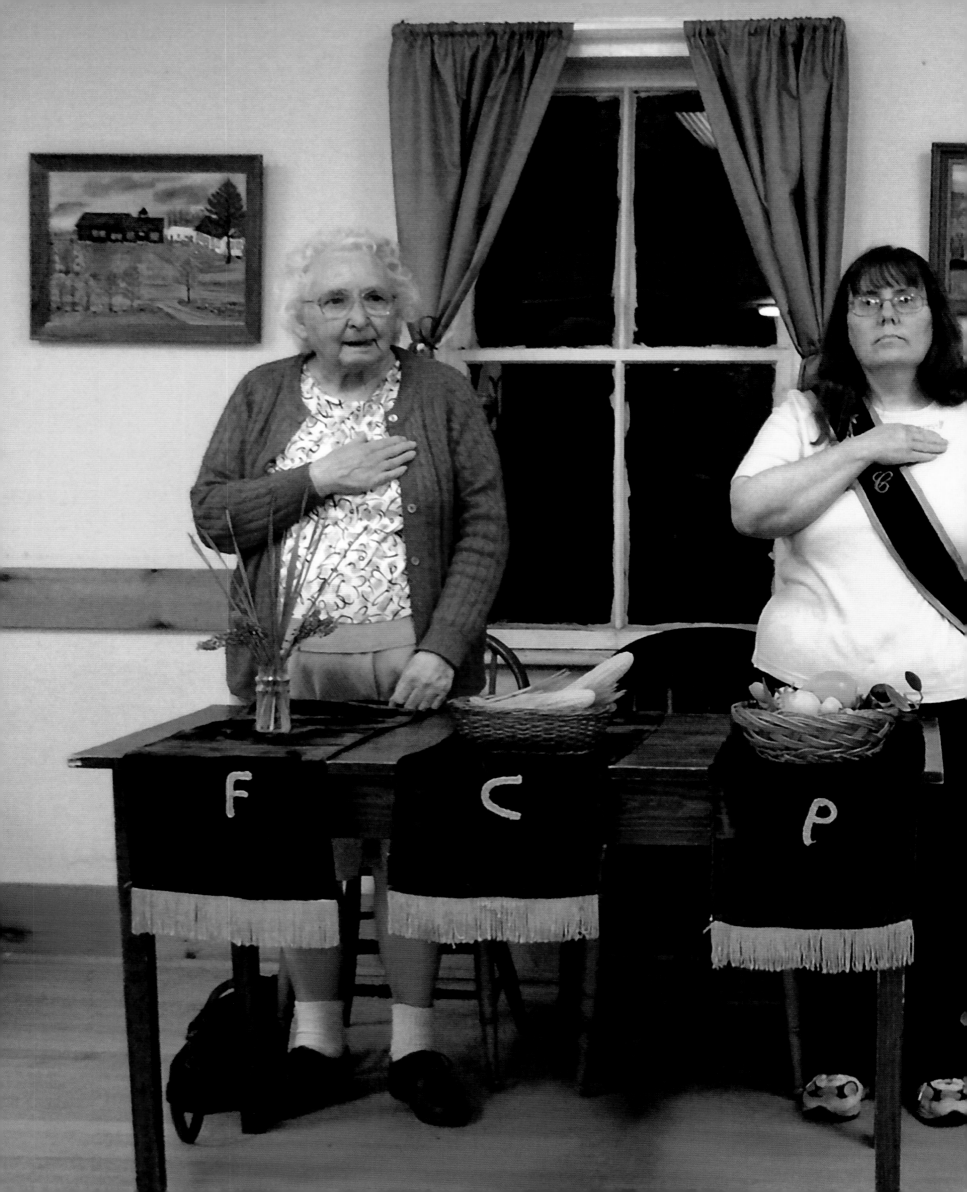

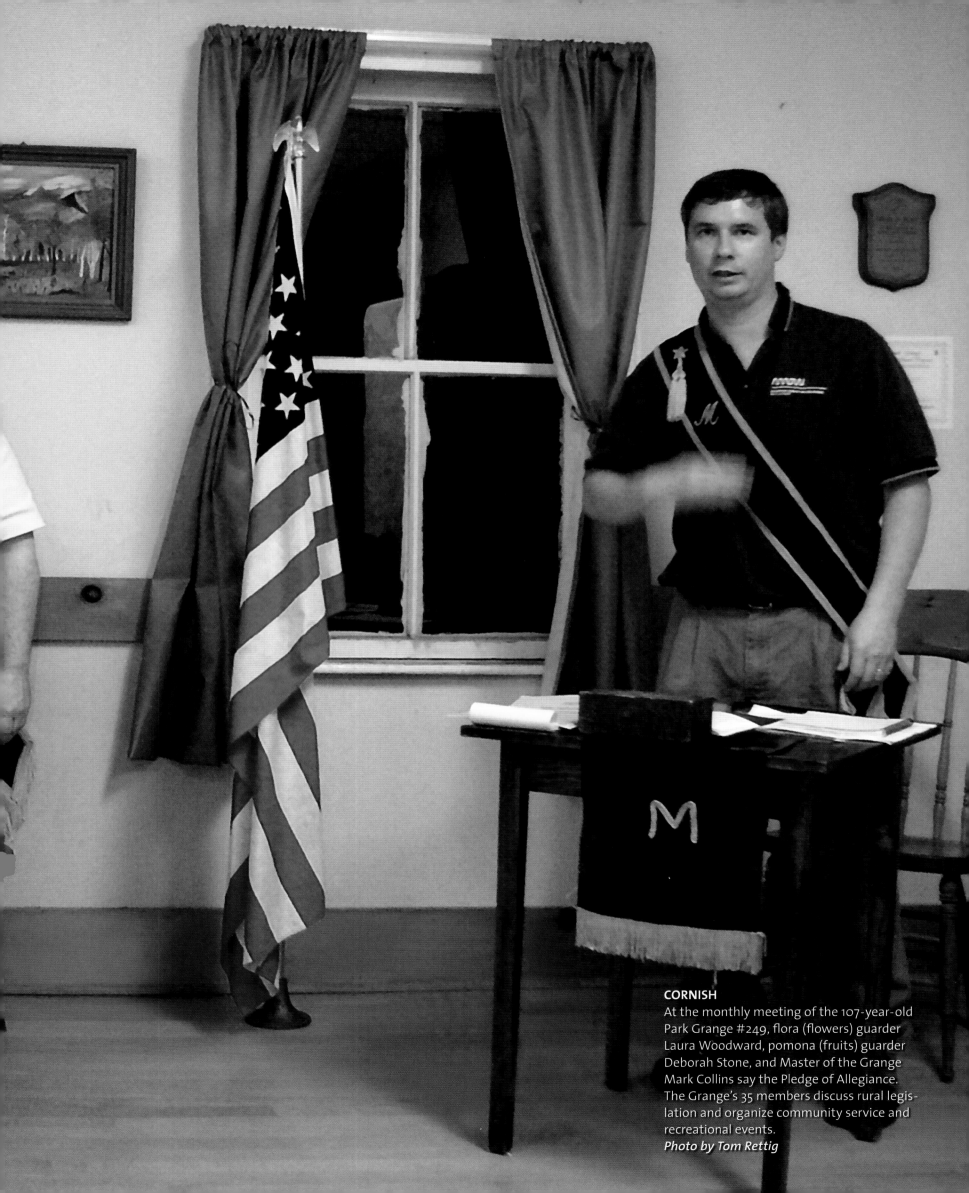

CORNISH

At the monthly meeting of the 107-year-old Park Grange #249, flora (flowers) guarder Laura Woodward, pomona (fruits) guarder Deborah Stone, and Master of the Grange Mark Collins say the Pledge of Allegiance. The Grange's 35 members discuss rural legislation and organize community service and recreational events.

Photo by Tom Rettig

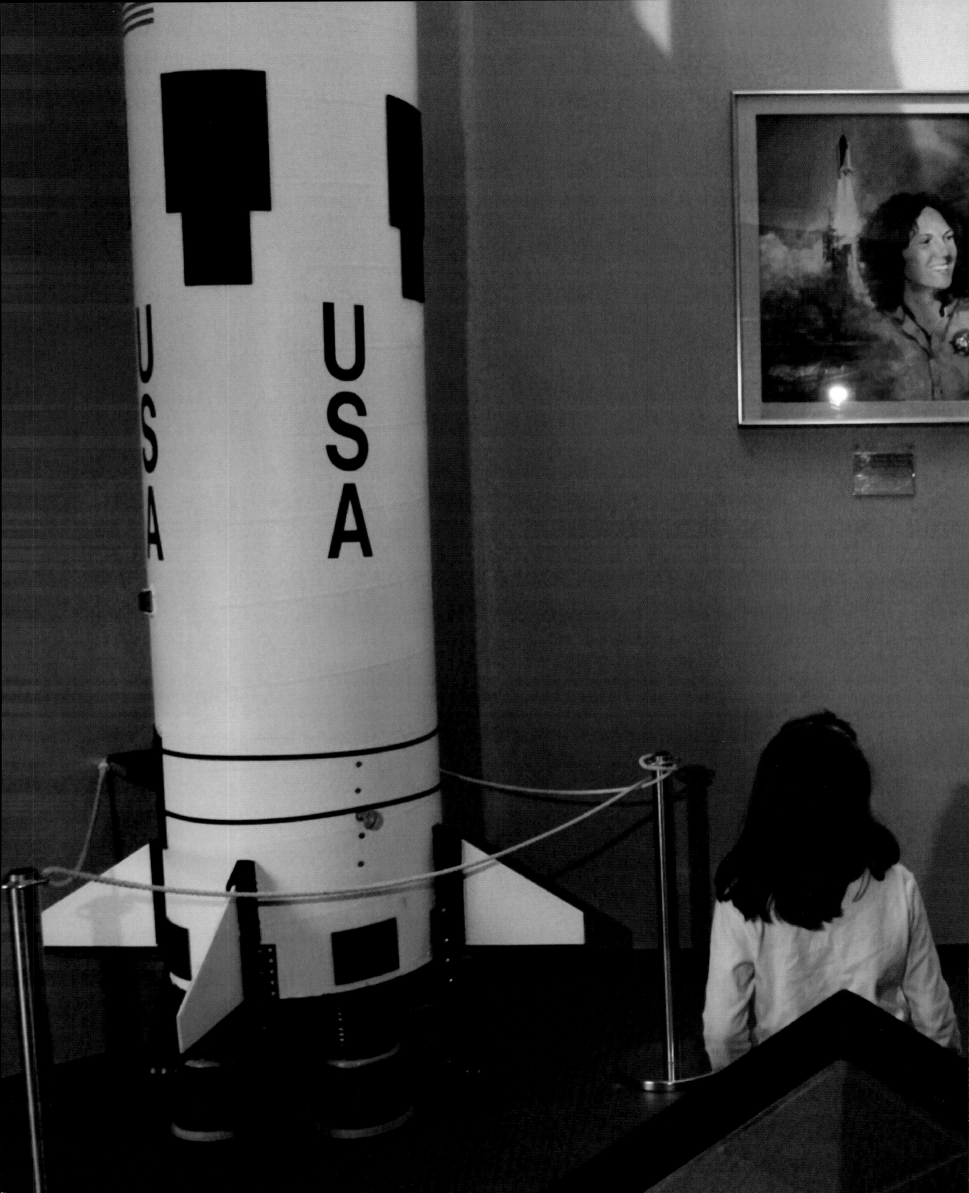

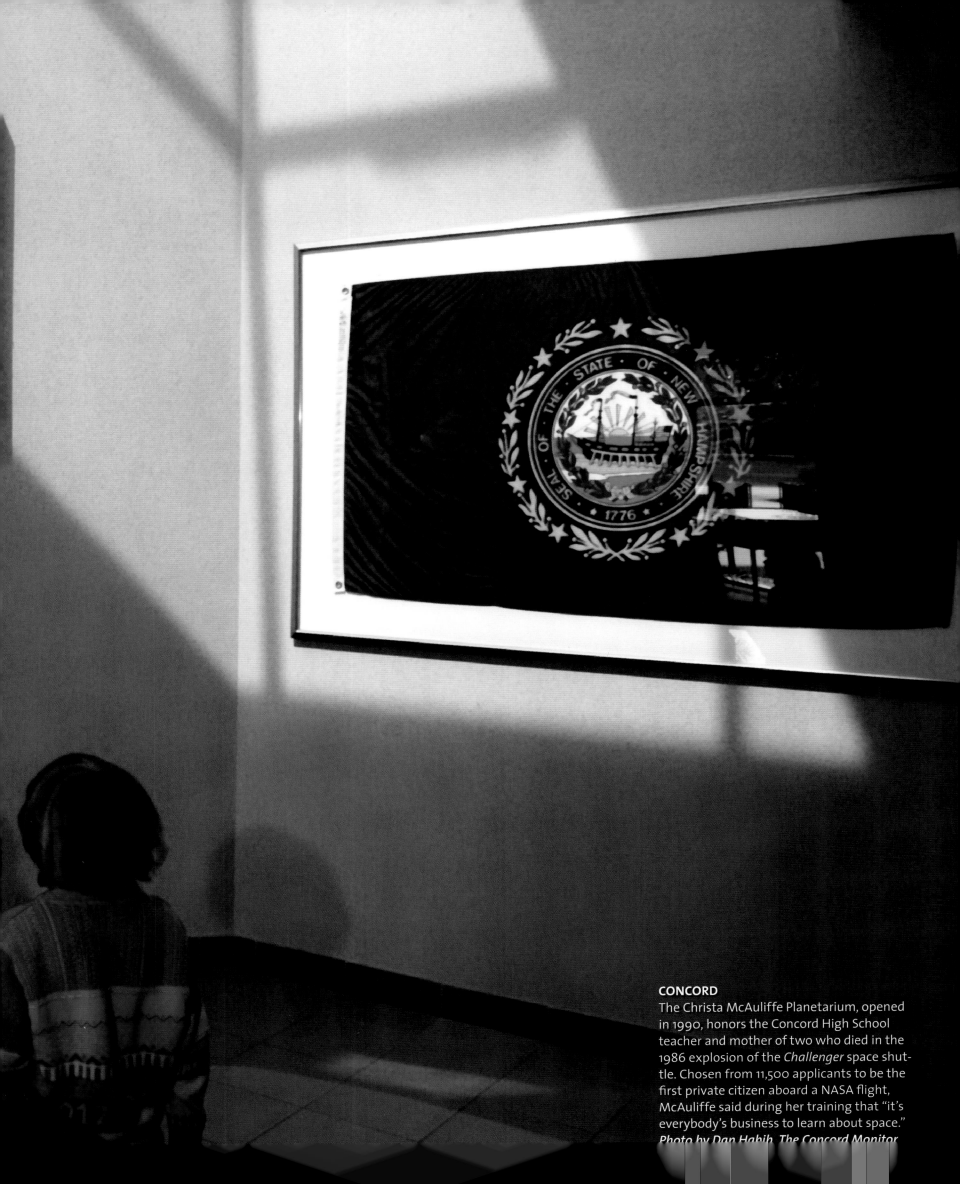

CONCORD
The Christa McAuliffe Planetarium, opened in 1990, honors the Concord High School teacher and mother of two who died in the 1986 explosion of the *Challenger* space shuttle. Chosen from 11,500 applicants to be the first private citizen aboard a NASA flight, McAuliffe said during her training that "it's everybody's business to learn about space."
Photo by Dan Habib, The Concord Monitor

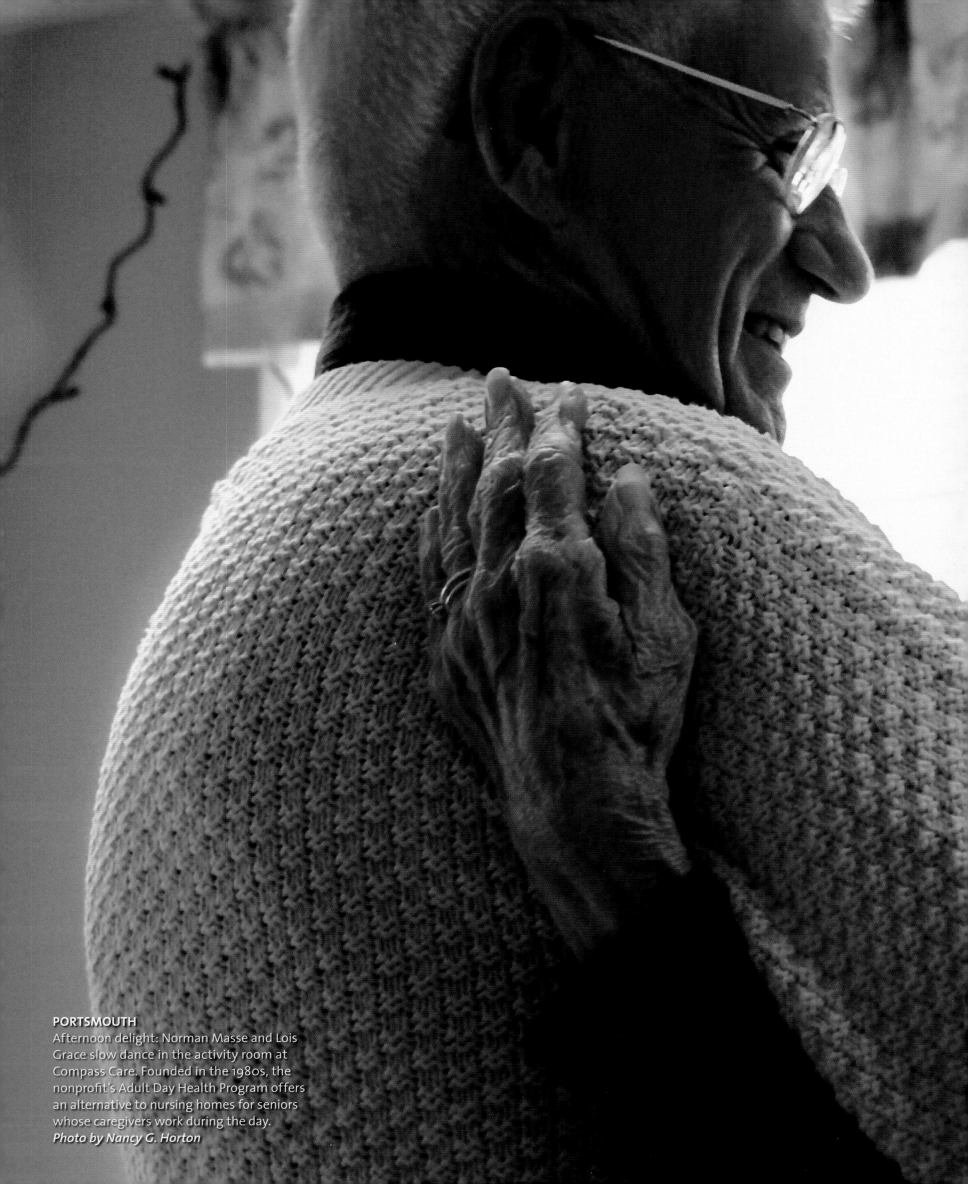

PORTSMOUTH
Afternoon delight: Norman Masse and Lois Grace slow dance in the activity room at Compass Care. Founded in the 1980s, the nonprofit's Adult Day Health Program offers an alternative to nursing homes for seniors whose caregivers work during the day.
Photo by Nancy G. Horton

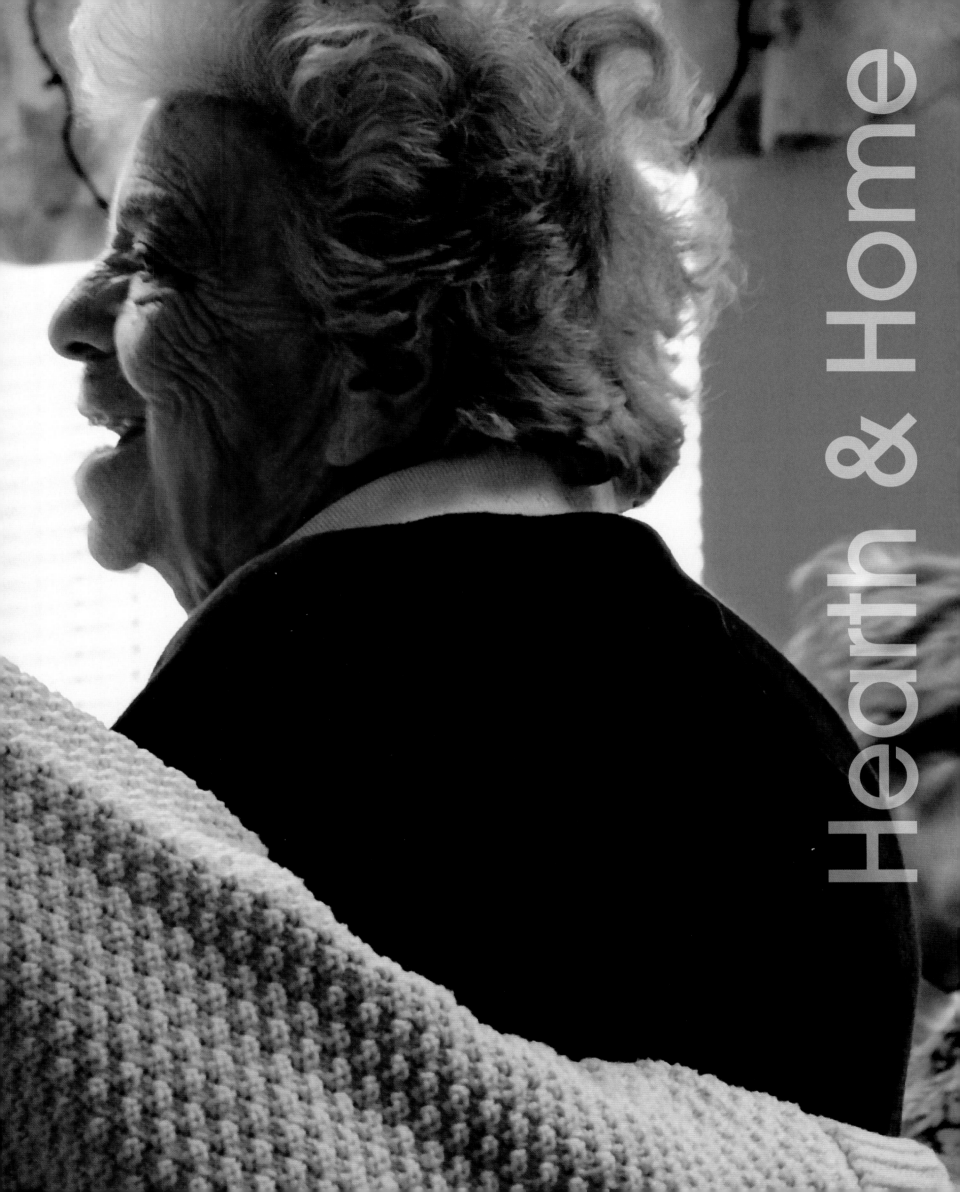

Hearth & Home

NASHUA
Just 12 minutes after being born, Kimberly and Matthew Thornton's third son, Peter Joseph, leaves a set of prints at St. Joseph Hospital.
Photo by Kathy Seward MacKay

EAST CONCORD
High school sweethearts Kelly and Chris Martin tried for six years to have children. Success came with their son Steven, who leaves the couple with little time for sleep. Chris, who works in an auto repair shop, is now considering becoming Mr. Mom. Kelly works at an insurance company.
Photo by Lori Duff

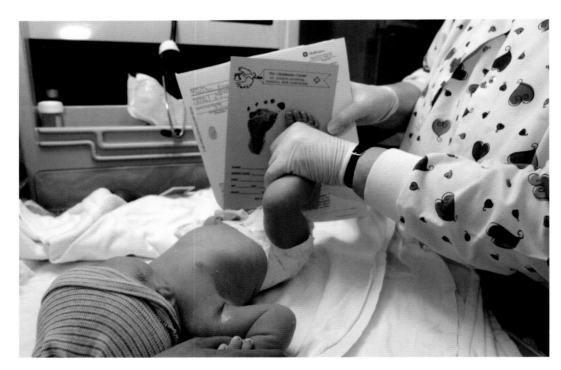

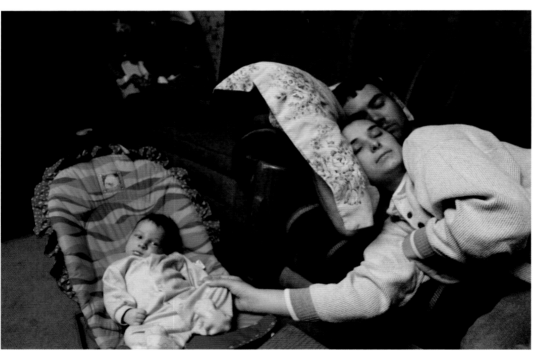

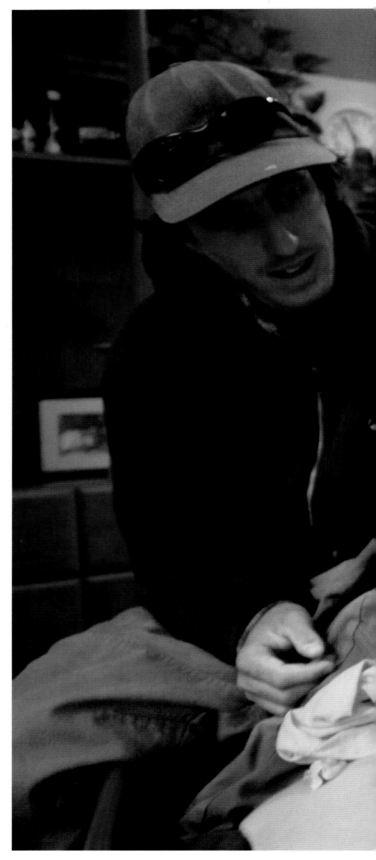

HOPKINTON

Cedar Raven, 11 days old, cries during her checkup by midwife Carol Leonard. Cedar's parents, Seth Kiedaisch and Catherine August, planned a natural delivery at Leonard's Longmeadow Farm Birthing Home. But after 28 hours of labor, August went to Concord Hospital for a C-section. "I didn't get her the way I wanted," says August. "But I'm grateful she is healthy and thriving."
Photo by Bob LaPree, The Union Leader

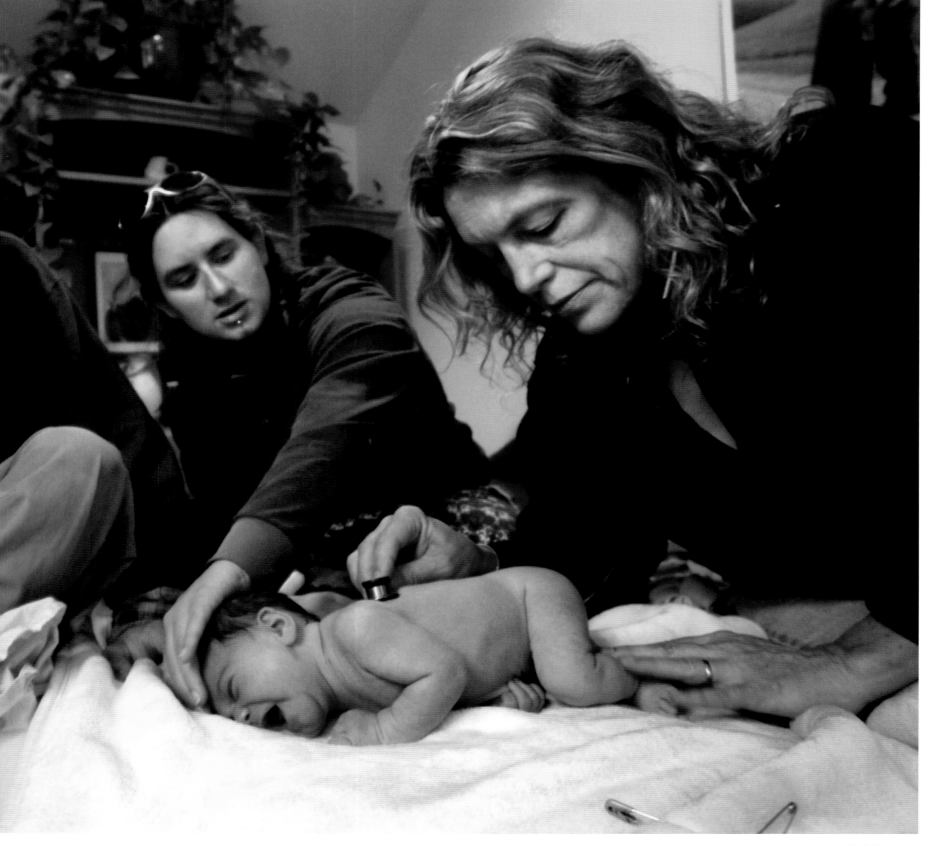

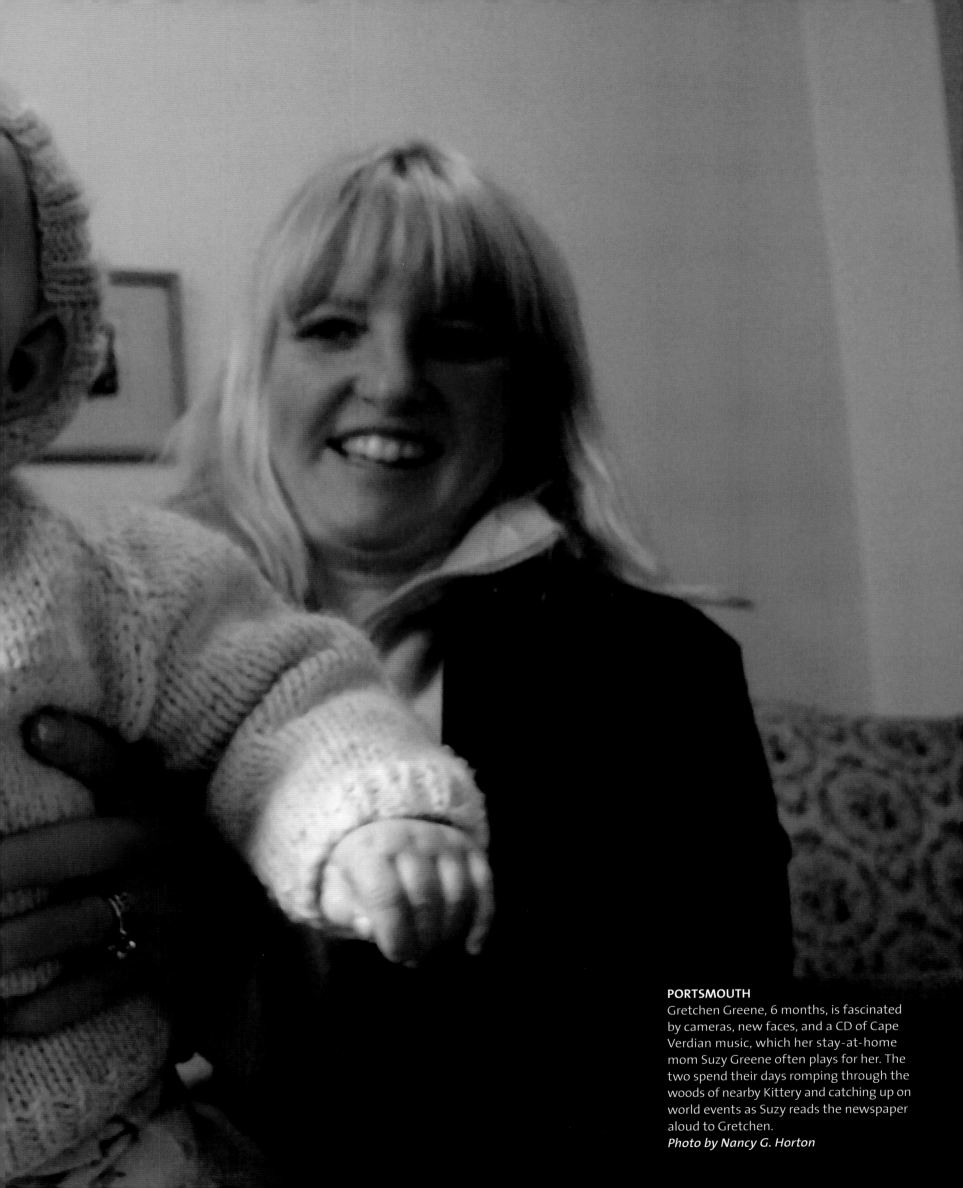

PORTSMOUTH
Gretchen Greene, 6 months, is fascinated by cameras, new faces, and a CD of Cape Verdian music, which her stay-at-home mom Suzy Greene often plays for her. The two spend their days romping through the woods of nearby Kittery and catching up on world events as Suzy reads the newspaper aloud to Gretchen.
Photo by Nancy G. Horton

NASHUA

First-generation Dominican American Ambar Morales waits for the school bus at her living room window. Although Ambar's mother left the Dominican Republic at the age of 10 and quickly learned English, she makes sure her three daughters speak Spanish. A single mother, Angela Morales works for the New Hampshire Migrant Education Program, helping new immigrants and their children transition to life in America.

Photo by Kathy Seward MacKay

CANTERBURY

The daily ritual at the Williams home begins at 5 a.m. when Sue, a mother of three and manager for an insurance company, gets up to do daughter Megan's hair. "Megan's out of the house by 6:30," Sue says. "And then we don't see each other for twelve hours, so the mornings are a good together time for us."

Photo by Ken Williams, The Concord Monitor

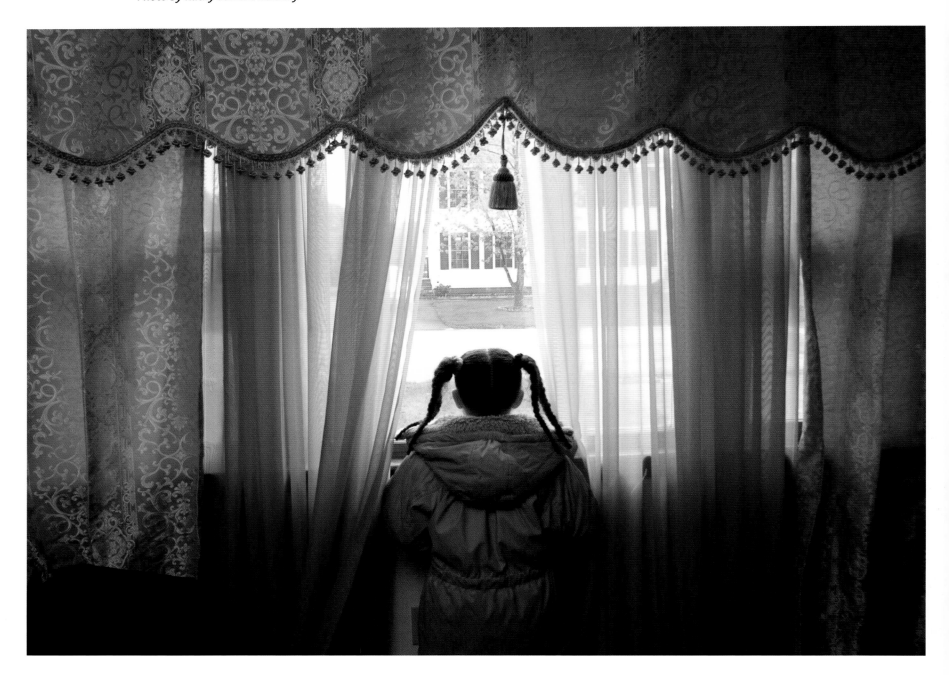

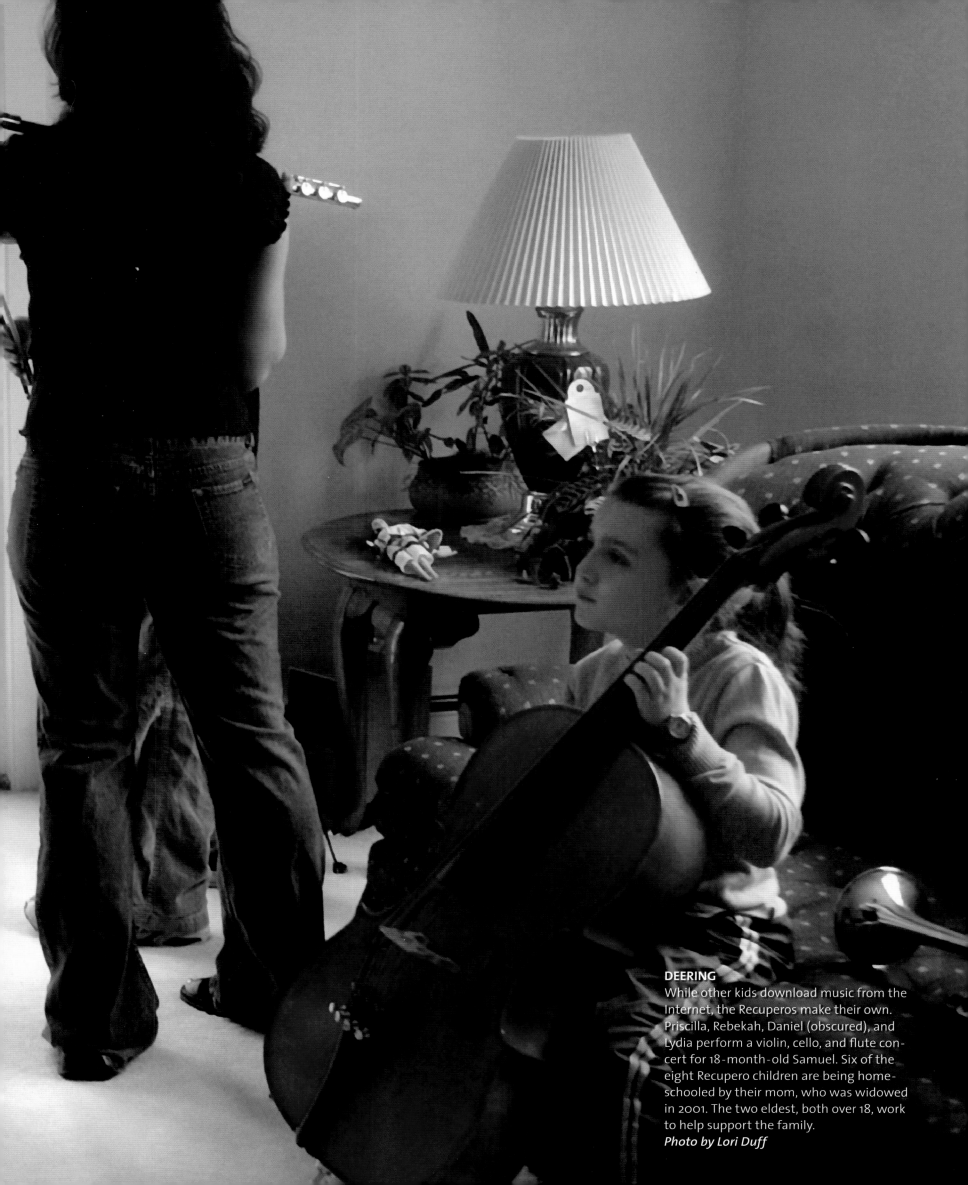

DEERING
While other kids download music from the Internet, the Recuperos make their own. Priscilla, Rebekah, Daniel (obscured), and Lydia perform a violin, cello, and flute concert for 18-month-old Samuel. Six of the eight Recupero children are being home-schooled by their mom, who was widowed in 2001. The two eldest, both over 18, work to help support the family.
Photo by Lori Duff

As Elizah Hulseman helps her little sister Charlotte get dressed for preschool, middle sister Isabel spins her umbrella, anticipating a rainy spring day. Even with their disparate personalities (Elizah is studious, Isabel playful, and Charlotte independent), the sisters are best friends.
Photos by Nancy G. Horton

PORTSMOUTH

Jessica Hulseman serves breakfast to her daughters Isabel and Elizah while husband Christian rushes to get out the door and to his job teaching social studies at Berwick Academy. The family moved from the San Juan Islands in Washington to Portsmouth in 2000 because Jessica and Christian wanted to return to the East Coast, where they both grew up.

HAMPTON

"Children are a blessing from the Lord," says Kevin Kimball, father of six. The Kimball children range in age from 2 weeks to 13 years. Jonathan and Gary, fighting over a toy cell phone, fall in the middle. After spending six years in Russia as Christian missionaries, Kimball and his wife Maureen returned to America and continue that vocation as employees of Campus Crusade for Christ.
Photo by Carrie Niland

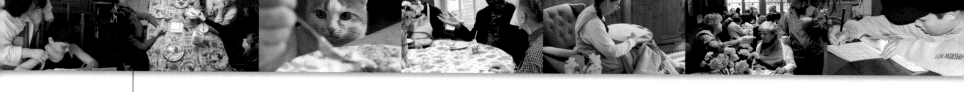

BOSCAWEN

Roy and Mary Meier (clockwise from left), Harold and Rhoda Hardy, and their granddaughter Heather Hardy dig into the family's weekly Saturday breakfast. Without fail, Harold and Rhoda open their home to their four children (Mary's the youngest), 10 grandkids, and whomever else shows up. "There's always room for one more," Rhoda says.

Photo by Ben Garvin, bengarvin.com

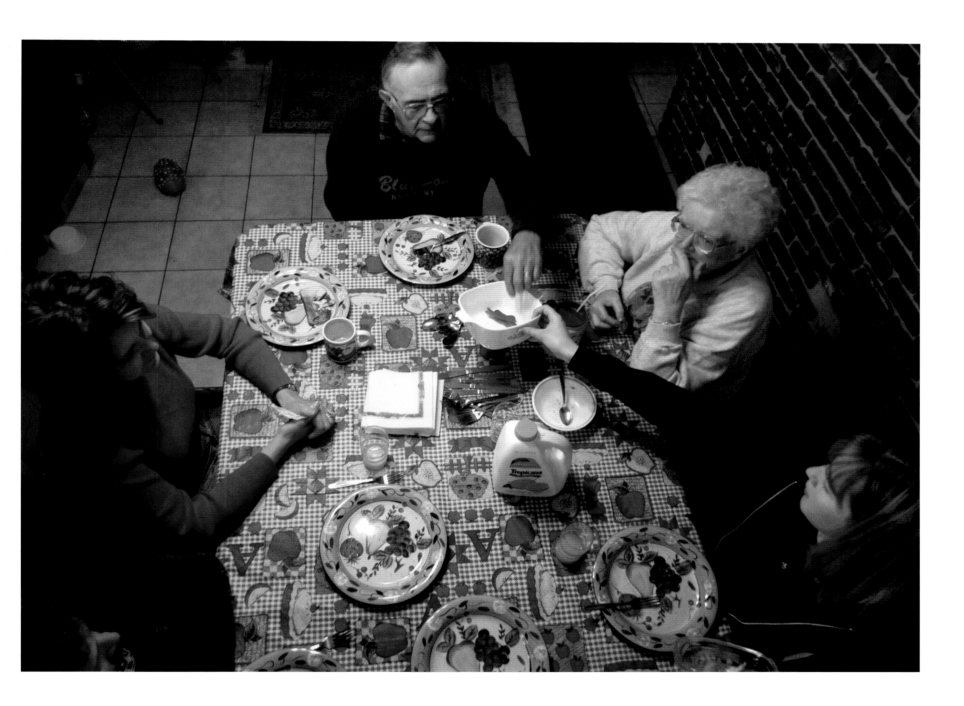

CONCORD
Outside their friend's house, Ricky Fife and
Kristine Senechal join their pals, ostensibly
to study after school.
Photo by Ben Garvin, bengarvin.com

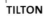

TILTON
Terrified Jack Russell terrier Bojangles waits for his annual booster shots at the Tilton Veterinary Hospital. "He starts shaking as soon as he gets in the door," says owner Susan Sinclair.
Photo by Ben Garvin, bengarvin.com

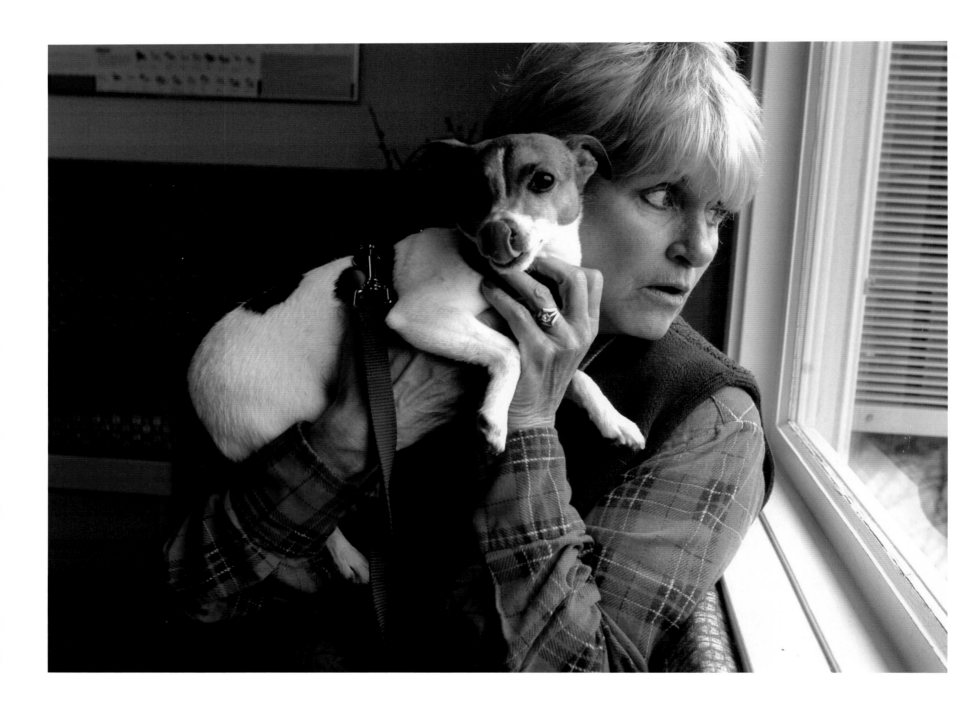

PORTSMOUTH

Zoe Pinione attends the Adult Day Health Program at Compass Care and catches up with Nellie during the therapy dog's weekly visit. Pinione, an outgoing Texan, now lives with her granddaughter just across the state line in Maine.

Photo by Nancy G. Horton

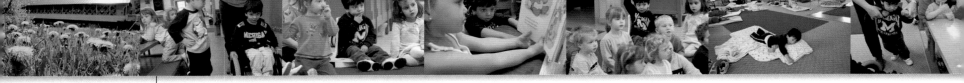

CONCORD

Samuel Habib, 3, rolls past classmate Jason Bogacz, 4, at Shaker Road School. The private school (preschool through ninth grade) is known for its accommodation of children with disabilities. In addition to doing regular classwork, Samuel, who has cerebral palsy, participates in occupational therapy, physical therapy, and speech therapy during the school day.
Photos by Dan Habib, The Concord Monitor

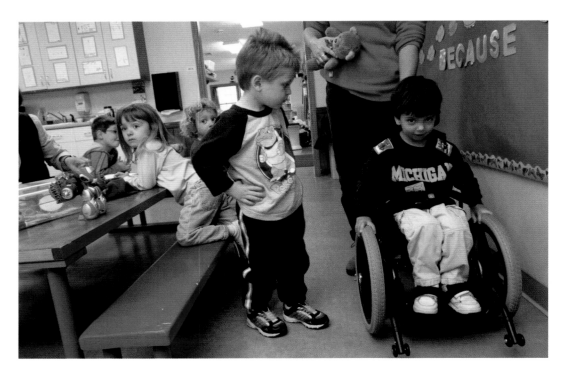

CONCORD

A little chair with a padded strap, made by his grandpa, enables Samuel to sit with his classmates during story time. "Samuel uses his eyes to connect with people," says his father Dan. "They are bright green and quite enchanting. He has learned that with certain expressions, he can work wonders."

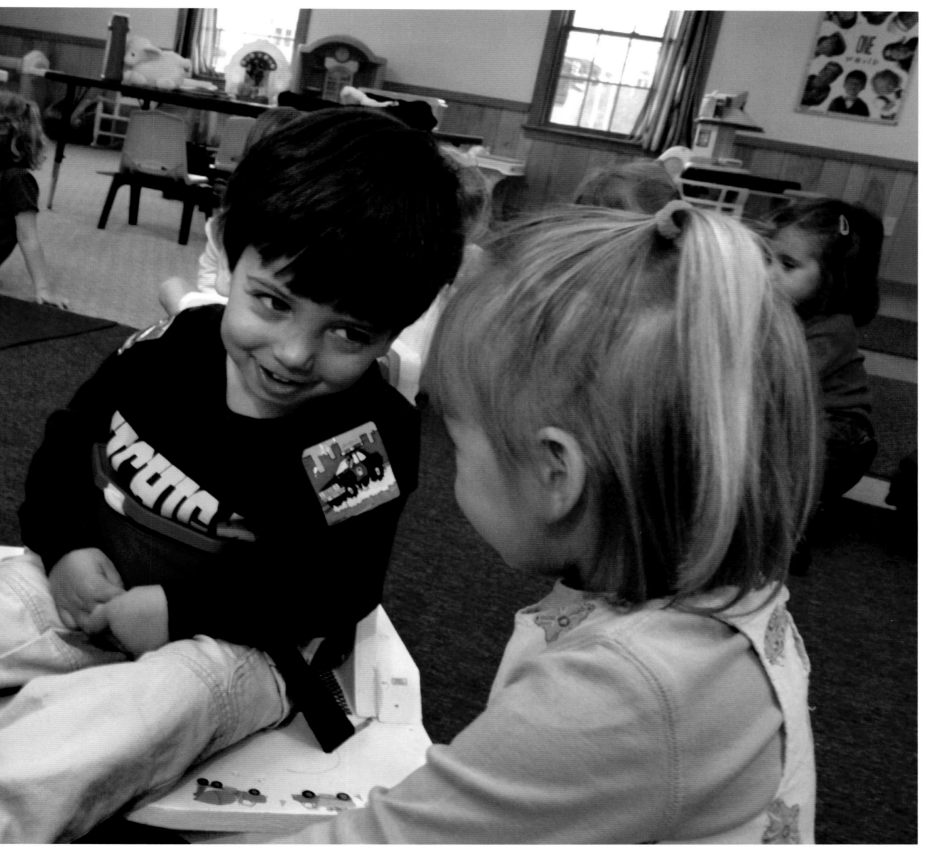

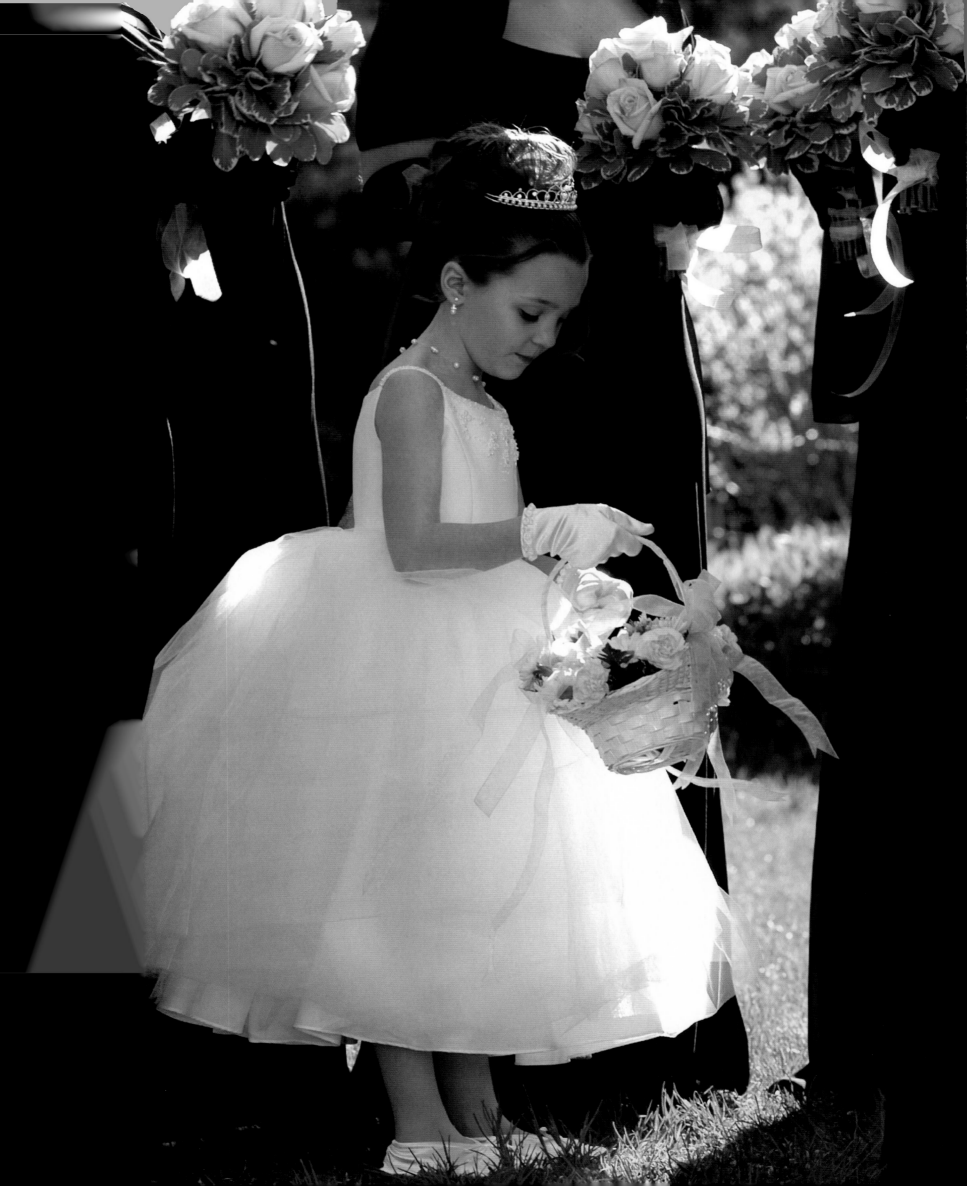

NASHUA

Flower girl Shannon Gallagher, 5, is the youngest participant in her cousin Coleen Manning's wedding to Alex Linke, held on a sunny Saturday at Greeley Park. Together with the bride, Shannon prepared for months for the big day, offering her expert opinion when it came to choosing a wedding gown and planning for the shower.

Photo by Kathy Seward MacKay

MANCHESTER

After dating for seven years, David Wallace III and Monique Rose Fisher tied the knot in Wagner Park in front of 100 friends and family members. Their daughter Octavia, 4, was the flower girl; son Isaiah, 6, served as ring bearer.

Photo by Bob LaPree, The Union Leader

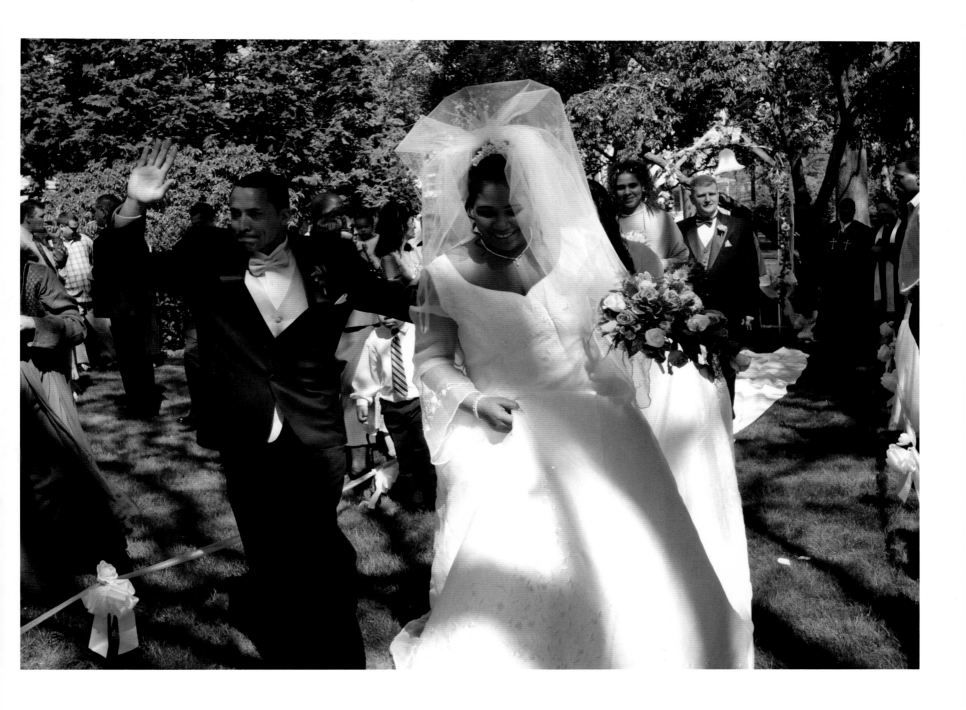

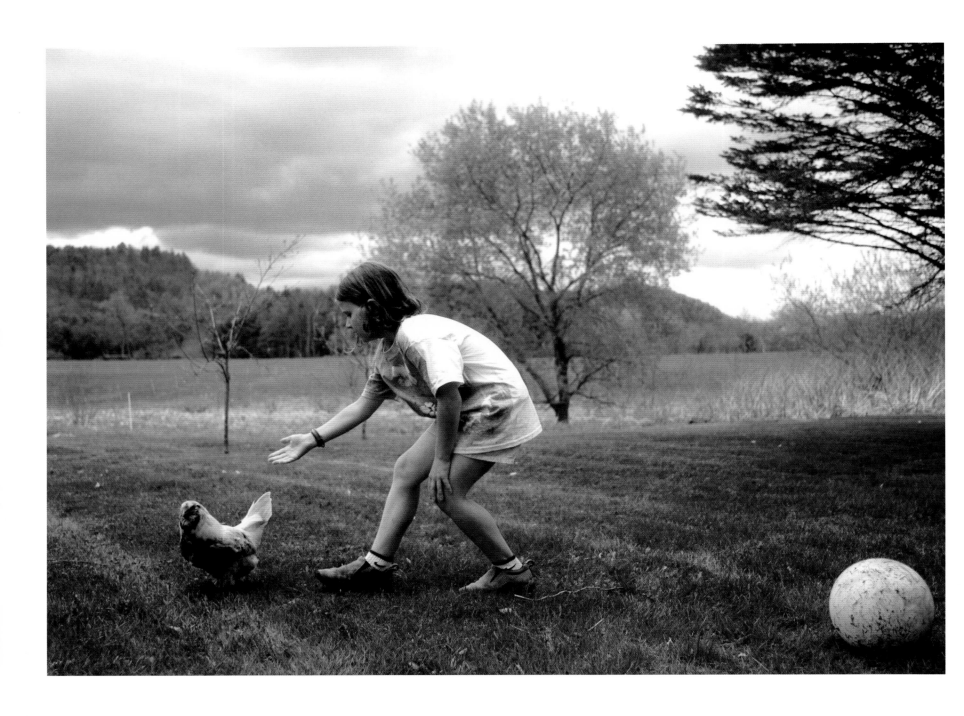

LYME

Kieran Mundy considers the family's 10 chickens to be pets rather than livestock. The hens, which lay eggs for the family's breakfast, get free run of the Mundys' third of an acre, plus all the organic compost they can peck at.

Photos by Laura DeCapua

LYME
Molly Mundy tries to entice pal Carolyn Elliot to
join her in scaling the backyard oak tree.

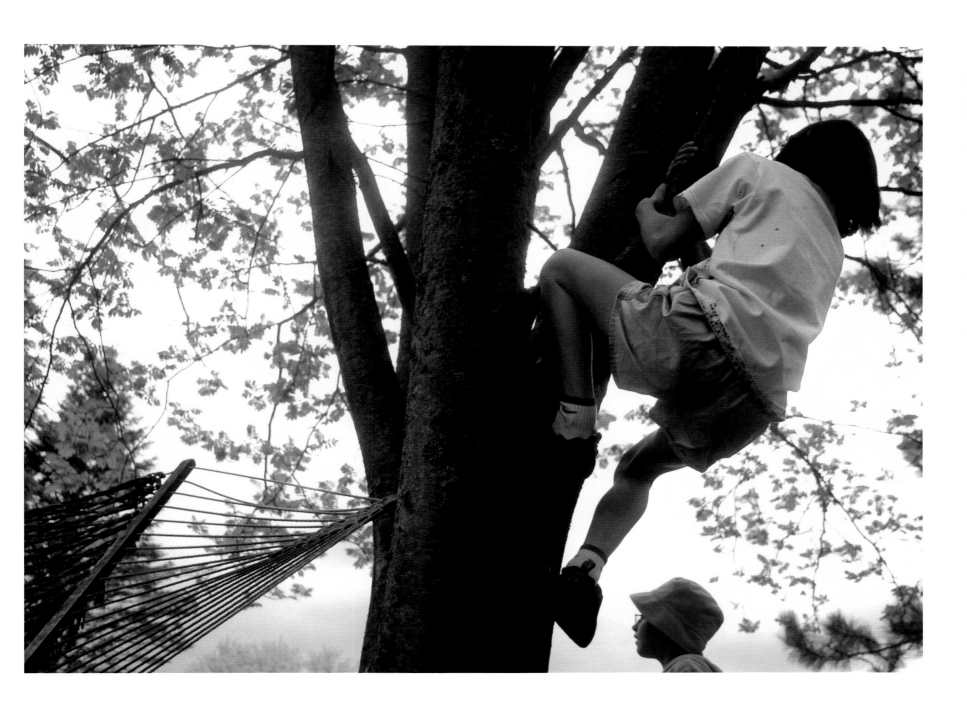

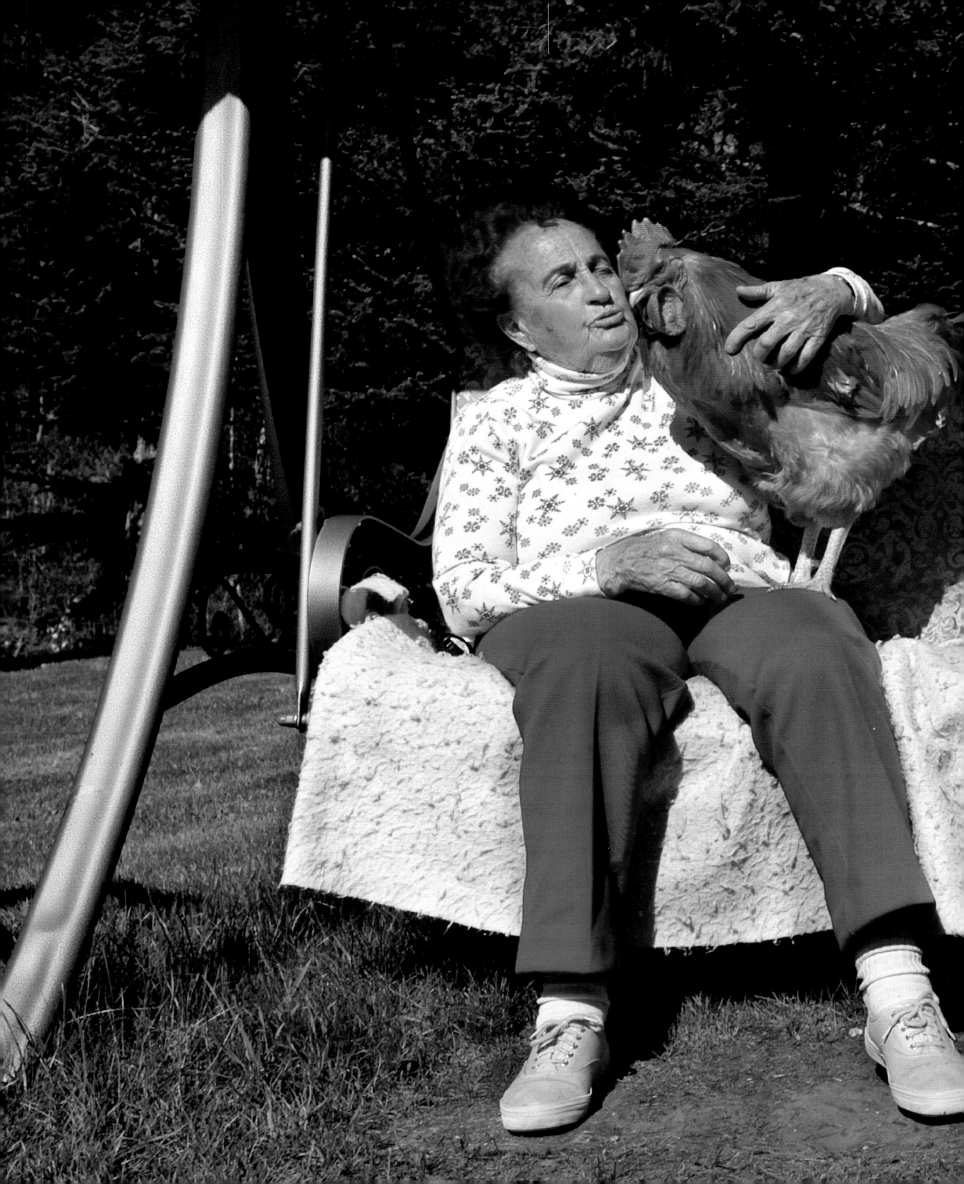

CANAAN

Ruth Neily moved to Goose Pond Road with her two children in 1956. She ran a dairy farm, raised chickens and pigs, and planted vegetables. These days, she spends time with her four grandkids, three horses, and Charlie, the rooster. "He comes when I call him, lays his head on my lap, and watches TV with me," she says.

Photo by Jennifer Hauck

The year 2003 marked a turning point in the history of photography: It was the first year that digital cameras outsold film cameras. To celebrate this unprecedented sea change, the *America 24/7* project invited amateur photographers—along with students and professionals—to shoot and, via the Internet, submit digital images. Think of it as audience participation. Their visions of community are interspersed with the professional frames throughout this book. On the following four pages, however, we present a gallery produced exclusively by amateur photographers.

EAST DERRY Driving by the East Derry Fire Station, John Blais noticed a firefighter undressing. Or so he thought. Upon closer inspection, the mystery fireman turned out to be just a pair of boots and a suit. ***Photo by John Blais***

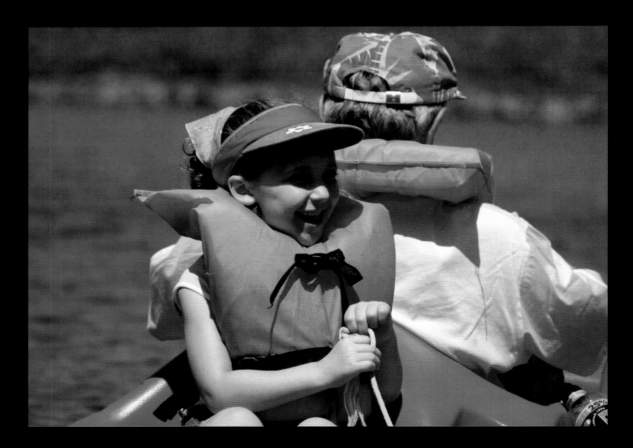

THORNTON While her grandfather Robert Risman paddles, Lauren Lavine smiles at the pleasing scenery of Corcoran's Pond. Lauren's family has been vacationing in the Waterville Valley for 30 years. ***Photo by Ron Risman***

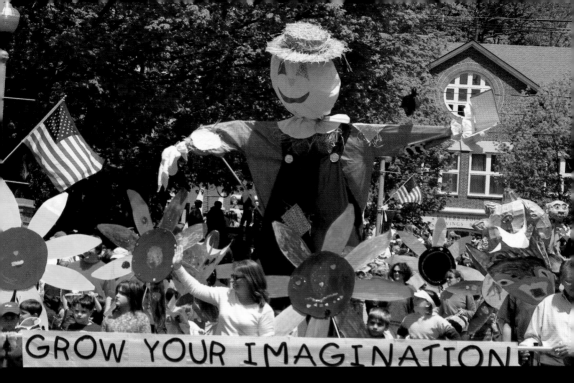

GROW YOUR IMAGINATION

ETERBOROUGH At the annual Children and the Arts Festival, kids march in the Giant Puppet Parade. With :reet painting, storytelling, and singing, the celebration showcases the talents of kids and adults who make ɔuth-oriented art. ***Photo by Alice Dodge***

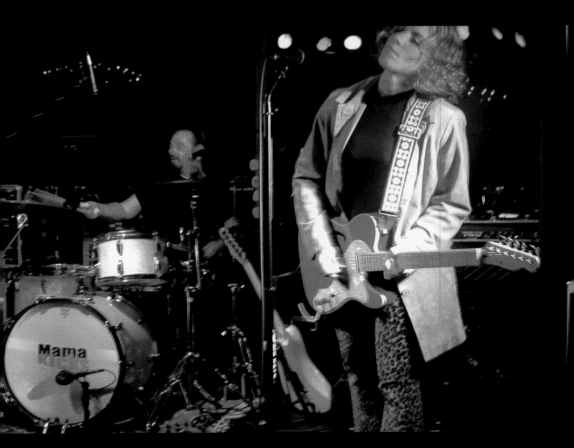

MANCHESTER Lisa Guyer of Mama Kicks sings to the beat of Dave Steffanelli's drumming at The Black Brimme nightclub. Playing Talking Heads, Grateful Dead, and Rolling Stones covers, the Manchester band supports them

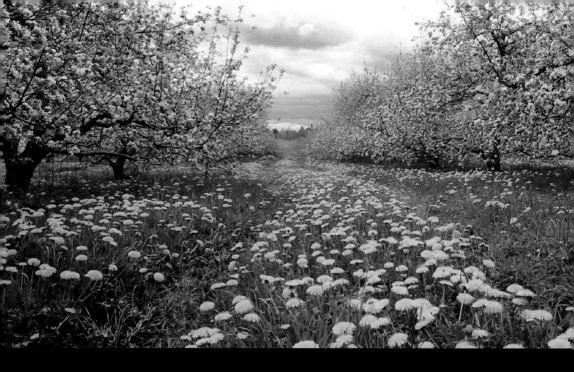

HOLLIS Dandelions fill in the fields between apple trees in the agricultural town of Hollis. *Photo by Jake Wyman*

LAISTOW Named after a marathon runner his owner met in San Francisco, Sparkie saunters through the yard

WINDHAM The Windham Girl Scout troop (and one Girl Scout boyfriend) mugs for the camera during Dabbler Day, when older Scouts teach the fledglings the skills they'll need to earn their badges. *Photo by Jack Donahue*

HANOVER On the Euro-Bungy trampoline, a Dartmouth College student catches air during Green Key Weekend. The event heralds the arrival of spring and is sponsored by the Green Key Society. *Photo by Ronald Kimball*

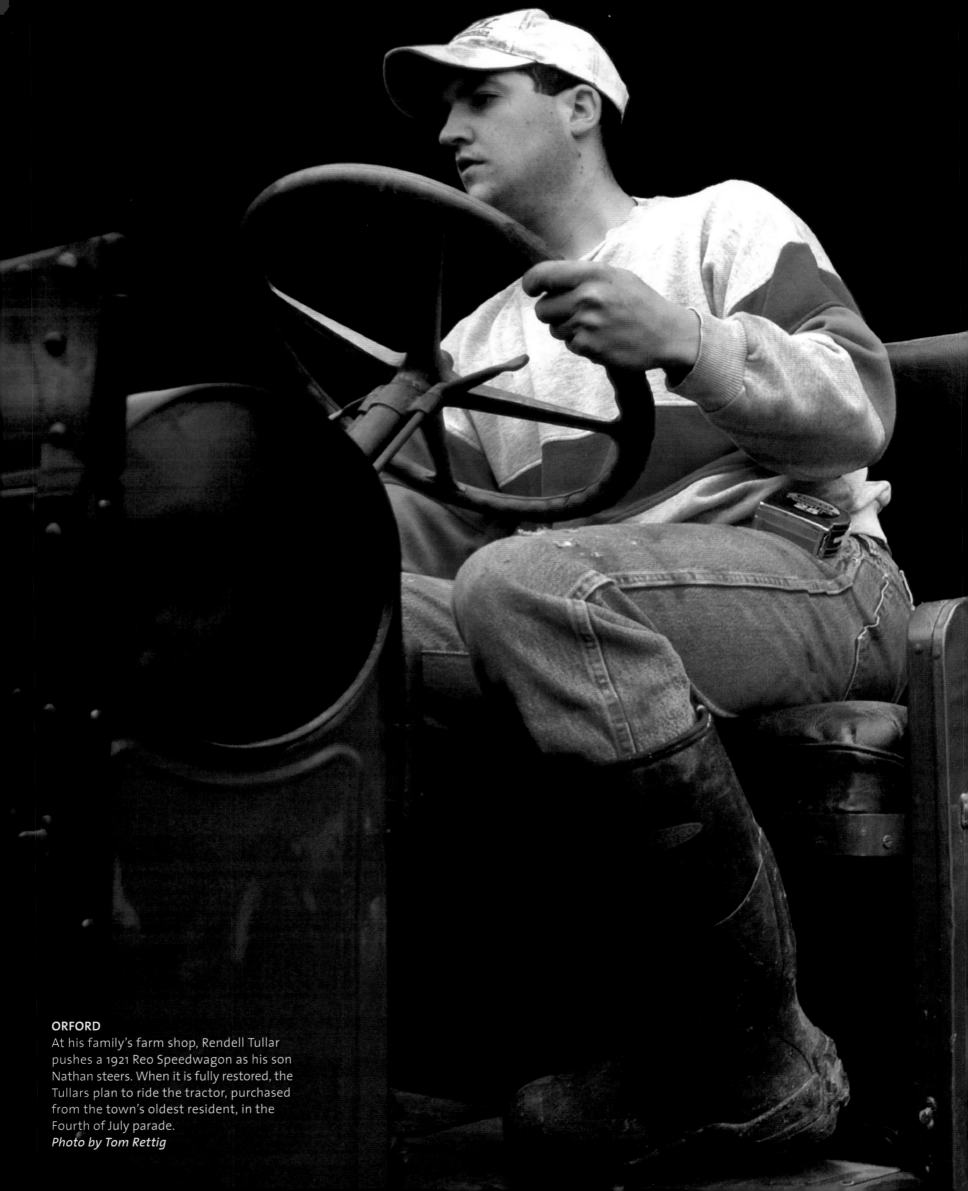

ORFORD
At his family's farm shop, Rendell Tullar pushes a 1921 Reo Speedwagon as his son Nathan steers. When it is fully restored, the Tullars plan to ride the tractor, purchased from the town's oldest resident, in the Fourth of July parade.
Photo by Tom Rettig

Hard At Work

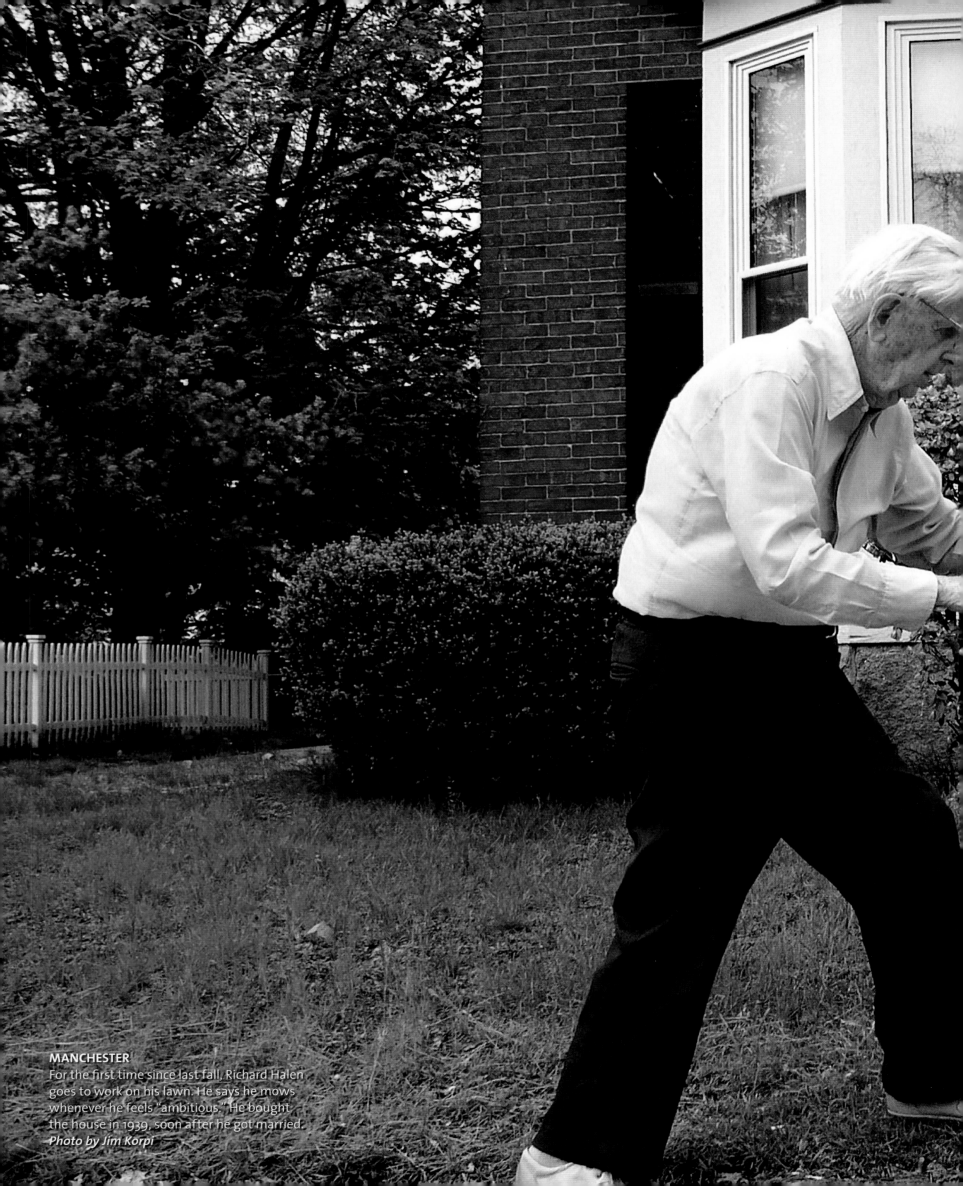

MANCHESTER
For the first time since last fall, Richard Halen goes to work on his lawn. He says he mows whenever he feels "ambitious." He bought the house in 1939, soon after he got married.
Photo by Jim Korpi

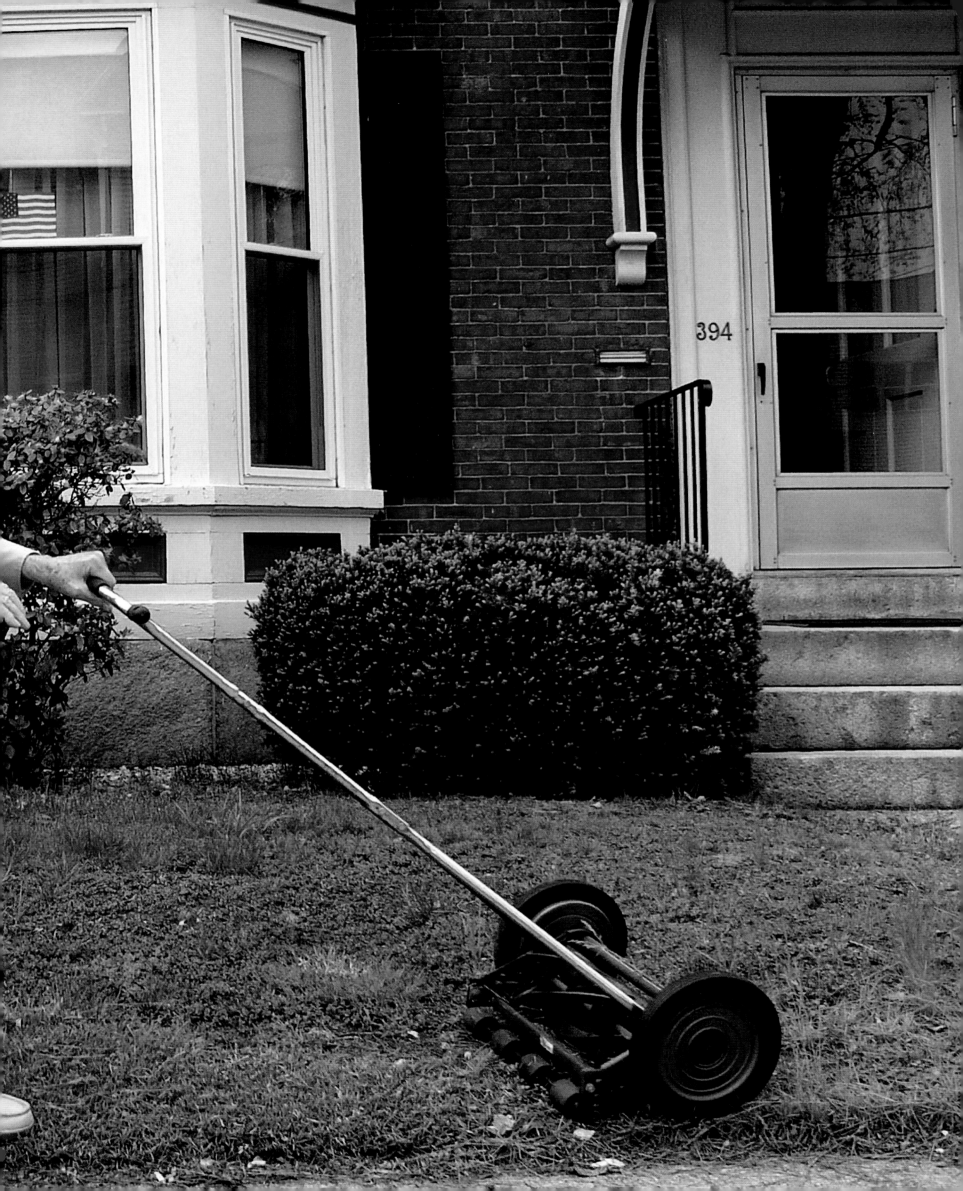

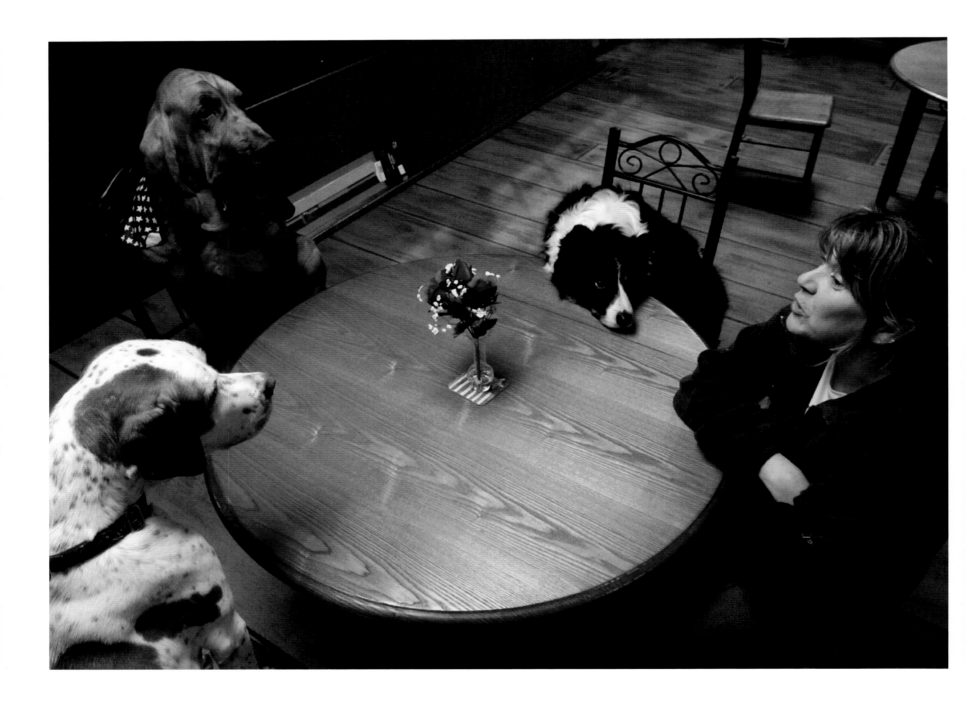

AMHERST
Who brought the cards? After an evening obedience class, trainer Celeste Meade briefs Breaker, Zipper, and Zoom on the dessert specials at American K9 Country's Canine Cafe.
Photo by Bob Hammerstrom

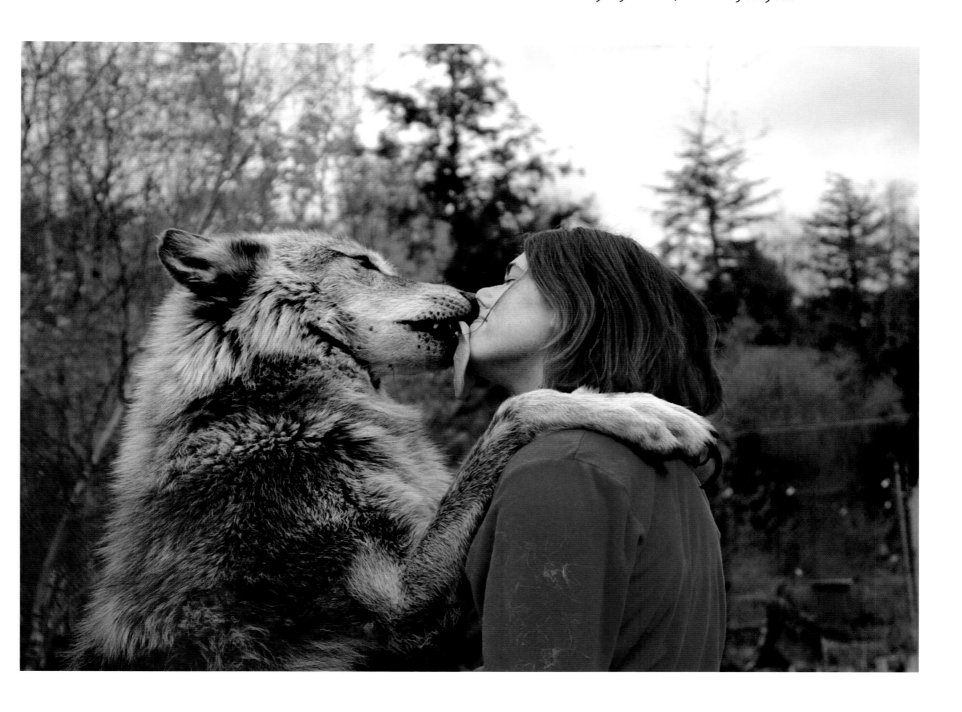

CHATHAM

Atlas, whose owner was killed in a barroom brawl, lavishes kisses on Aimee Crosby. Crosby and husband Fred Keating care for 98 wolf dogs at their 50-acre Loki Clan Wolf Refuge. Founded by Keating in 1989, the nonprofit takes in unwanted wolf dogs and educates the public about the wild ways of the captive species, which number 1.5 million in America.

Photo by Lloyd E. Jones, The Conway Daily Sun

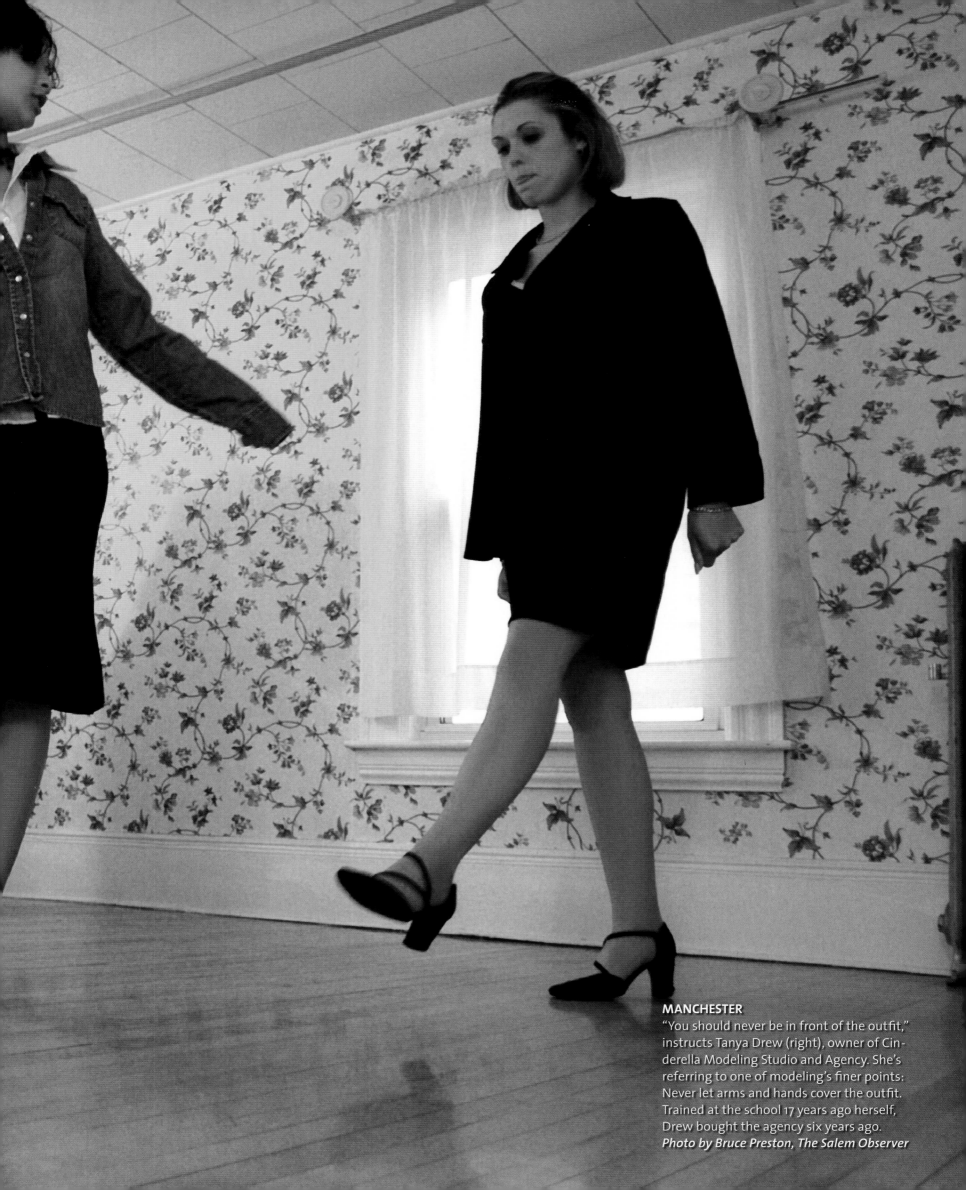

MANCHESTER

"You should never be in front of the outfit," instructs Tanya Drew (right), owner of Cinderella Modeling Studio and Agency. She's referring to one of modeling's finer points: Never let arms and hands cover the outfit. Trained at the school 17 years ago herself, Drew bought the agency six years ago.
Photo by Bruce Preston, The Salem Observer

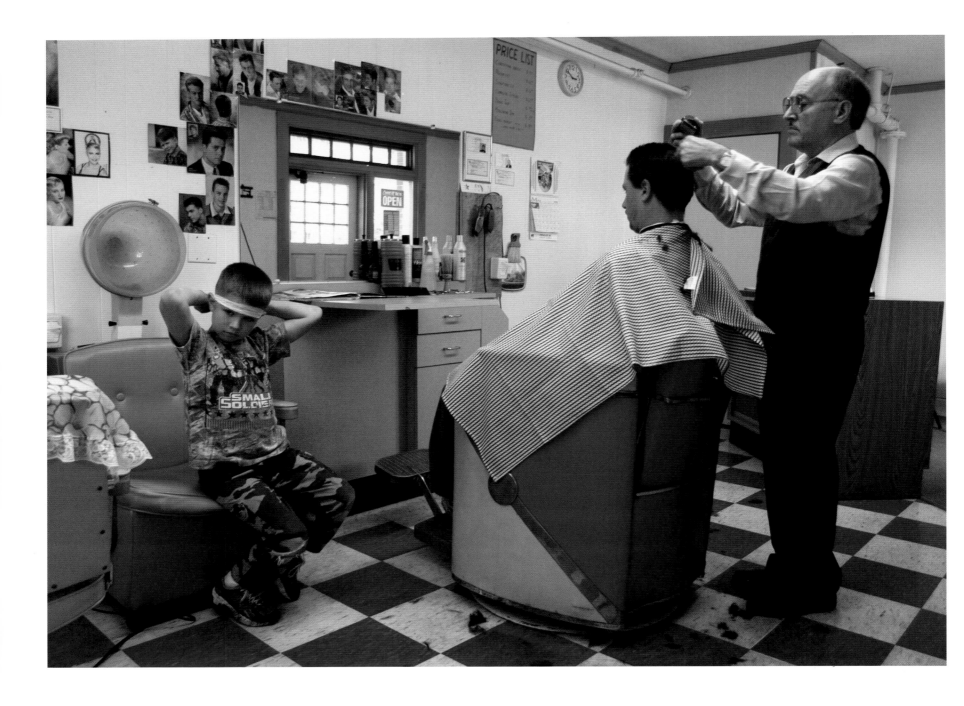

WHITEFIELD

Nickolas Brundk adjusts his headband as his dad Andrew gets a trim from Frank Pecze, owner of Frank's Family Barber & Beauty Shop. A native of Hungary, Pecze immigrated to America just after his homeland's 1956 revolution. He picked up English wherever he could and apprenticed with barbers until 1971, when he opened his own shop.
Photo by Jamie Gemmiti, Cross Road Studio

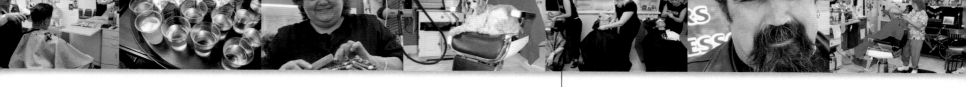

TILTON

Hip hairstylists at Gabriel's Salon pay homage to pink plumage. A TV documentary crew turned the town upside down filming at the kitschy "pink flamingo preserve" set up by the local Society for the Preservation of Artificial Wildlife. The documentary, called *The Secret Life of Lawn Ornaments*, was scheduled to air on cable channel HGTV.

Photo by Ben Garvin, bengarvin.com

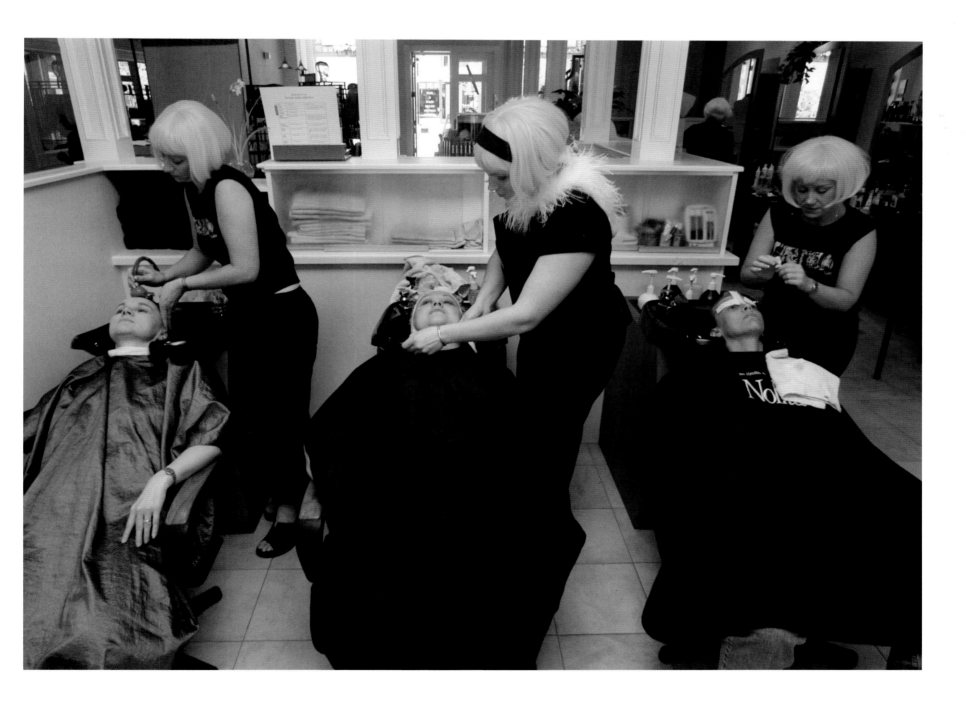

MILFORD

A crane at Fletcher Granite lifts a block of quarry-man Hermel Grenier's carefully chiseled rock. For 30 years, Grenier has been blasting, drilling, and hauling granite at the Milford quarry, which processes 40,000 cubic feet of the rock each year for use as building cladding, curbstones, and landscape elements around the world.

Photos by Kathy Seward MacKay

MILFORD

Quarrymen Derek Nolin and Hermel Grenier prepare granite for splitting at Fletcher Granite. The 80-acre quarry has been operating since the early 20th century.

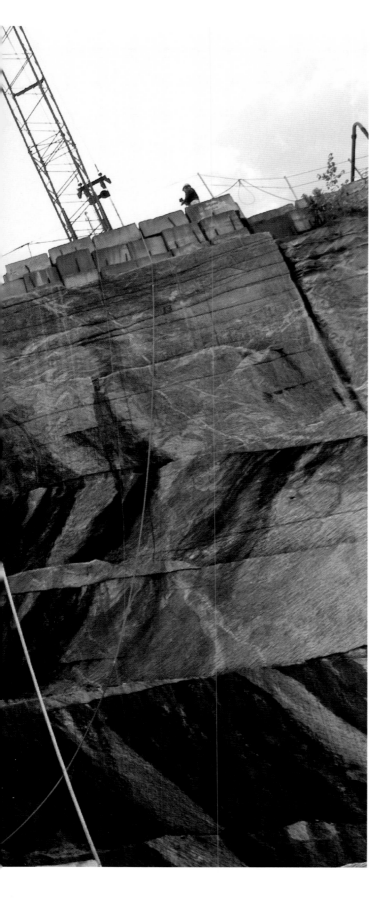

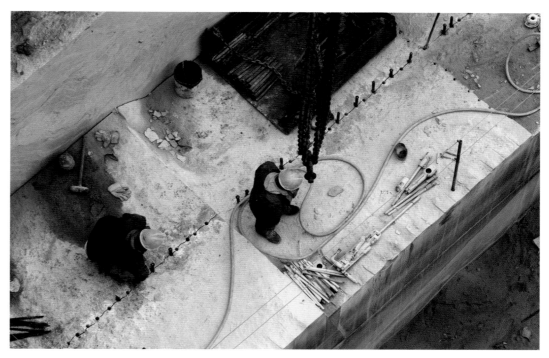

ORFORD

Nathan Tullar tends to the calves at the 1,700-acre farm his family has owned since 1956. The Tullars maintain 600 cows—300 for milking and 300 for slaughter—and grow corn, alfalfa, and hay for silage. Fame touched the farm when, in 1993, a happy Holstein produced 58,952 pounds of milk, setting the world record for hormone-free milk production.

Photo by Tom Rettig

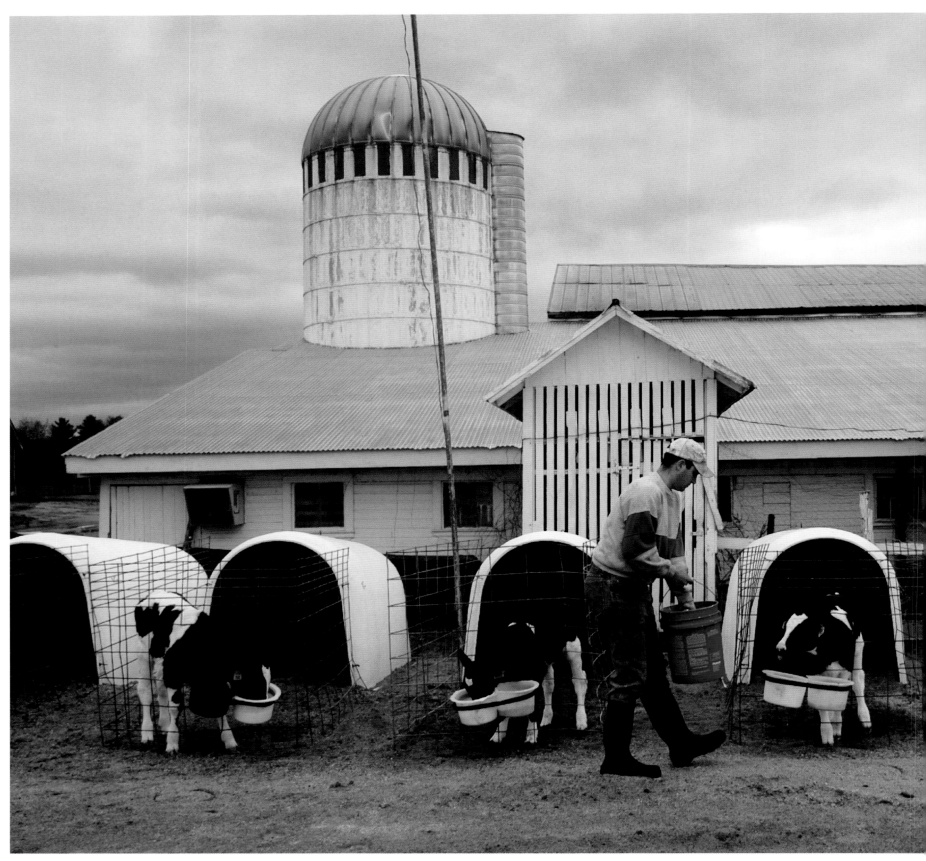

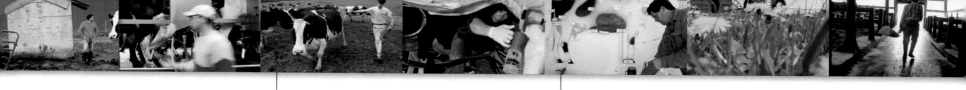

STRATHAM

Farmhand John Wells moves some of the 200 Holsteins on the Stuart Farm. Even with three generations working the farm, owners John and Lorraine Merrill face an uphill battle. Milk prices paid to New England dairy farmers are at a 20-year low.

Photo by Carrie Niland

ORFORD

Pin the bladder on the bovine: Rendell Tullar stands next to a wooden replica of a Holstein, which he uses at 4-H talks to educate people about dairy cows.

Photo by Tom Rettig

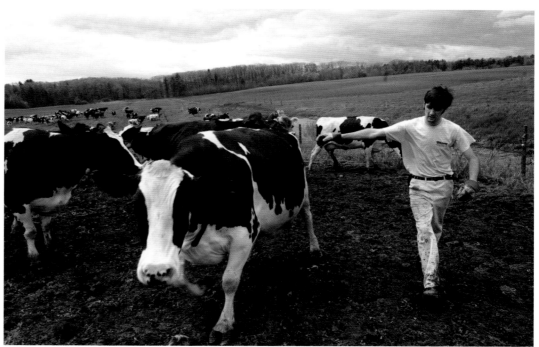

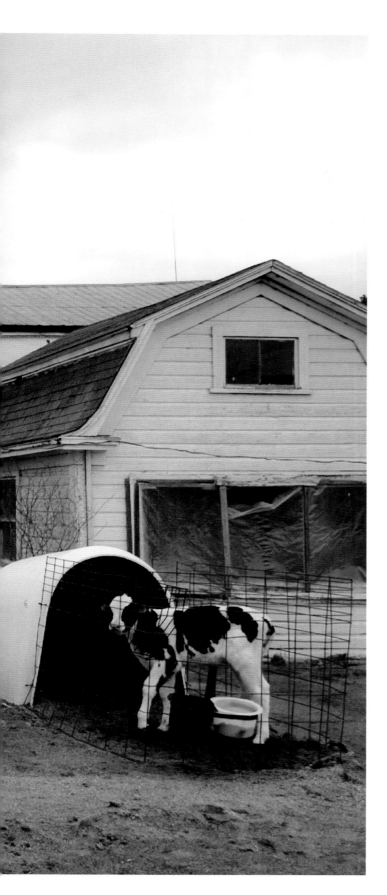

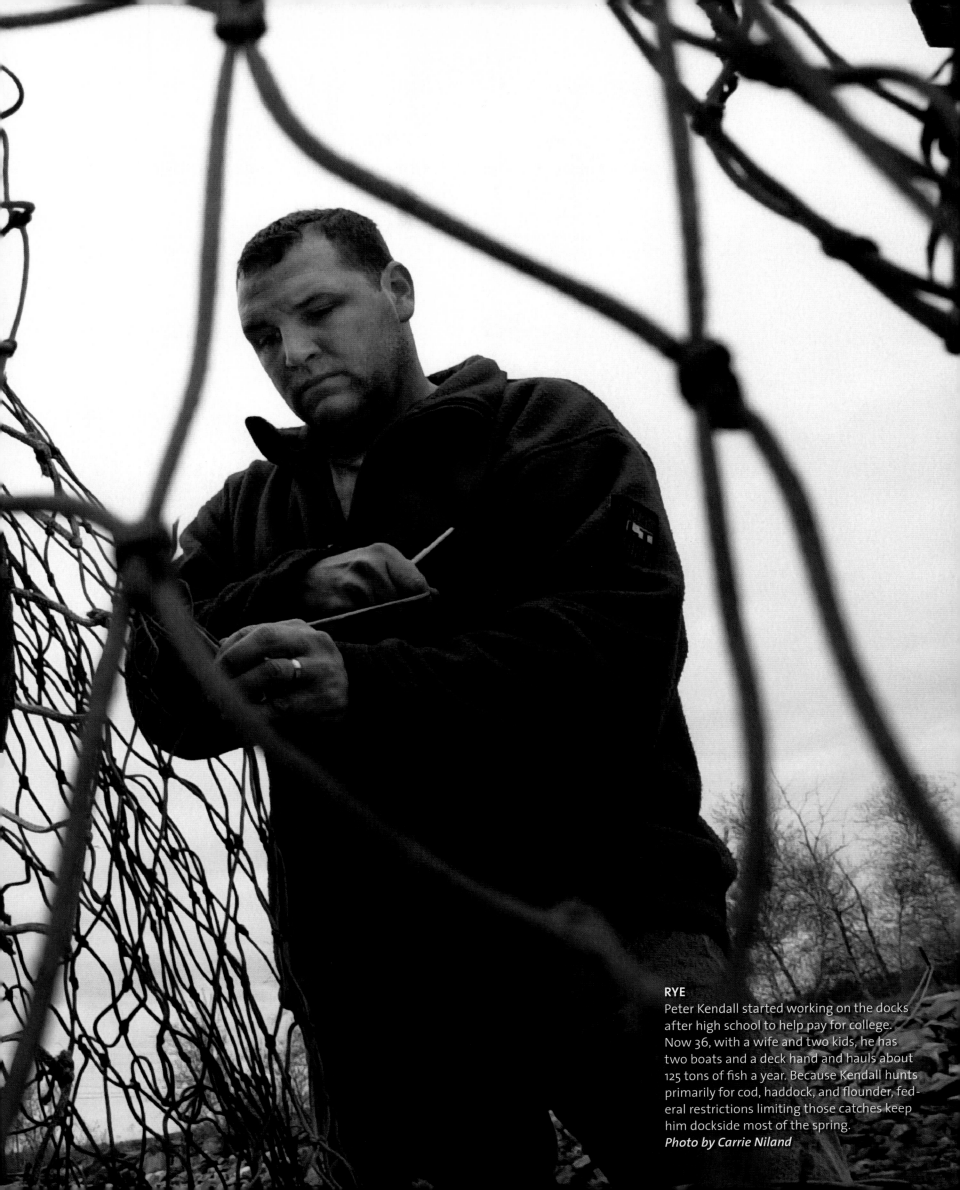

RYE

Peter Kendall started working on the docks after high school to help pay for college. Now 36, with a wife and two kids, he has two boats and a deck hand and hauls about 125 tons of fish a year. Because Kendall hunts primarily for cod, haddock, and flounder, federal restrictions limiting those catches keep him dockside most of the spring.
Photo by Carrie Niland

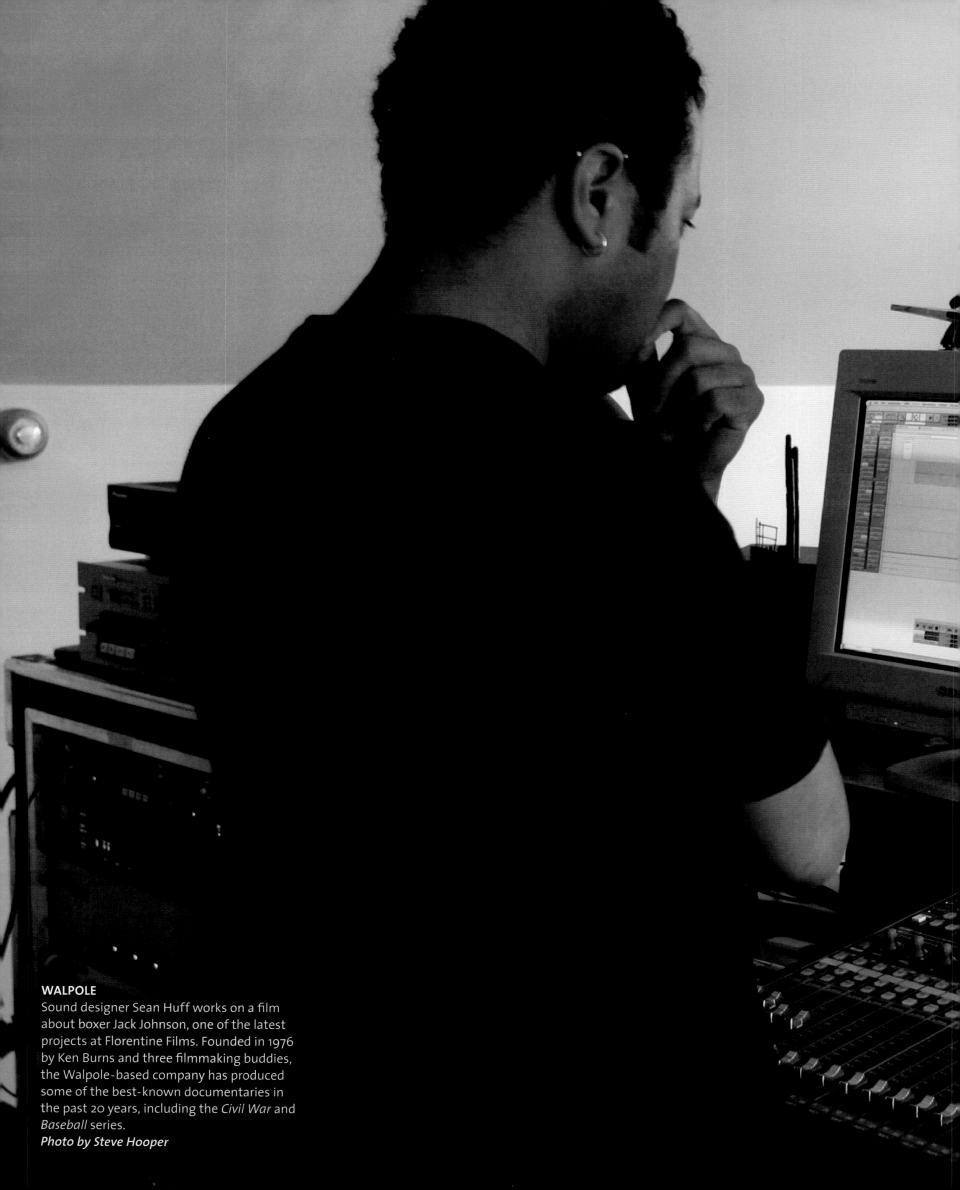

WALPOLE
Sound designer Sean Huff works on a film about boxer Jack Johnson, one of the latest projects at Florentine Films. Founded in 1976 by Ken Burns and three filmmaking buddies, the Walpole-based company has produced some of the best-known documentaries in the past 20 years, including the *Civil War* and *Baseball* series.
Photo by Steve Hooper

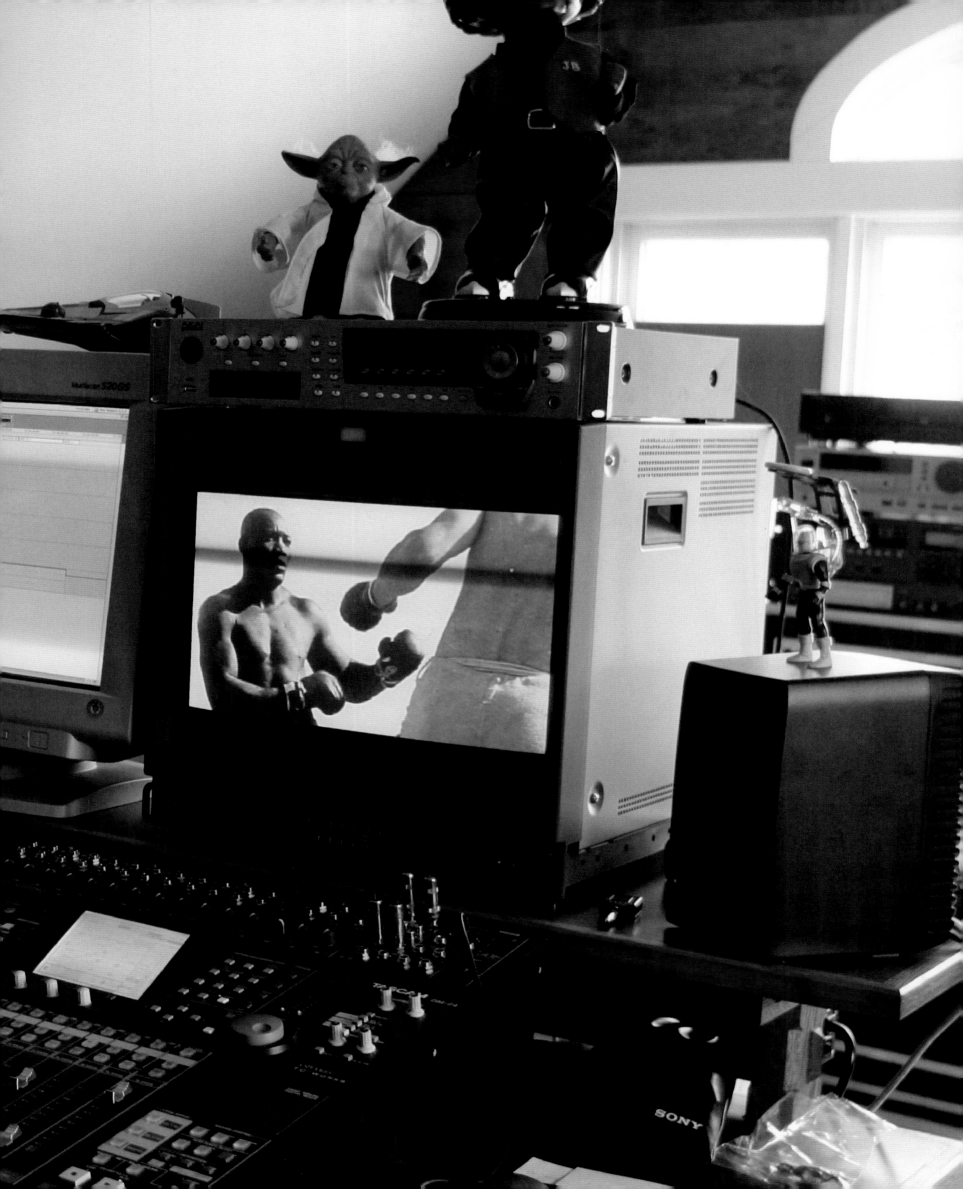

TILTON

During the morning rush at Pauli's Bakery and Restaurant, waitress Eileen McQuaid-Elliott snatches a quiet moment for herself while she waits for an order.
Photo by Ben Garvin, bengarvin.com

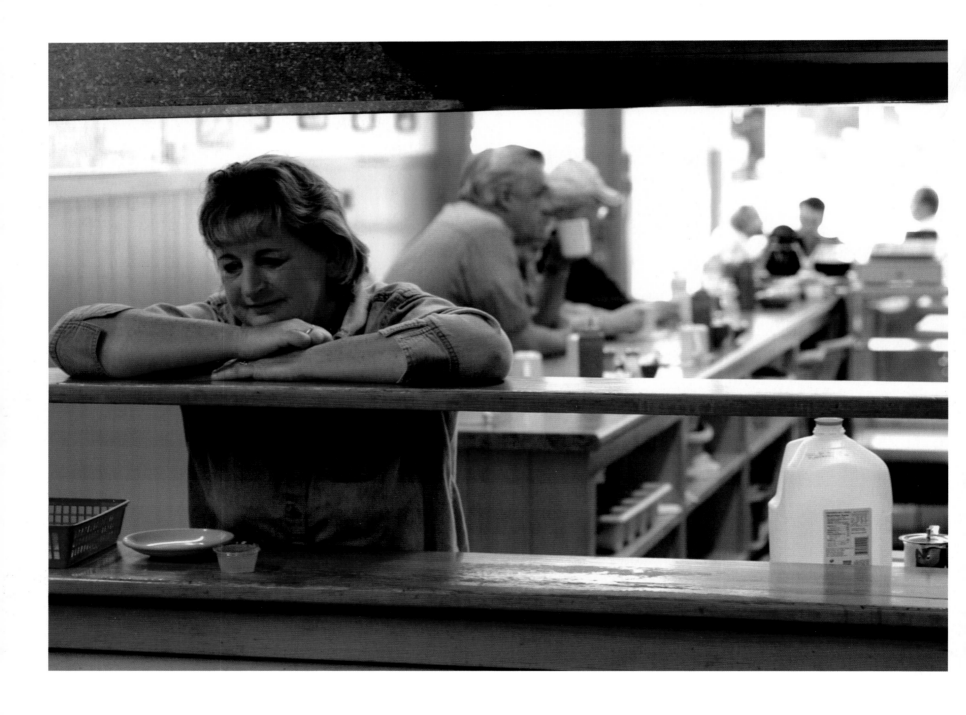

NASHUA

With more than 10,000 people to feed during St. Philip Greek Orthodox Church's yearly fundraiser, Achilles Scontsas, Odesia Vasiliou, and 10 others spent two days cutting up, marinating, and skewering 2,000 pounds of lamb. The 6-foot shish kabobs are cooked in a custom-made rotisserie. The effort paid off, raising $45,000 for the church.
Photo by Bob Hammerstrom

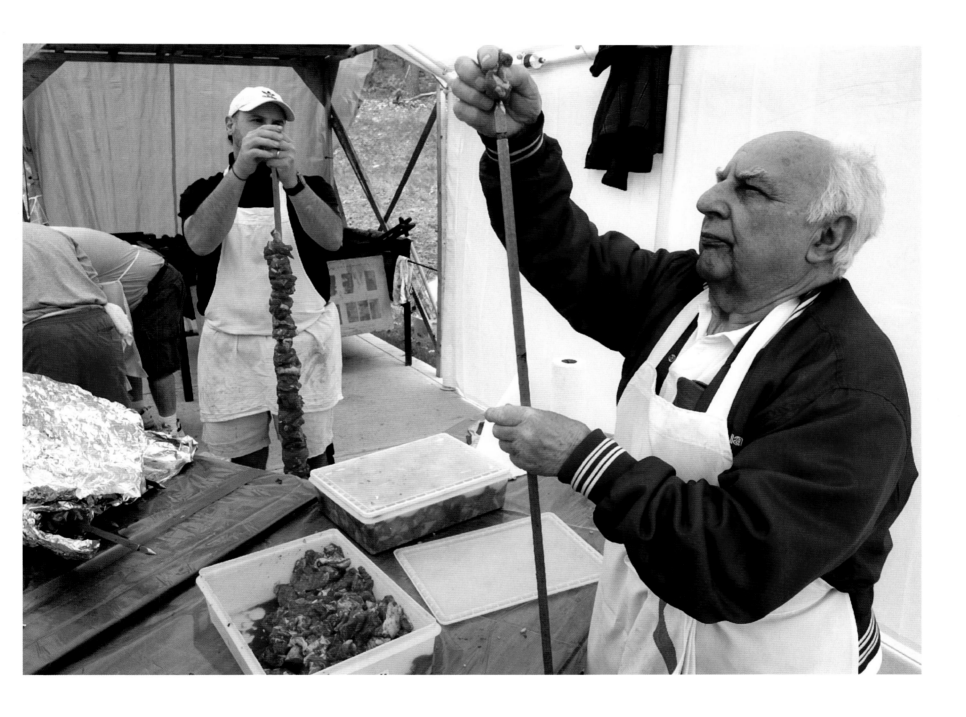

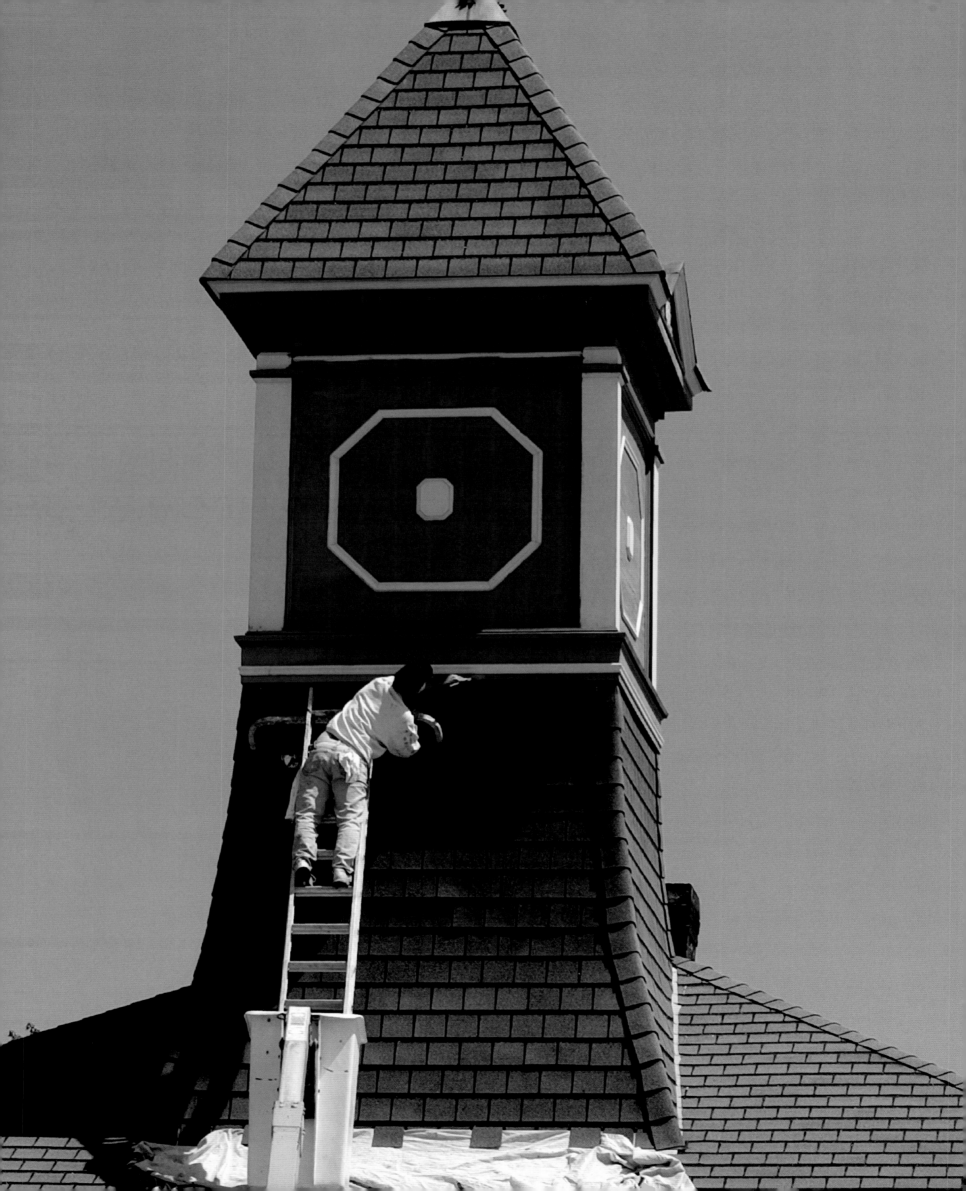

MILFORD

Opened on November 15, 1894, the Fitchburg Depot has lived many lives. Trains transported granite and passengers until the line was shut down in 1931. Since then, the depot has been a grocery store, a crafts store, an apartment building, and a private home. Today, it houses United Auto Body.

Photo by Bob Hammerstrom

MANCHESTER

Because a gentleman always carries a clean one in his pocket, Maurice St. Onge washes his handkerchiefs at least twice a week.

Photo by Jim Korpi

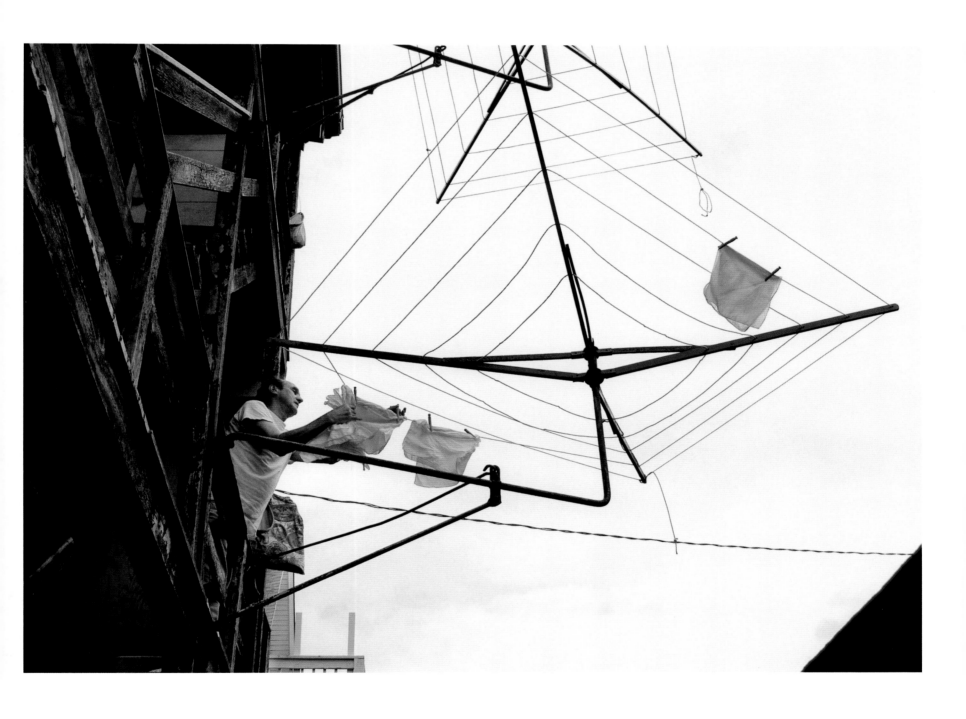

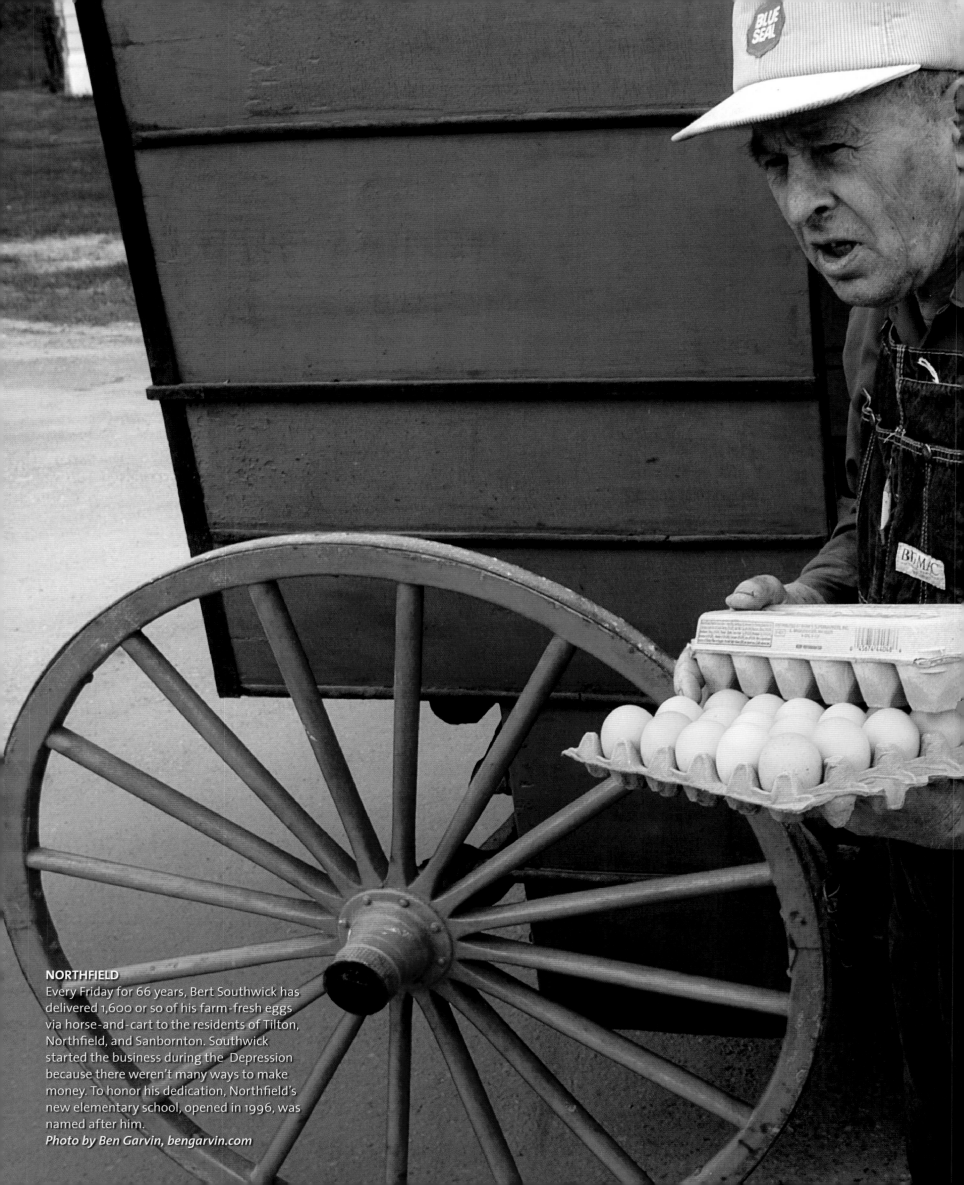

NORTHFIELD
Every Friday for 66 years, Bert Southwick has
delivered 1,600 or so of his farm-fresh eggs
via horse-and-cart to the residents of Tilton,
Northfield, and Sanbornton. Southwick
started the business during the Depression
because there weren't many ways to make
money. To honor his dedication, Northfield's
new elementary school, opened in 1996, was
named after him.
Photo by Ben Garvin, bengarvin.com

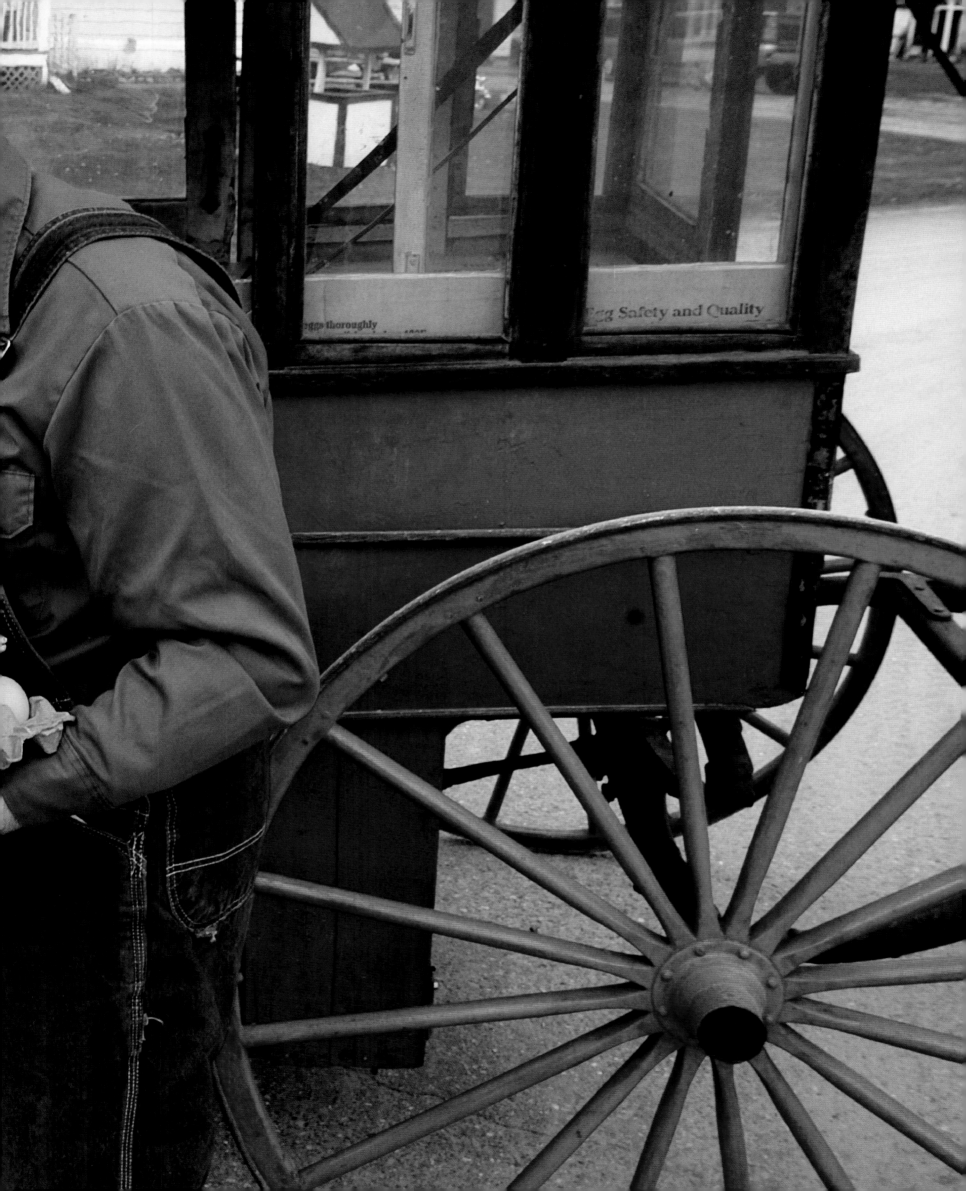

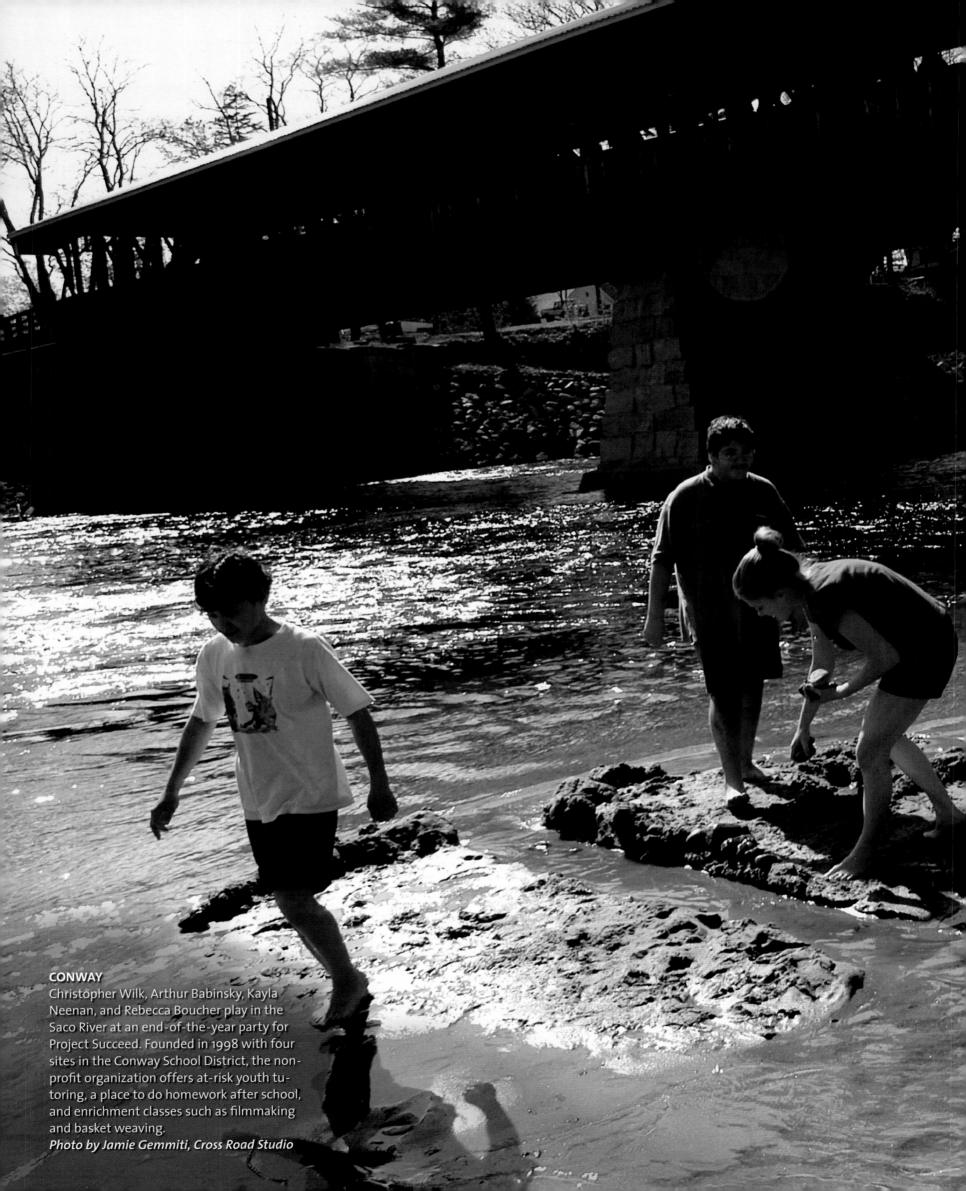

CONWAY

Christopher Wilk, Arthur Babinsky, Kayla Neenan, and Rebecca Boucher play in the Saco River at an end-of-the-year party for Project Succeed. Founded in 1998 with four sites in the Conway School District, the non-profit organization offers at-risk youth tutoring, a place to do homework after school, and enrichment classes such as filmmaking and basket weaving.

Photo by Jamie Gemmiti, Cross Road Studio

New Hampshire At Play

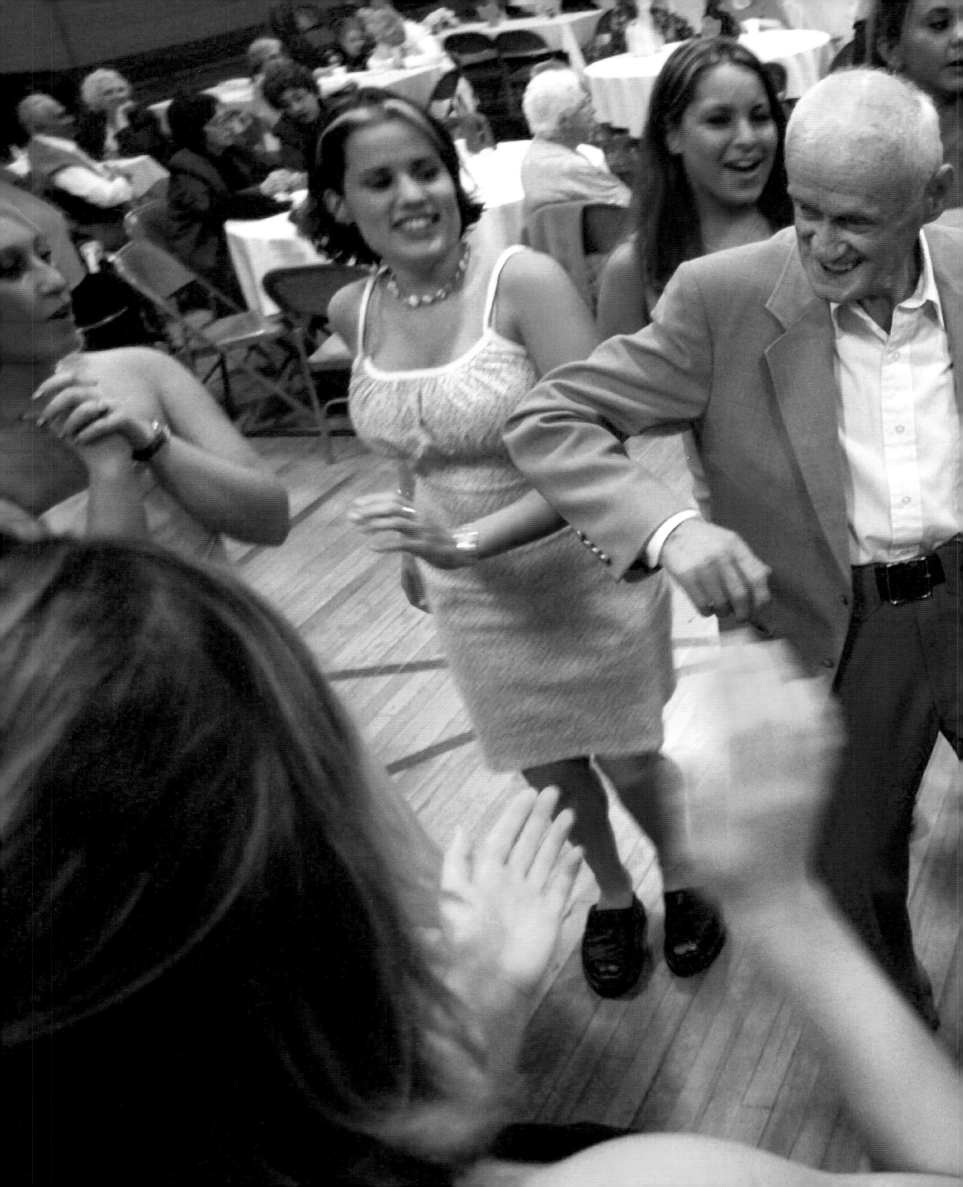

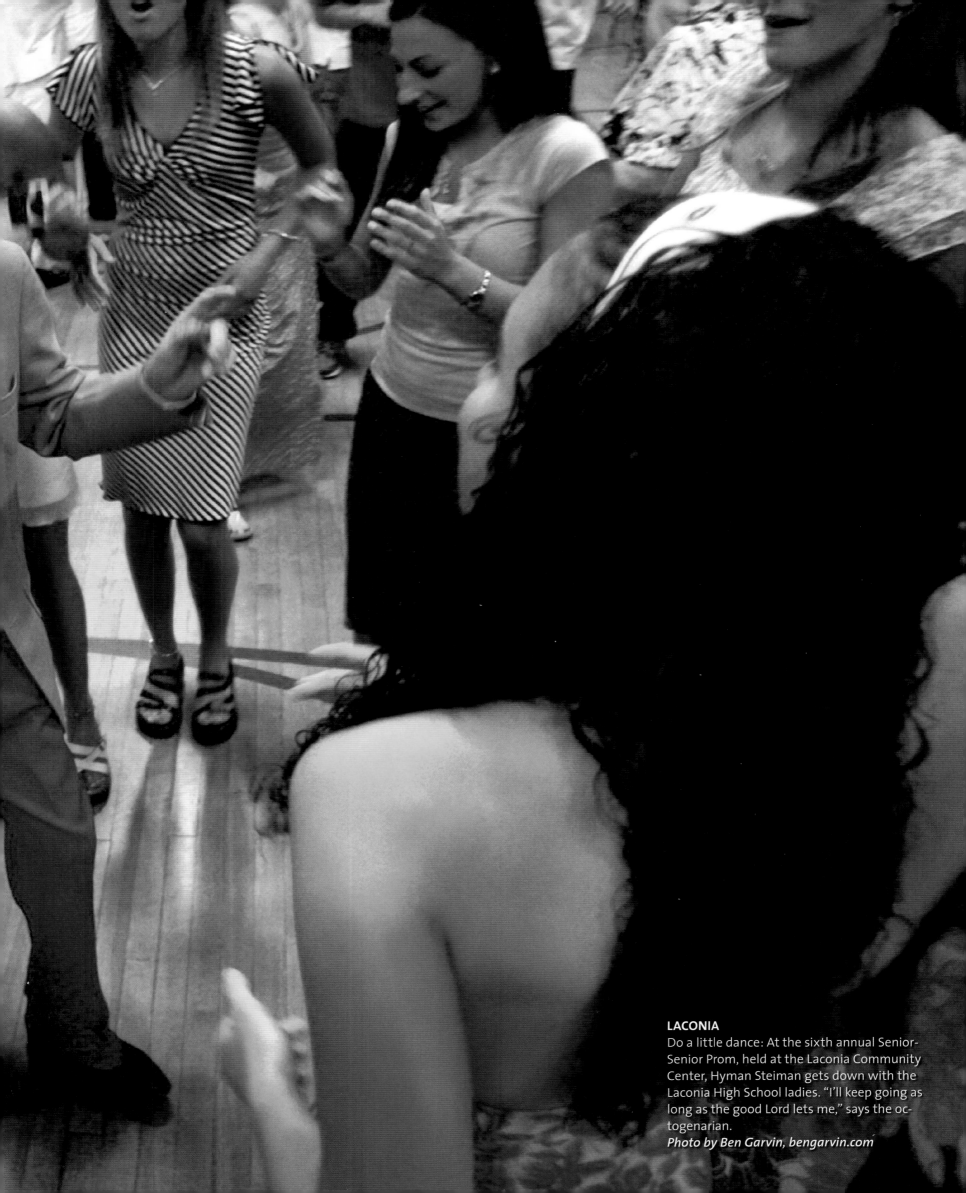

LACONIA
Do a little dance: At the sixth annual Senior-Senior Prom, held at the Laconia Community Center, Hyman Steiman gets down with the Laconia High School ladies. "I'll keep going as long as the good Lord lets me," says the octogenarian.
Photo by Ben Garvin, bengarvin.com

CONCORD

Lisa Violette doesn't seem too concerned about the risks as she soaks up ultraviolet rays at the Hot Spot Tanning Center. For more than a decade, the 39-year-old homemaker has stopped in for her 15-minute, twice-weekly toasting. "I just feel better when I'm tan," she says. "I feel more alive."
Photo by Ben Garvin, bengarvin.com

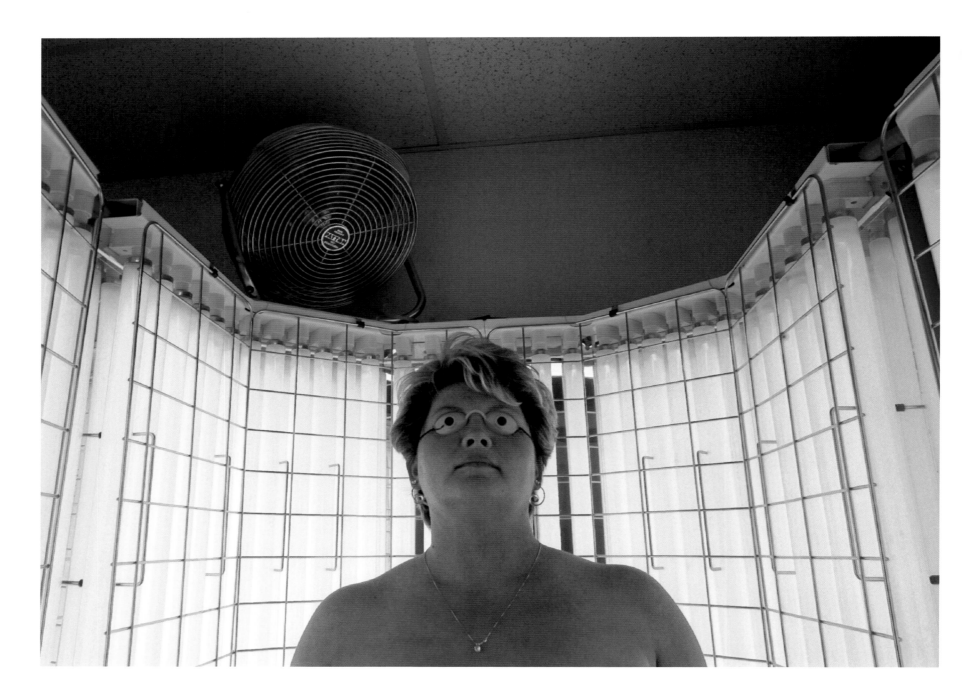

NASHUA

"If I were you, I'd fall in love with me," Renée Tramack belts during a dress rehearsal with her female barbershop chorus, New England Voices in Harmony.
Photo by Kathy Seward MacKay

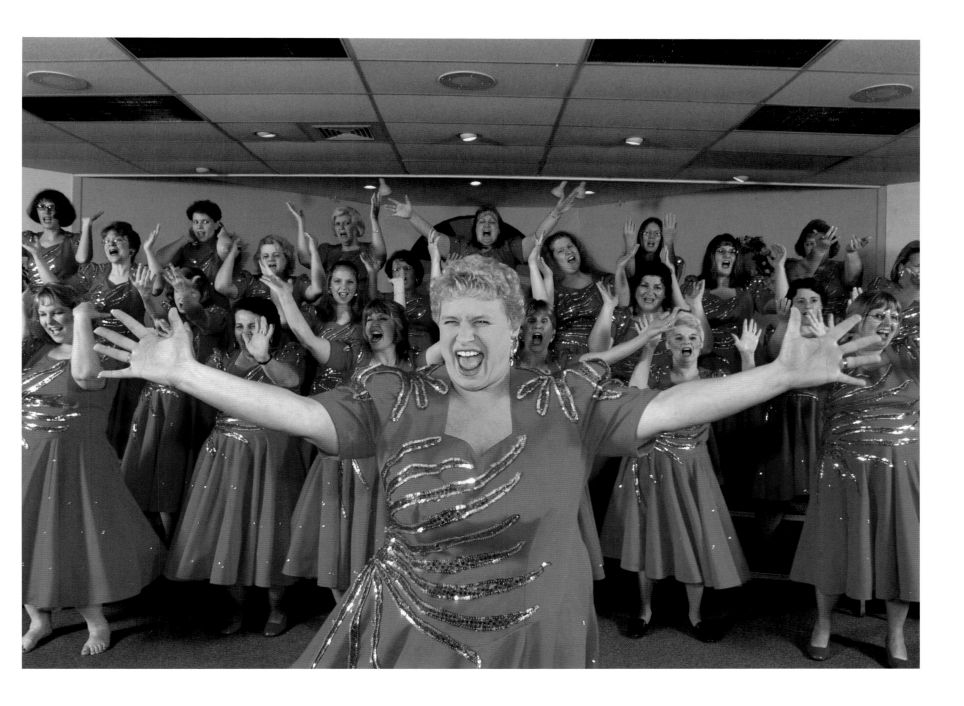

LYME

Ian and Kieran Mundy spend the morning tiptoe-
ing through the marsh behind their house. Their
parents laid down telephone poles for traversing
the particularly mucky parts.
Photo by Laura DeCapua

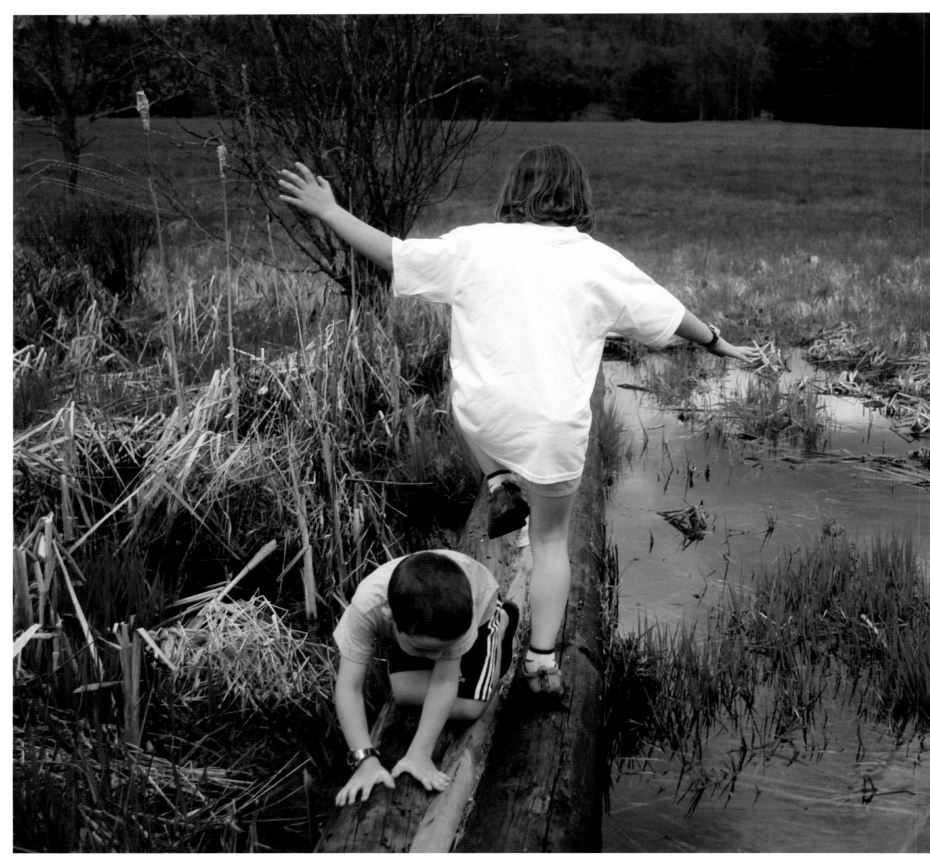

Jessica Gosselin, Nikki LaBounty, and Kathy Ovitt hunker down at Jean Marie's Candy Works. The local hangout has survived the ongoing economic downturn with its comforting standbys of hot dogs, milkshakes, and confections.
Photo by Jim Korpi

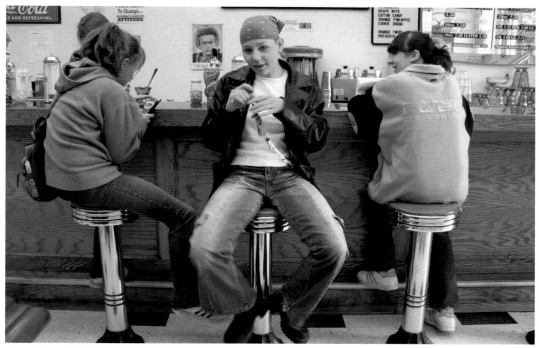

MILFORD

Justin Kasynak and dad Bob plan on some good eating tonight. The rainbow trout was one of several the pair caught during the annual Police Department Fishing Derby.
Photos by Bob Hammerstrom

RYE

Playing hooky: Stev Zelubowski was home sick, but not so sick that he couldn't try out his new St. Croix Wild River rod. The new gear netted him a striper bass.

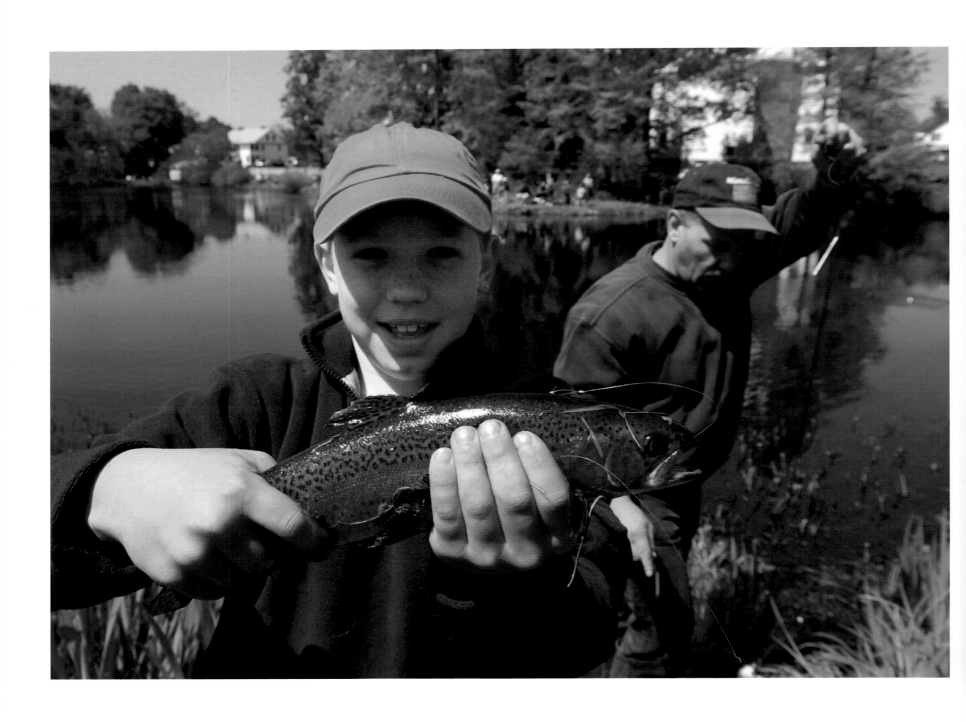

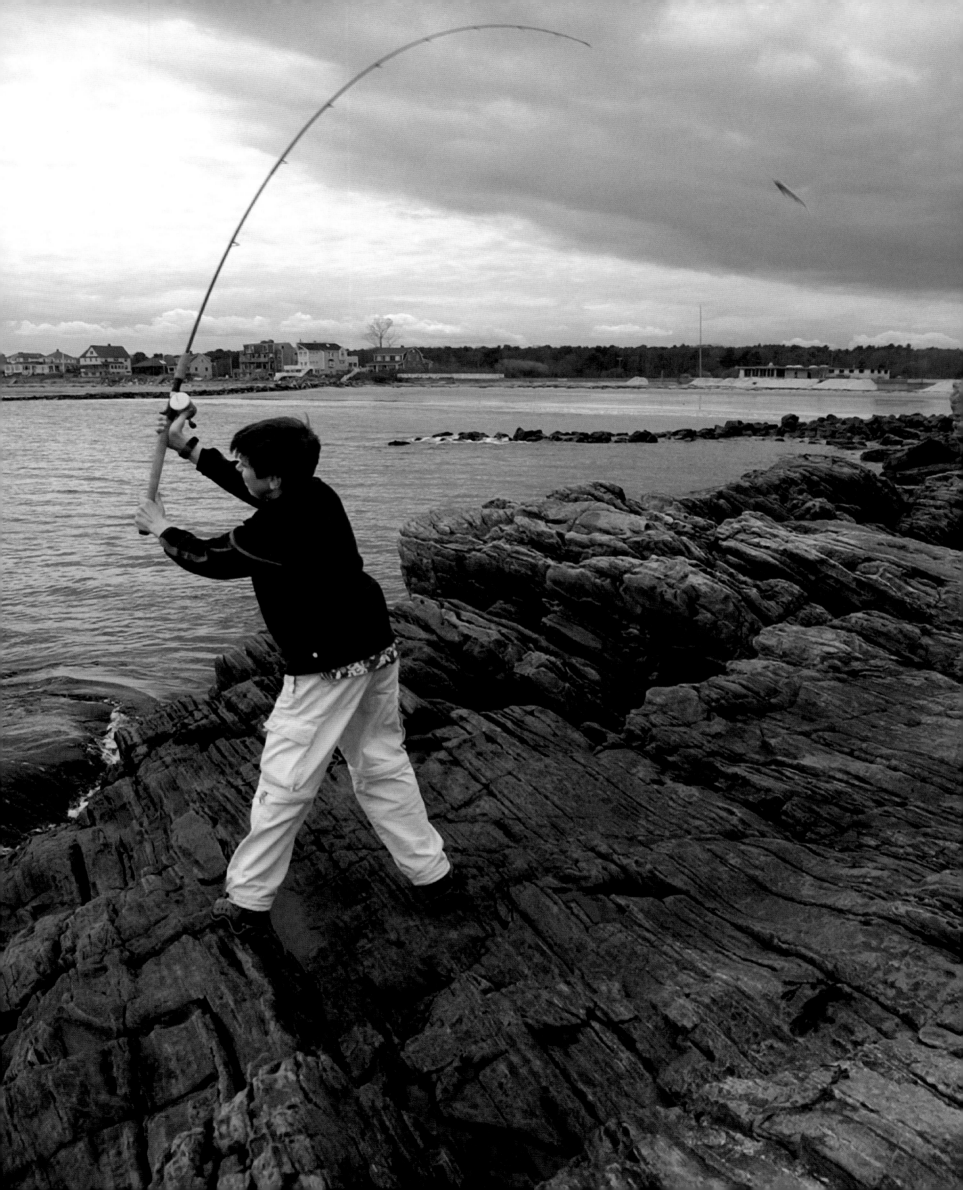

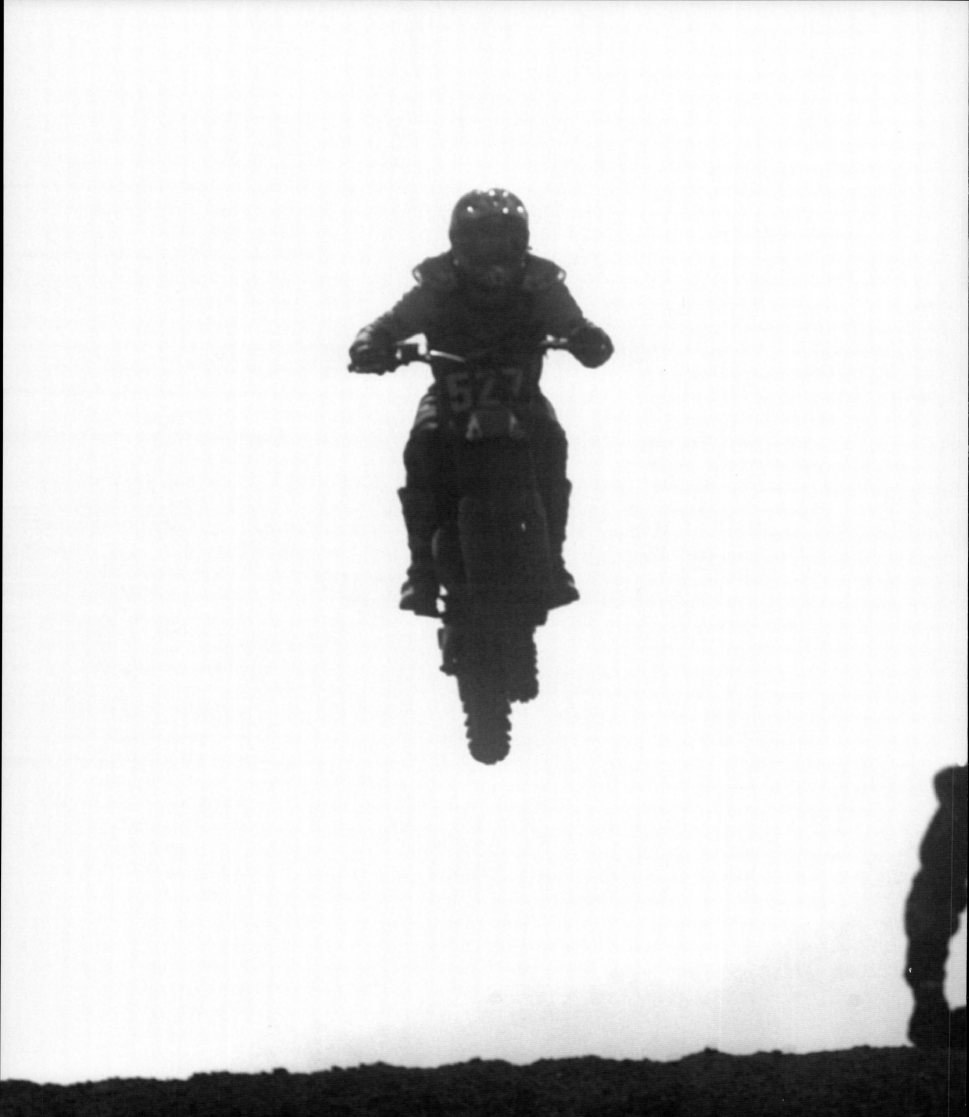

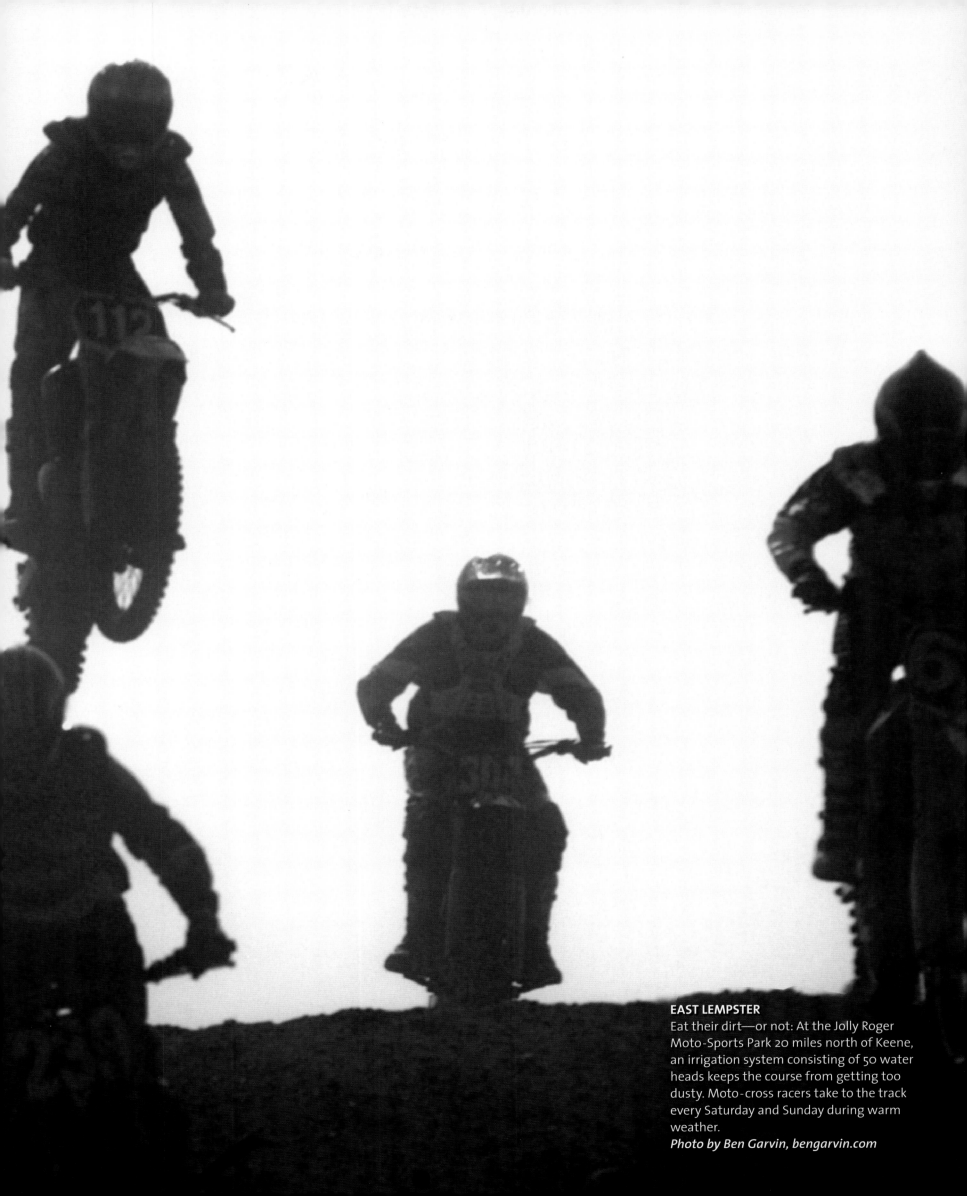

EAST LEMPSTER
Eat their dirt—or not: At the Jolly Roger Moto-Sports Park 20 miles north of Keene, an irrigation system consisting of 50 water heads keeps the course from getting too dusty. Moto-cross racers take to the track every Saturday and Sunday during warm weather.
Photo by Ben Garvin, bengarvin.com

KEENE

Teachers, parents, and students from the Montessori Schoolhouse hitch a ride on the hay truck at Stonewall Farm. Operated as a commercial dairy since 1908, the 160-acre farm offers educational workshops on sheep shearing, raising bees, and harvesting maple syrup.

Photos by Steve Hooper

KEENE

As part of Stonewall Farm's hands-on "Wetland Wonders" program, student Collyn Grenier dips a net in one of the property's three ponds and hauls out a handful of tiny marine creatures. Tim Sanborn shows Collyn the difference between crayfish, tadpoles, dragonfly nymphs, and newts before returning them to their watery home.

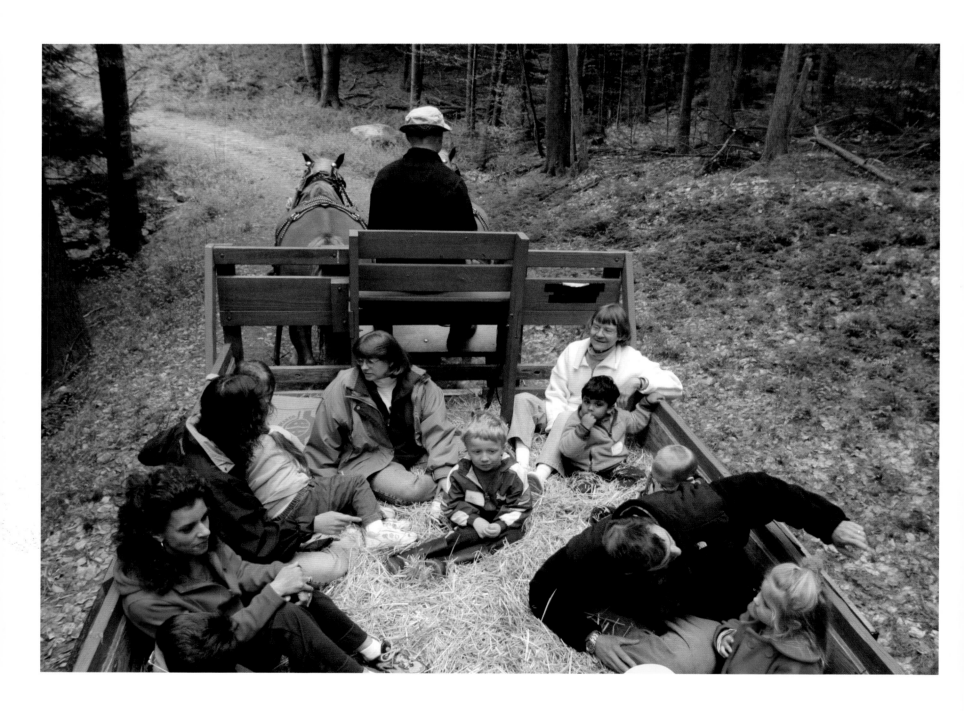

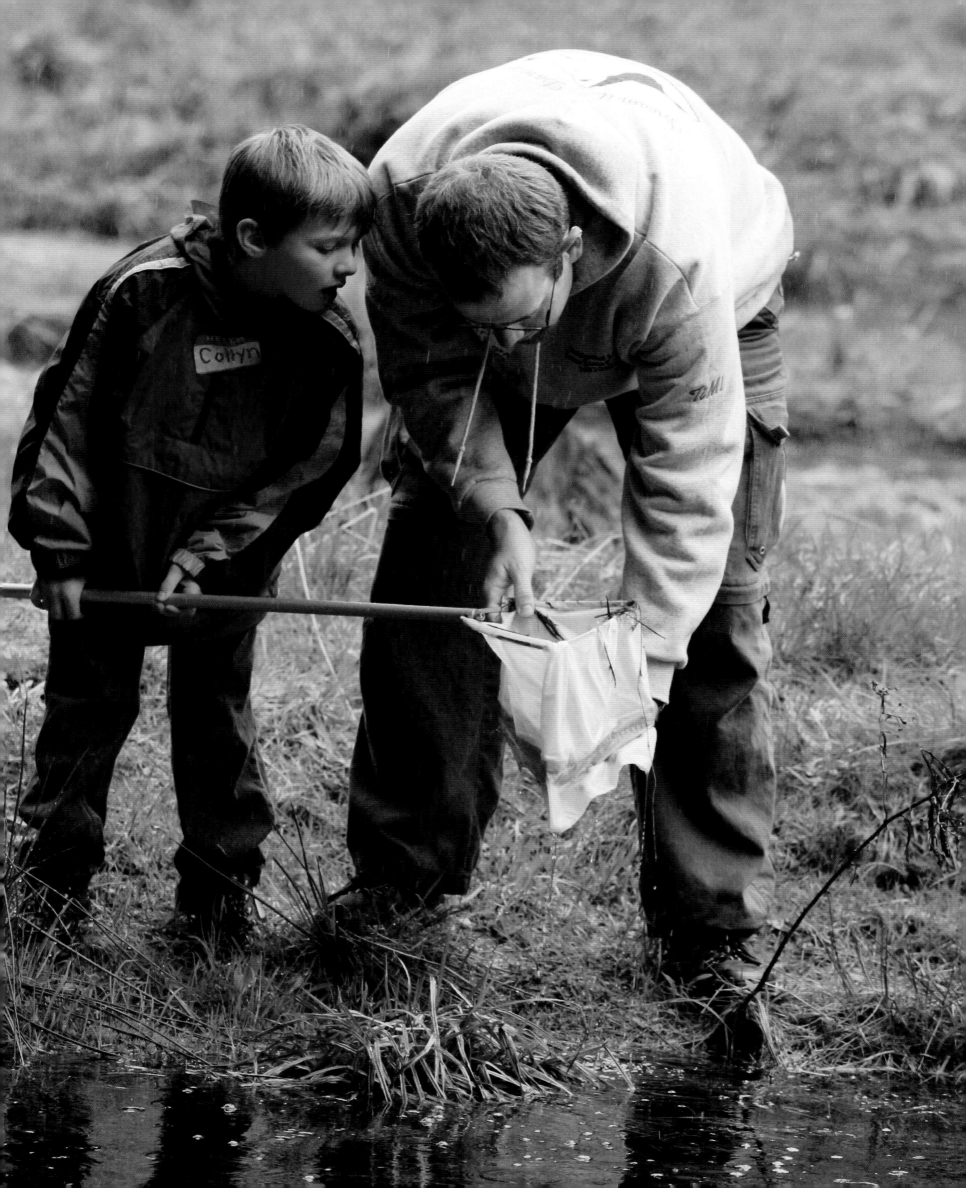

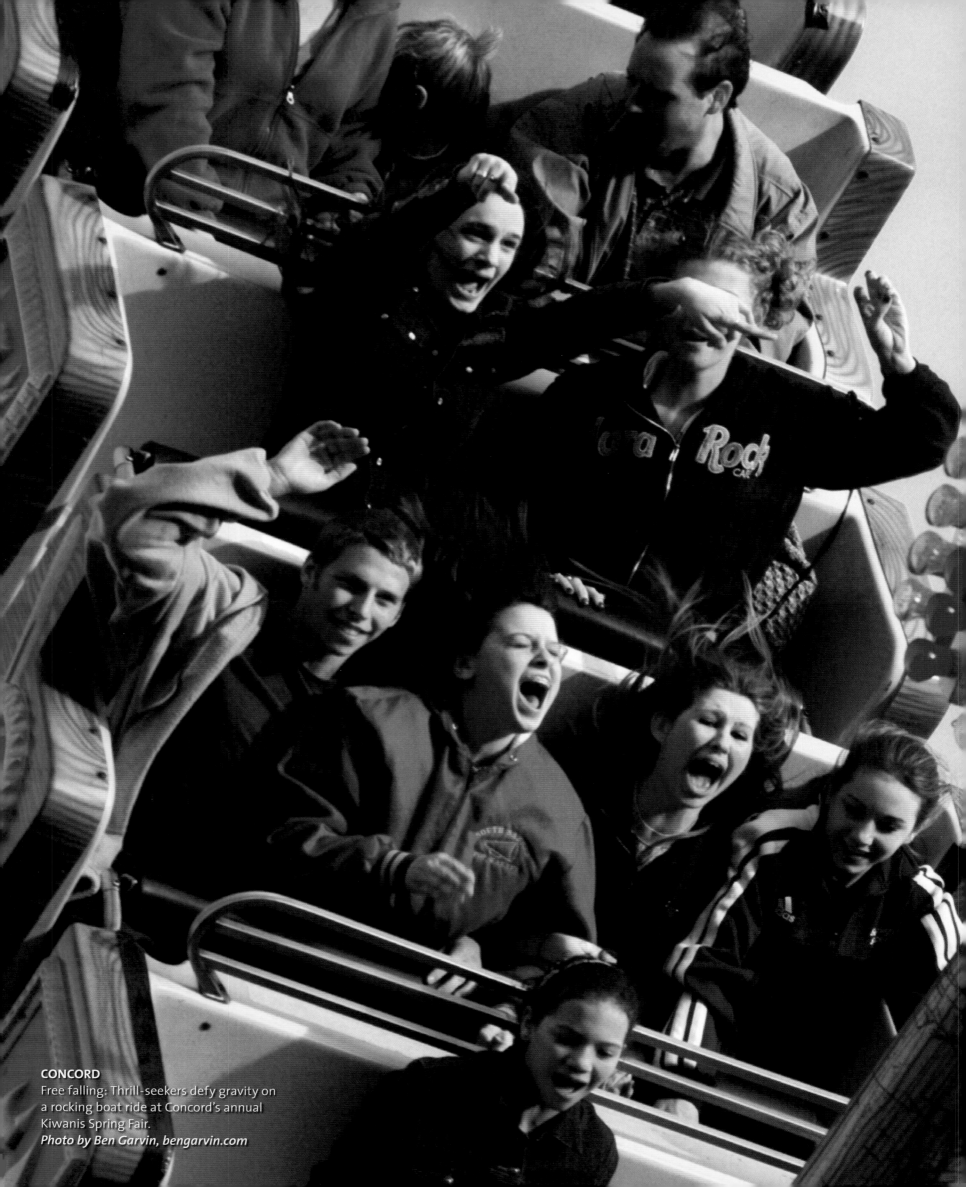

CONCORD
Free falling: Thrill-seekers defy gravity on a rocking boat ride at Concord's annual Kiwanis Spring Fair.
Photo by Ben Garvin, bengarvin.com

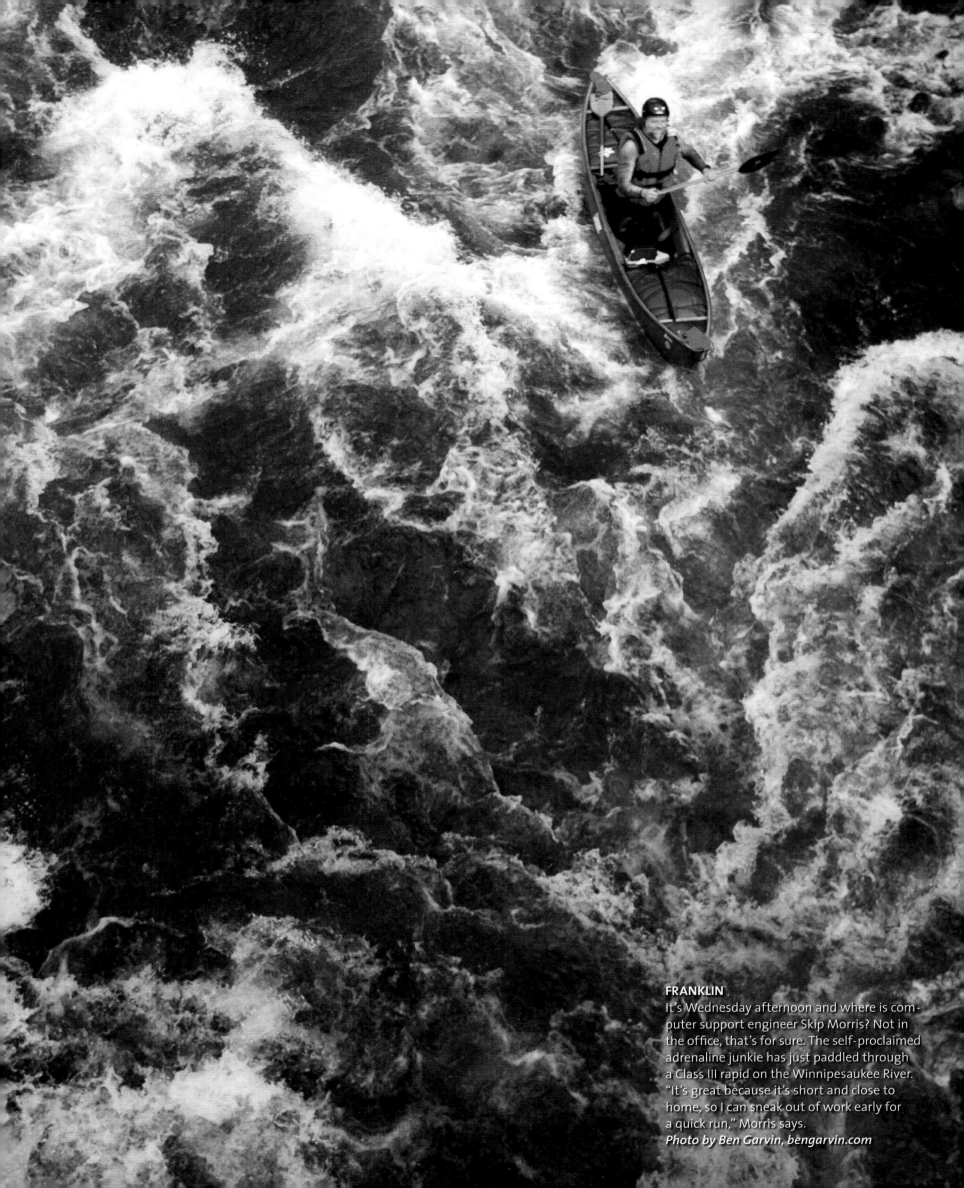

FRANKLIN

It's Wednesday afternoon and where is computer support engineer Skip Morris? Not in the office, that's for sure. The self-proclaimed adrenaline junkie has just paddled through a Class III rapid on the Winnipesaukee River. "It's great because it's short and close to home, so I can sneak out of work early for a quick run," Morris says.

Photo by Ben Garvin, bengarvin.com

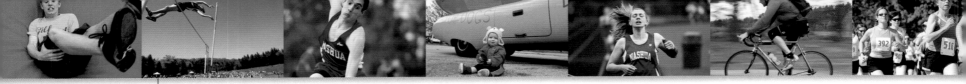

BRISTOL
Pole-vaulter Dan Tozier, a senior at A. Crosby Kennett Senior High School in Conway, competes in the Bristol Lions Club Invitational track meet at Newfound Regional High School. Tozier finished first with a 12-foot 6-inch jump.
Photo by Ben Garvin, bengarvin.com

Côte Chamberlin-Trombley streaks through the air during recess at Benjamin Franklin Elementary. The 8-year-old is too young to remember, but the year he was born, scenes for the movie *Jumanji* were filmed just a quarter-mile down the road from his school.

Photo by Michael Moore

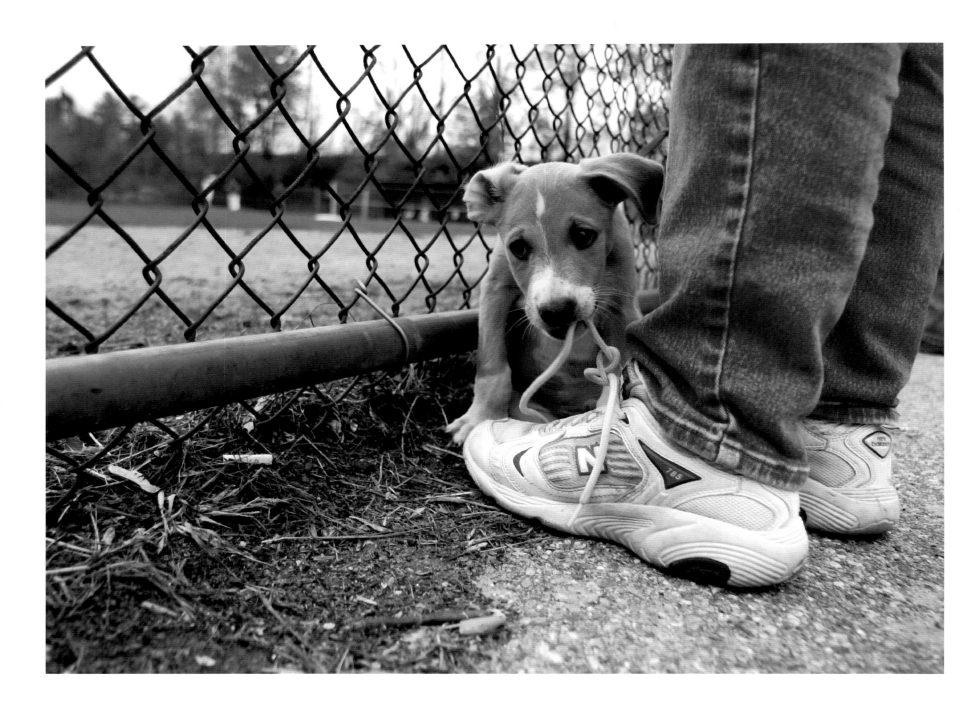

PORTSMOUTH

Senior Joseph Krumm of Dover High School's track and field team hurls the discus at a meet against Portsmouth High School. When Krumm was born with Down's syndrome, his father left his job with the U.S. Air Force so Joseph would not have to move every two years. His mother has since become editor of a newspaper for the parents of disabled children.

Photo by Deb Cram, Portsmouth Herald

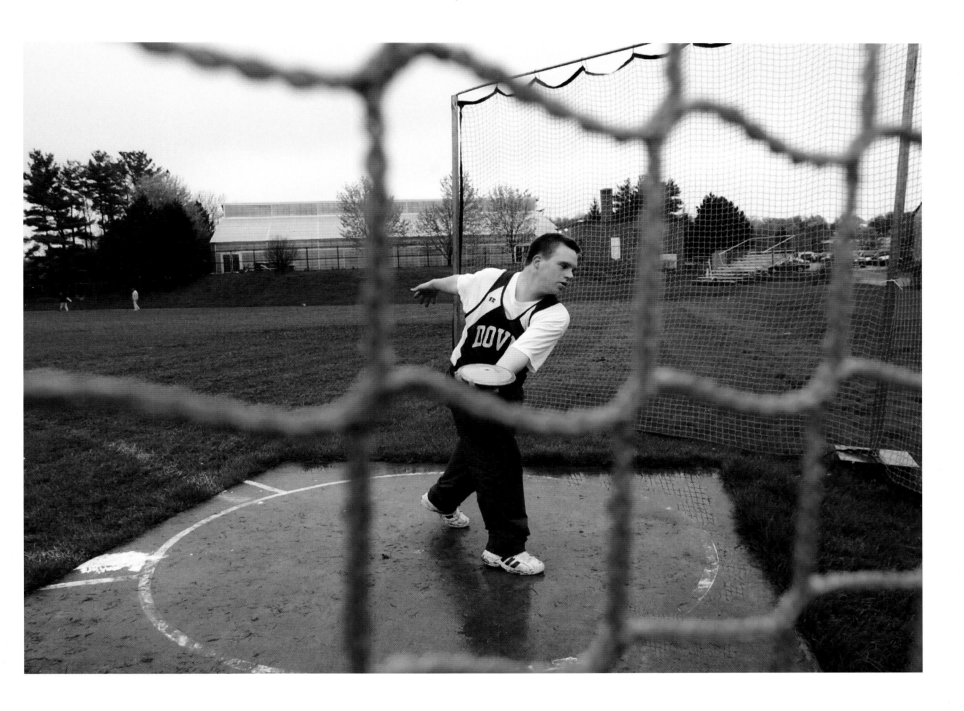

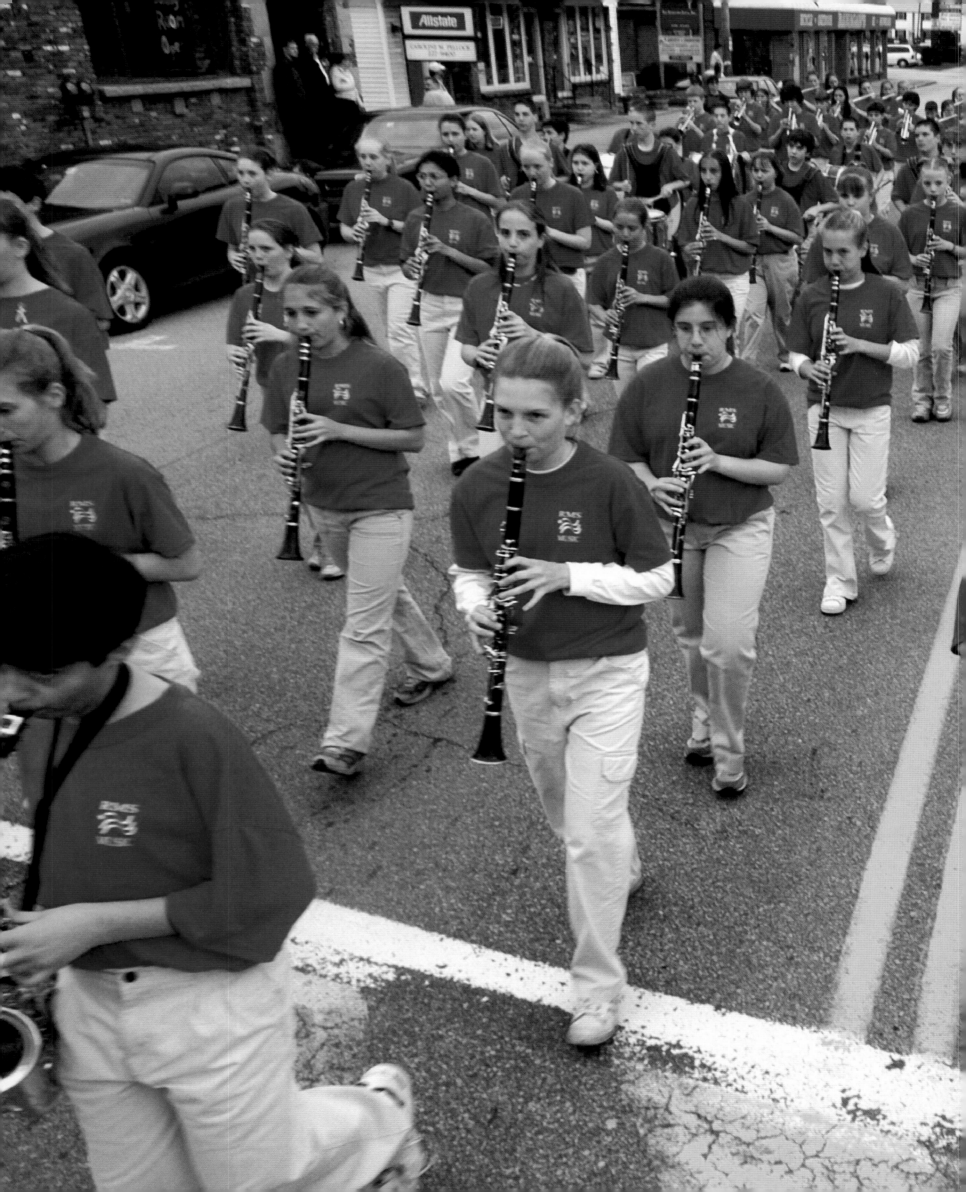

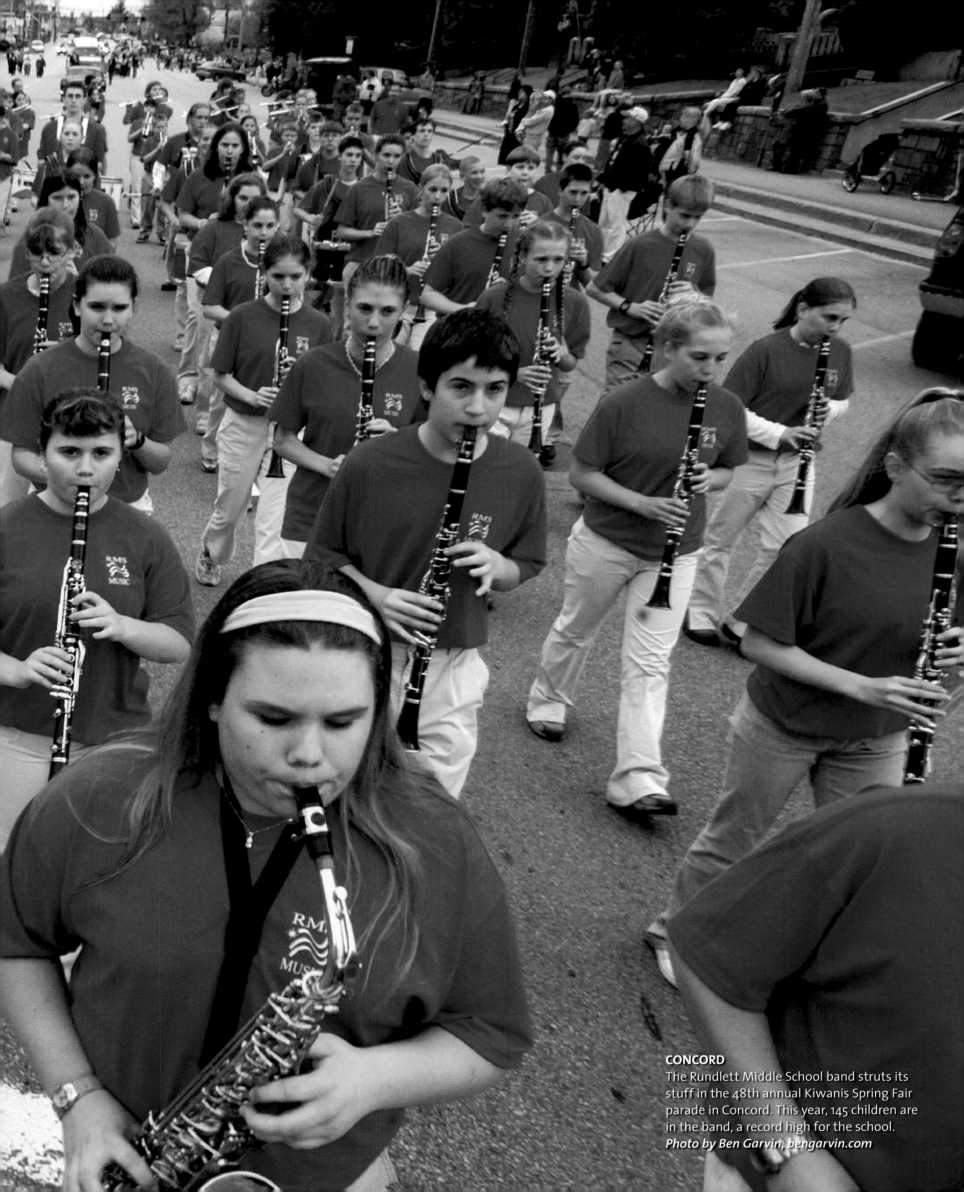

CONCORD
The Rundlett Middle School band struts its stuff in the 48th annual Kiwanis Spring Fair parade in Concord. This year, 145 children are in the band, a record high for the school.
Photo by Ben Garvin, bengarvin.com

HOPKINTON

With a model of the space shuttle *Excelsior* right next to their desks, most of the third-graders in Dave Tilley's class at Harold Martin School end up being fascinated with space travel. Students Nate Carr and Mikayla Belson go over the pre-flight checklist to prep for a mission.

Photo by Bob LaPree, The Union Leader

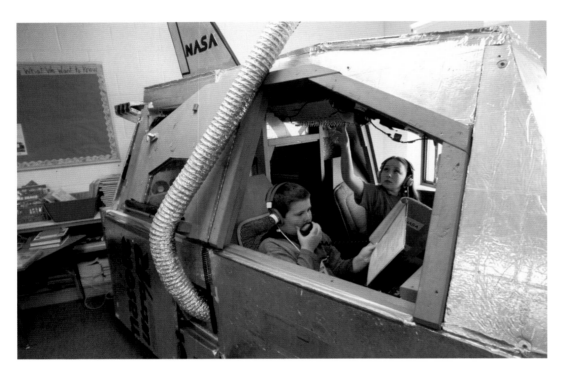

Slip-sliding away: Natasha Chase exits the Fun House, one of the tot-tempting attractions at the Kiwanis Spring Fair.
Photo by Ben Garvin, bengarvin.com

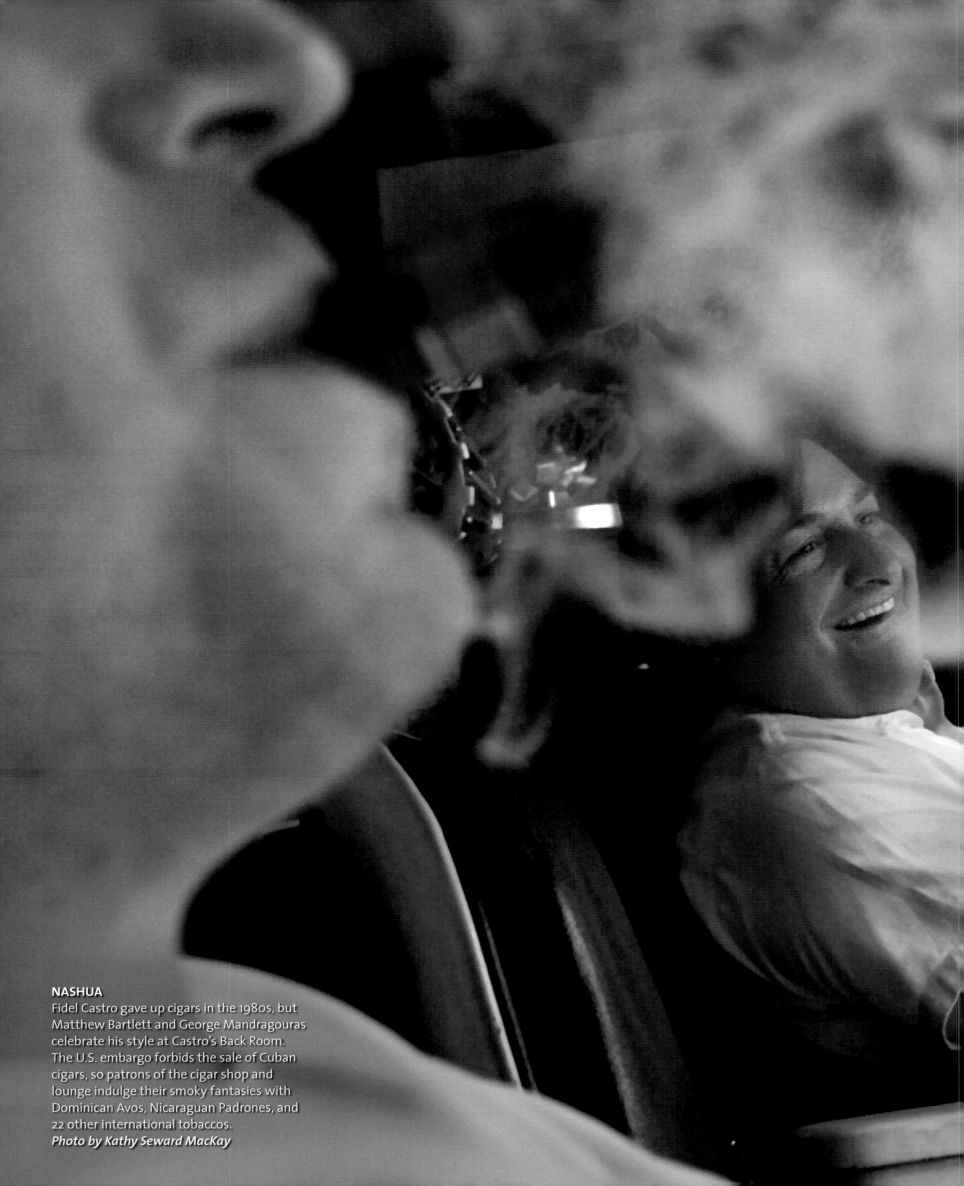

NASHUA
Fidel Castro gave up cigars in the 1980s, but
Matthew Bartlett and George Mandragouras
celebrate his style at Castro's Back Room.
The U.S. embargo forbids the sale of Cuban
cigars, so patrons of the cigar shop and
lounge indulge their smoky fantasies with
Dominican Avos, Nicaraguan Padrones, and
22 other international tobaccos.
Photo by Kathy Seward MacKay

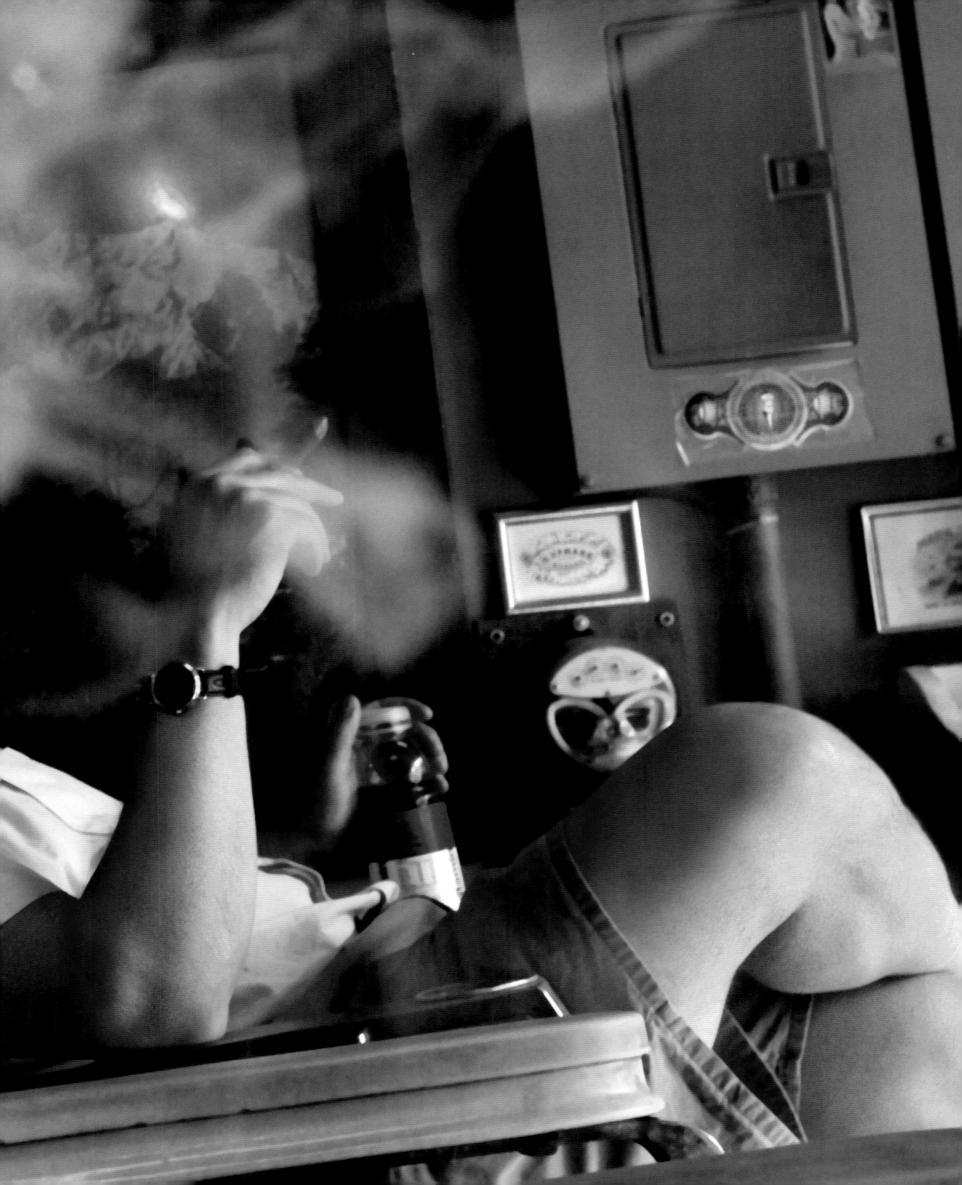

At Funspot Bingo Hall, 30-year bingo veteran Roger Hickum lines up 18 cards. Before each game, he positions his dobbers, the inkpad figurines used to mark the cards. The lucky rabbits' feet and green gator remember his late father. And whenever number 66 is called, Hickum rings a little bell for a dear old friend who passed away.
Photos by Ben Garvin, bengarvin.com

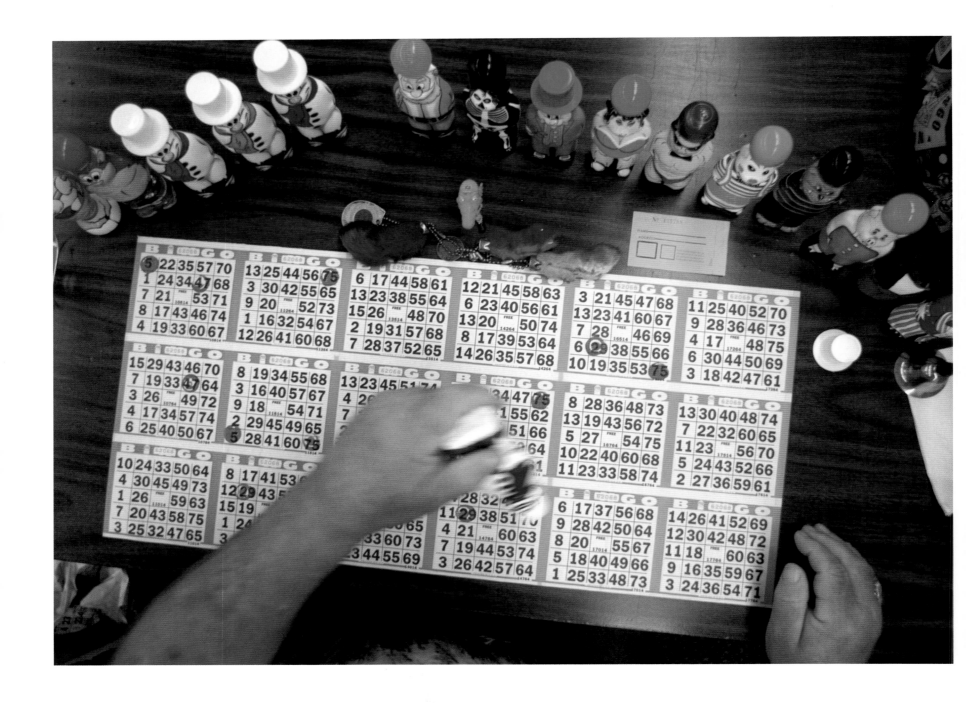

LACONIA

At the sixth annual Senior-Senior Prom, Laconia High School 12th-graders capture the moment with one lucky lady. The event, sponsored by the senior class and the city's Parks and Recreation Department, is held in the Community Center on Union Avenue. The order of the evening: dinner, dancing, and good times.

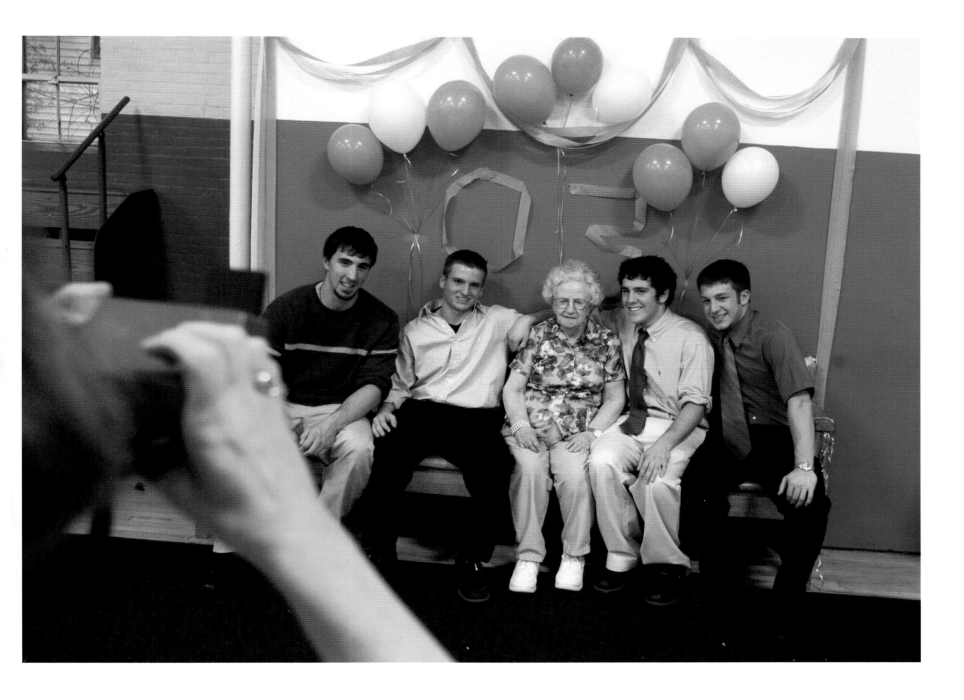

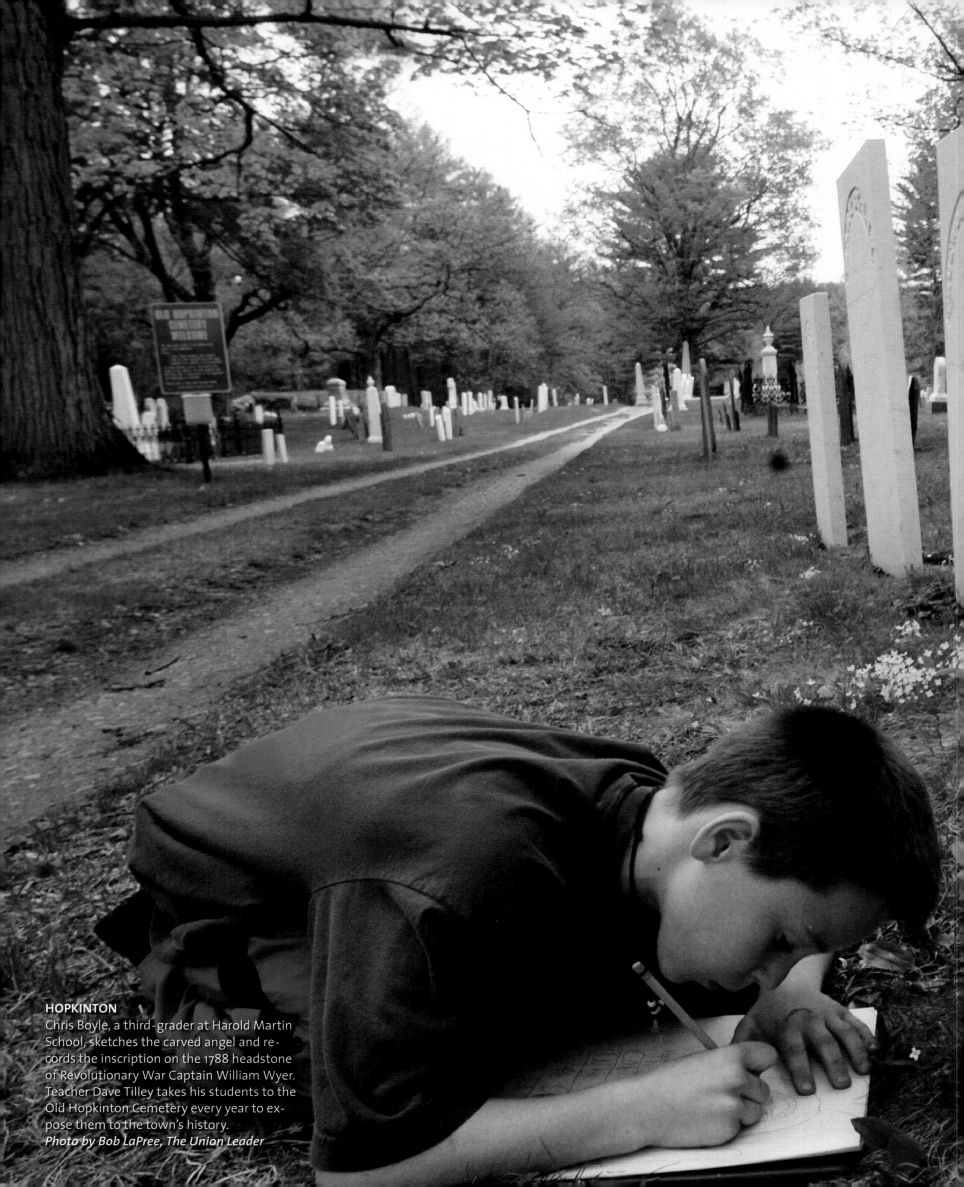

HOPKINTON

Chris Boyle, a third-grader at Harold Martin School, sketches the carved angel and records the inscription on the 1788 headstone of Revolutionary War Captain William Wyer. Teacher Dave Tilley takes his students to the Old Hopkinton Cemetery every year to expose them to the town's history.
Photo by Bob LaPree, The Union Leader

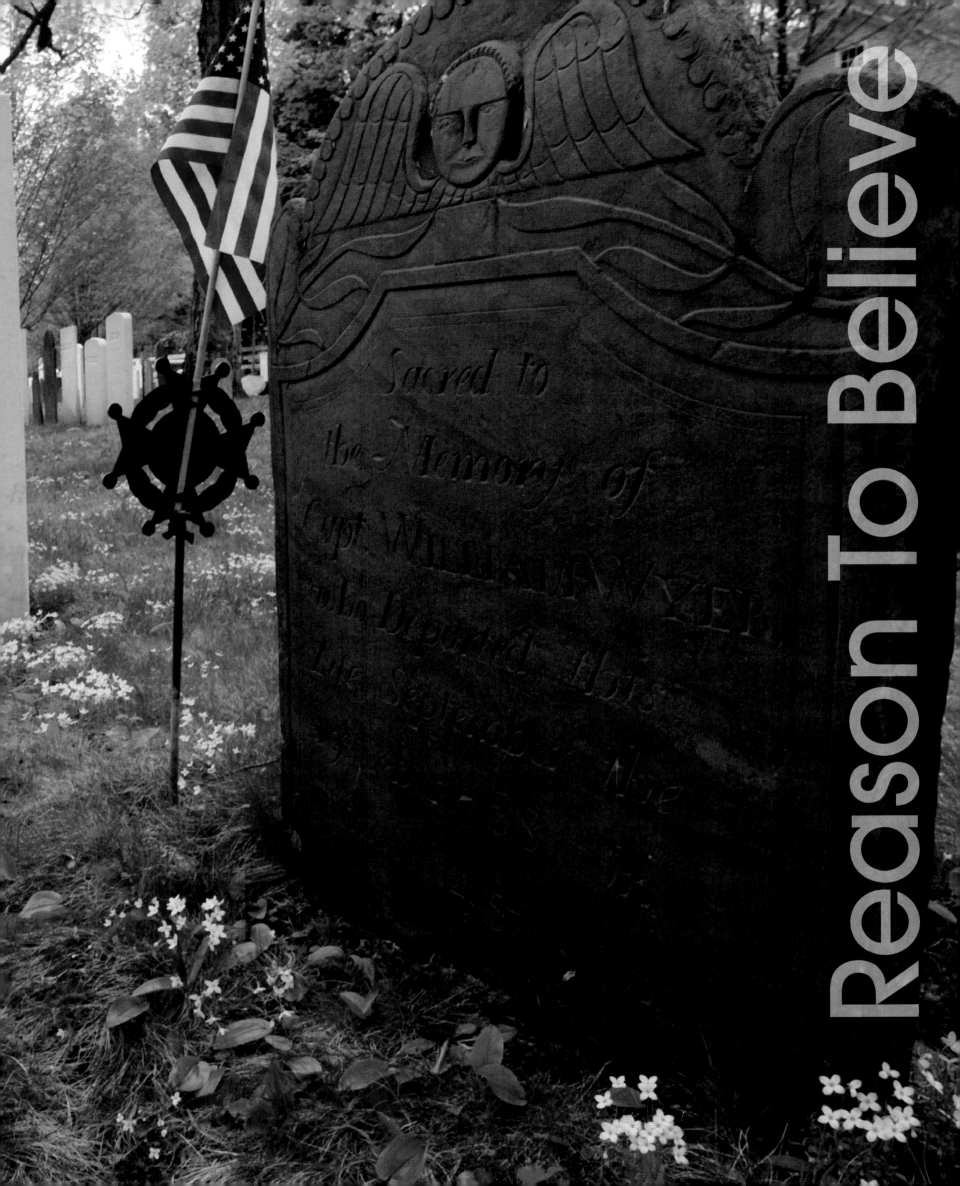

Reason To Believe

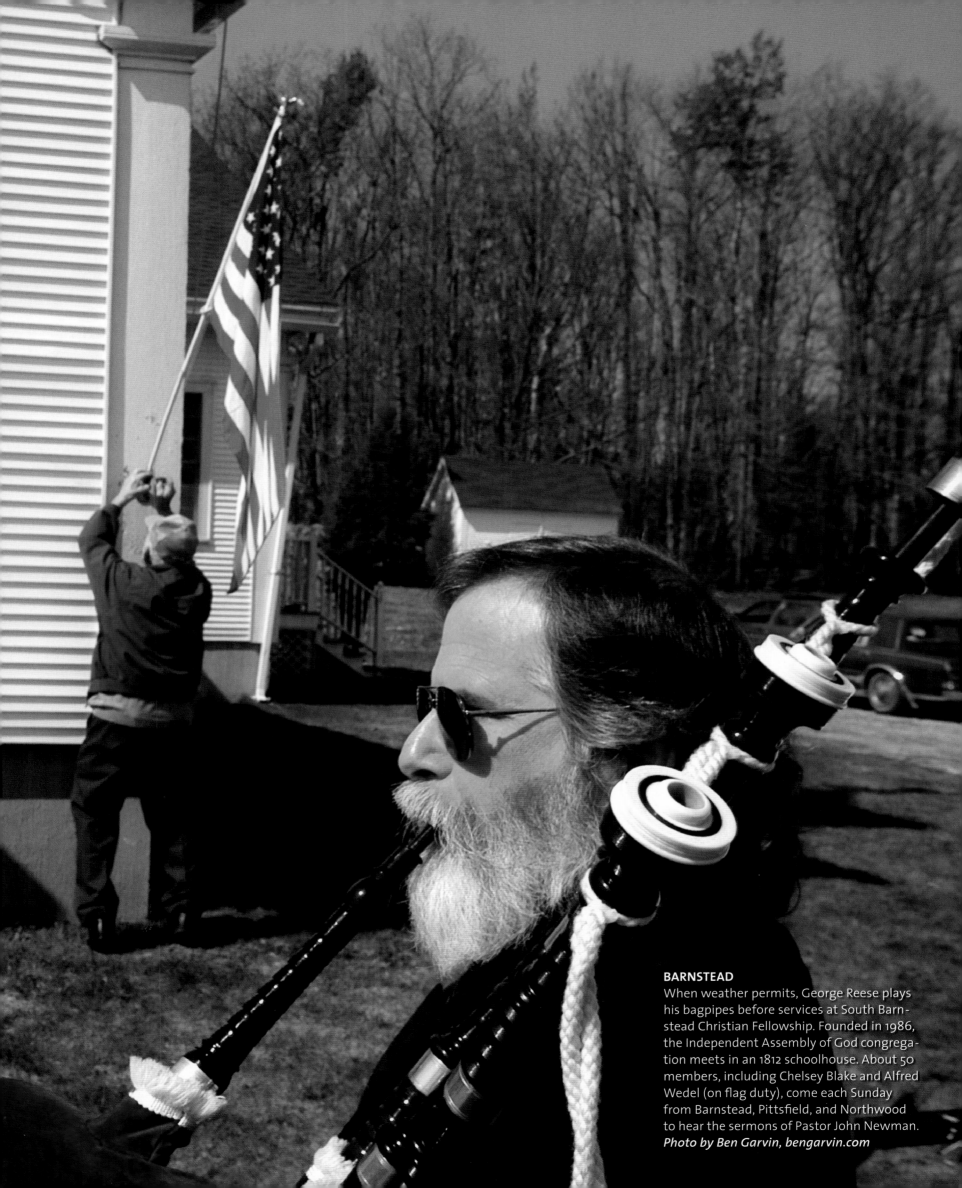

BARNSTEAD
When weather permits, George Reese plays his bagpipes before services at South Barnstead Christian Fellowship. Founded in 1986, the Independent Assembly of God congregation meets in an 1812 schoolhouse. About 50 members, including Chelsey Blake and Alfred Wedel (on flag duty), come each Sunday from Barnstead, Pittsfield, and Northwood to hear the sermons of Pastor John Newman.
Photo by Ben Garvin, bengarvin.com

BOSCAWEN

Pastor Linda Gray of Boscawen Congregational Church shows her appreciation for livestock. She promised to kiss a cow if her parishioners raised at least $1,000 for the Heifer Project International, a nonprofit that provides farm animals to developing communities around the globe. The congregation met the challenge, and Bossie got a smooch.
Photo by Ben Garvin, bengarvin.com

SALEM

Blessed be the bikers: Mother Diane Bragg of St. David's Episcopal Church sprinkles holy water during the "Blessing of the Bikes" service. Bragg has provided a blessing service for animals for several years, but this was the first year for bikes. "I got the idea when I found out there was a bunch of motorcyclists in the congregation," says Bragg, who's been rector since 1998.

Photo by Bruce Preston, The Salem Observer

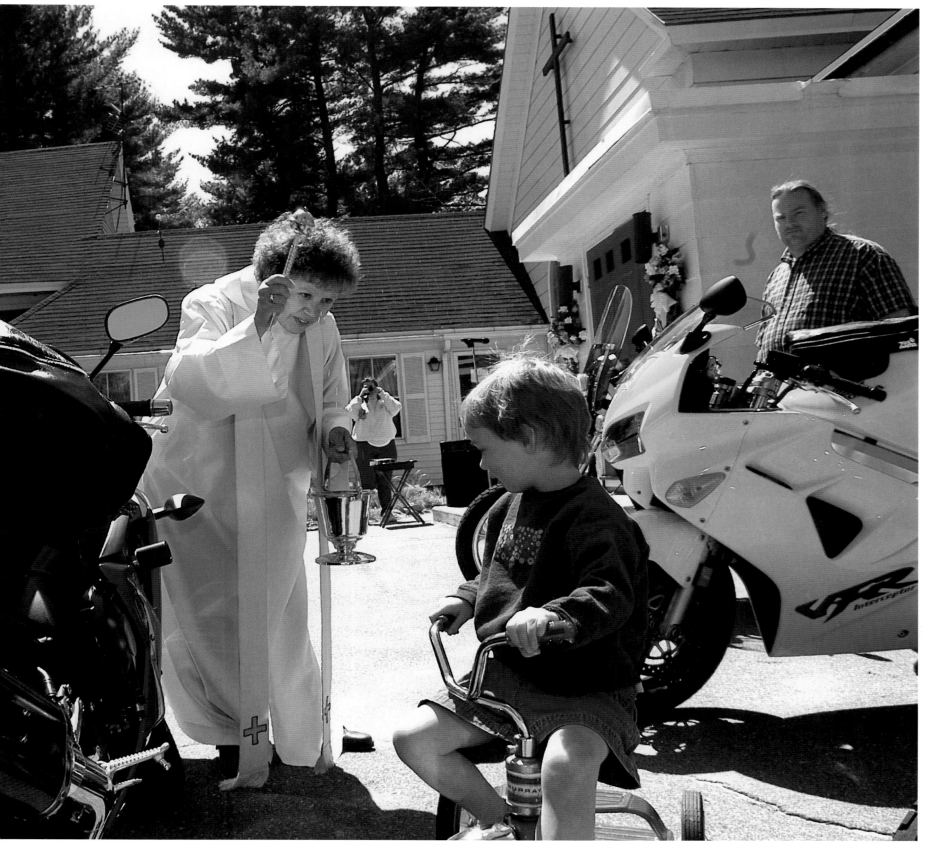

NASHUA

Steven Loignon, who lost both his legs after an automobile accident in 2001, stands on his prostheses to receive his diploma in Operational Management at Daniel Webster College. Since his accident, Loignon has founded a home brewing supply company called Shapleigh Hops and the nonprofit Stepping Back Into Life, offering disabled students college scholarships.

Photo by Evan Richman, The Boston Globe

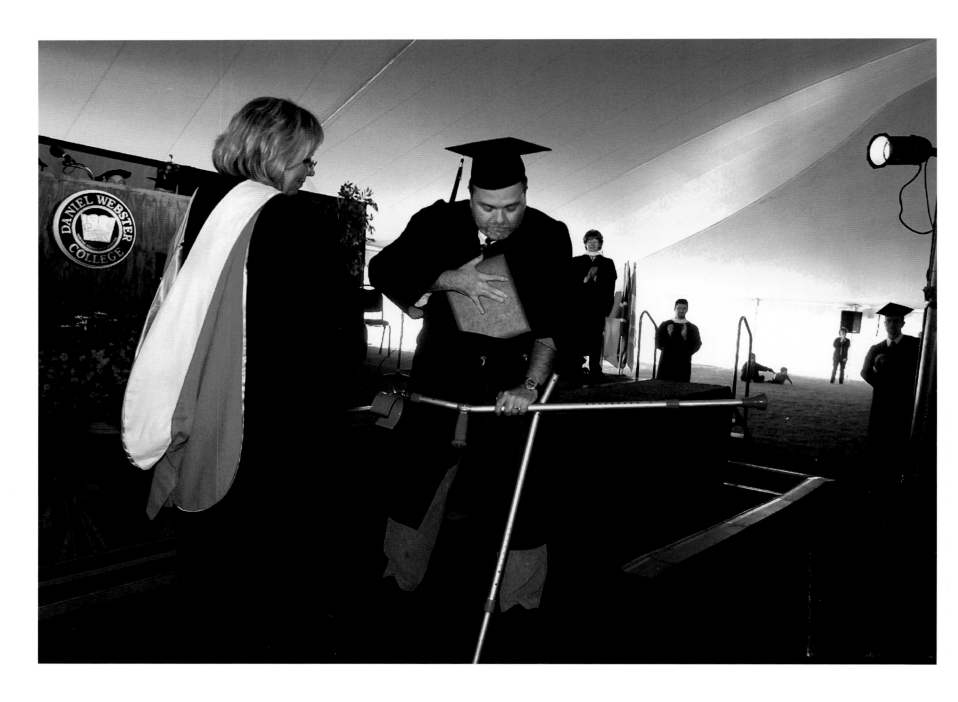

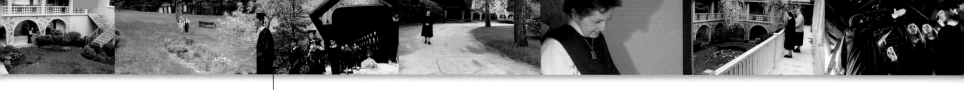

HENNIKER

The Contoocook River covered bridge, erected in 1969, makes for a picturesque processional of the 153 students of New England College's 2003 graduating class. Enrollment at the 57-year-old liberal arts college is small at 1,200 students, but it's diverse: Eighty-five percent of the school's students come from outside the state, representing 33 states and 20 countries.
Photo by Lori Duff

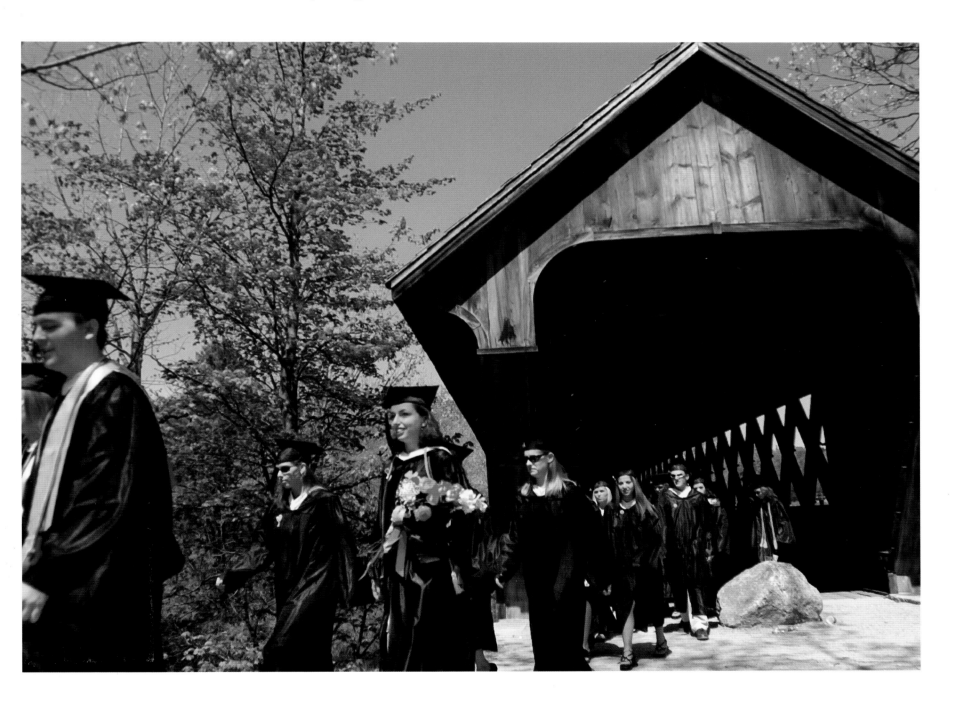

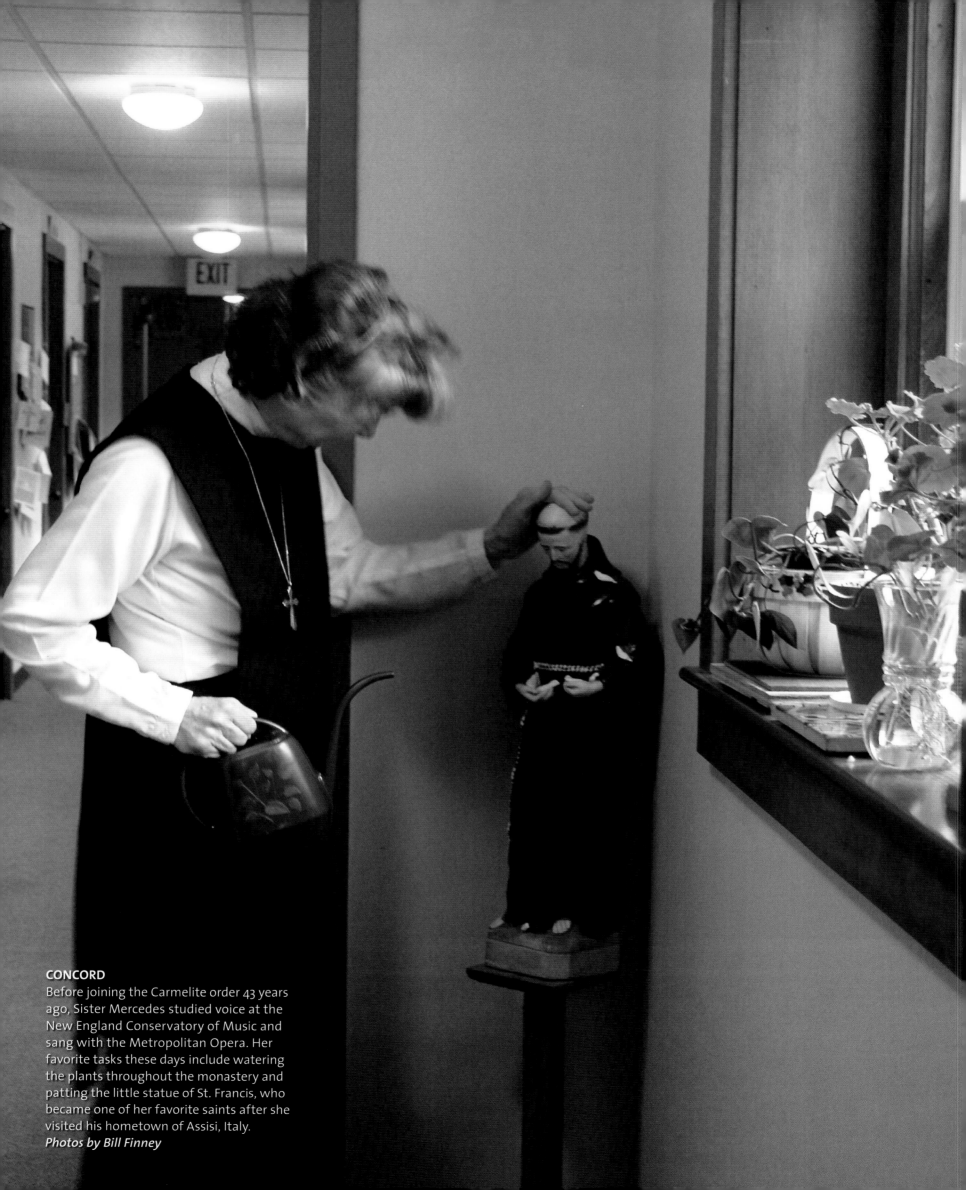

CONCORD

Before joining the Carmelite order 43 years ago, Sister Mercedes studied voice at the New England Conservatory of Music and sang with the Metropolitan Opera. Her favorite tasks these days include watering the plants throughout the monastery and patting the little statue of St. Francis, who became one of her favorite saints after she visited his hometown of Assisi, Italy.

Photos by Bill Finney

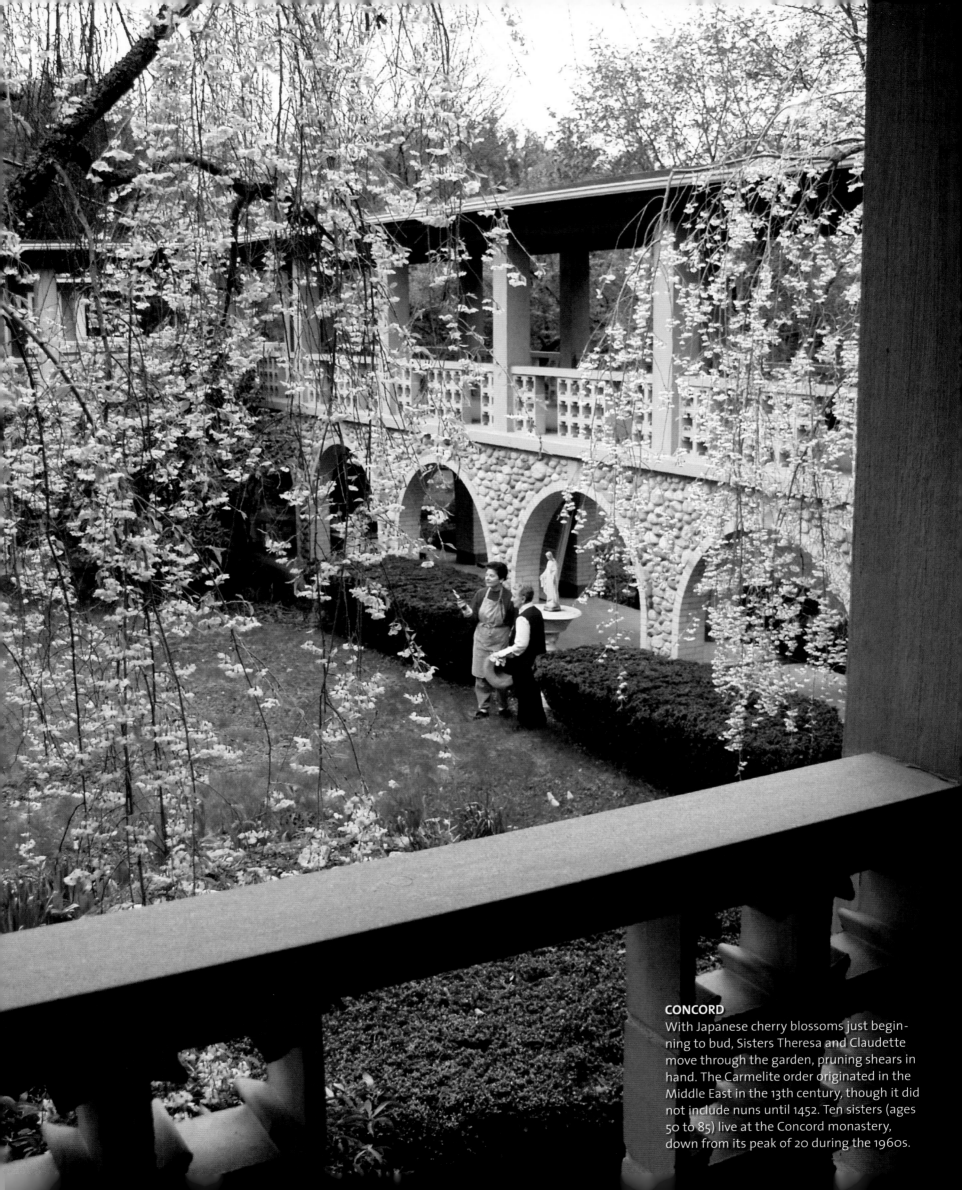

CONCORD

With Japanese cherry blossoms just beginning to bud, Sisters Theresa and Claudette move through the garden, pruning shears in hand. The Carmelite order originated in the Middle East in the 13th century, though it did not include nuns until 1452. Ten sisters (ages 50 to 85) live at the Concord monastery, down from its peak of 20 during the 1960s.

EPSOM

After pledging allegiance to the American and Christian flags, the students at Cornerstone Christian Academy spend a half-hour in private prayer and listening to Bible stories. First-grader Matt Miller likes having special time every day to talk to God.

Photo by Lori Duff

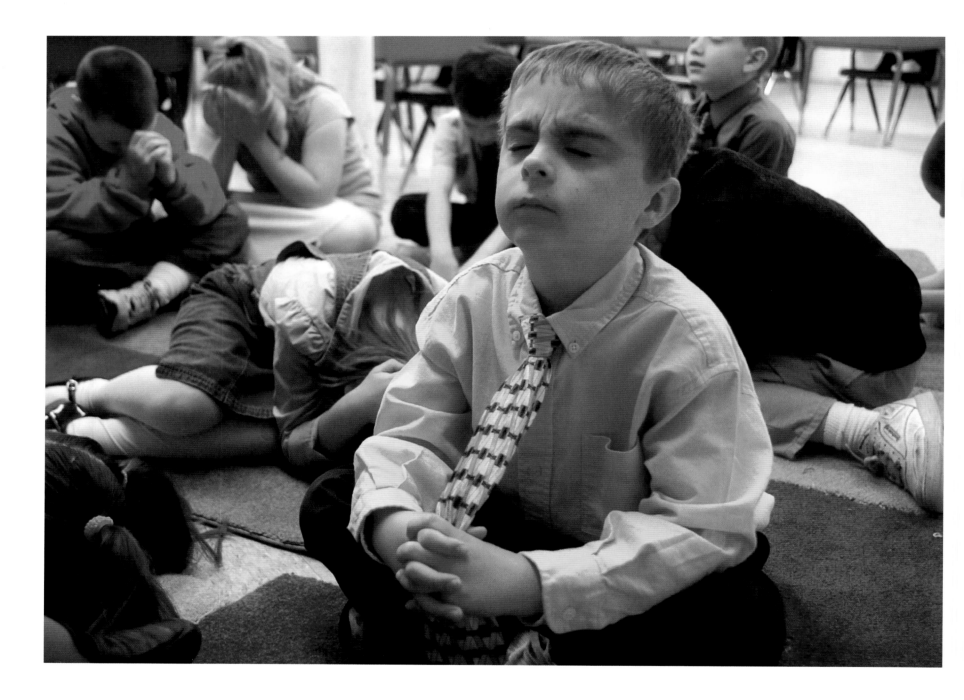

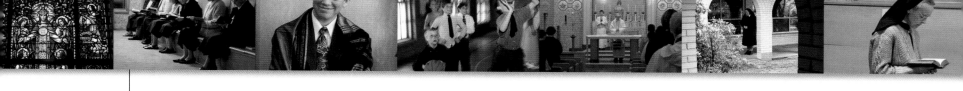

CONCORD

The sisters at the Carmelite monastery pray together four times a day and hold a public mass in the main chapel every morning. In addition, they devote two hours each day to solitary reflection. Although they sell religious books and icons to help support themselves, the sisters consider contemplative prayer their main mission.

Photo by Bill Finney

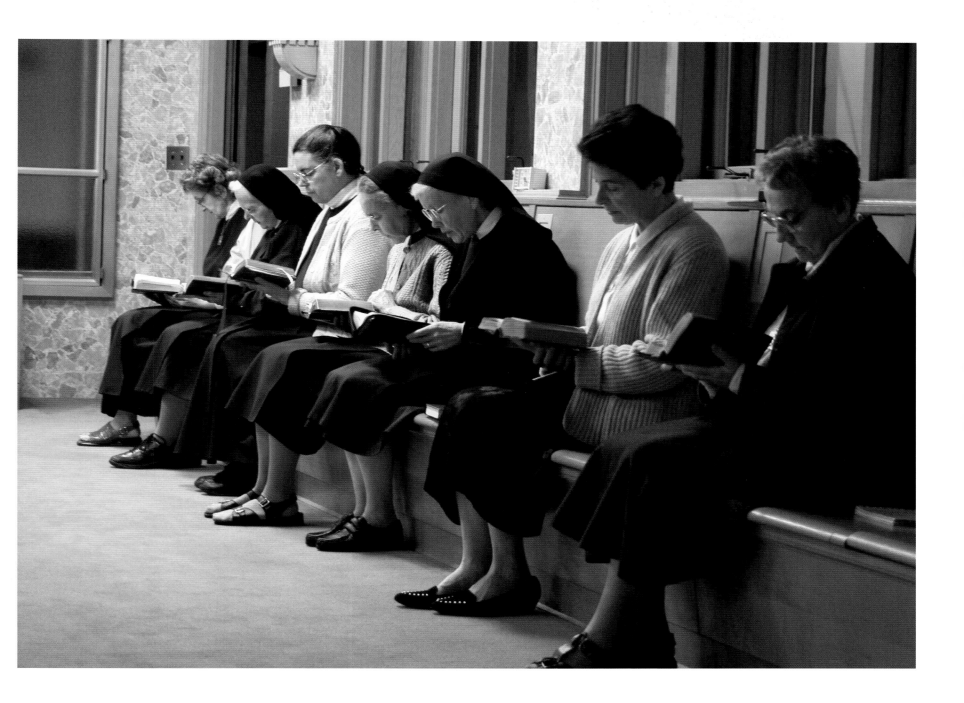

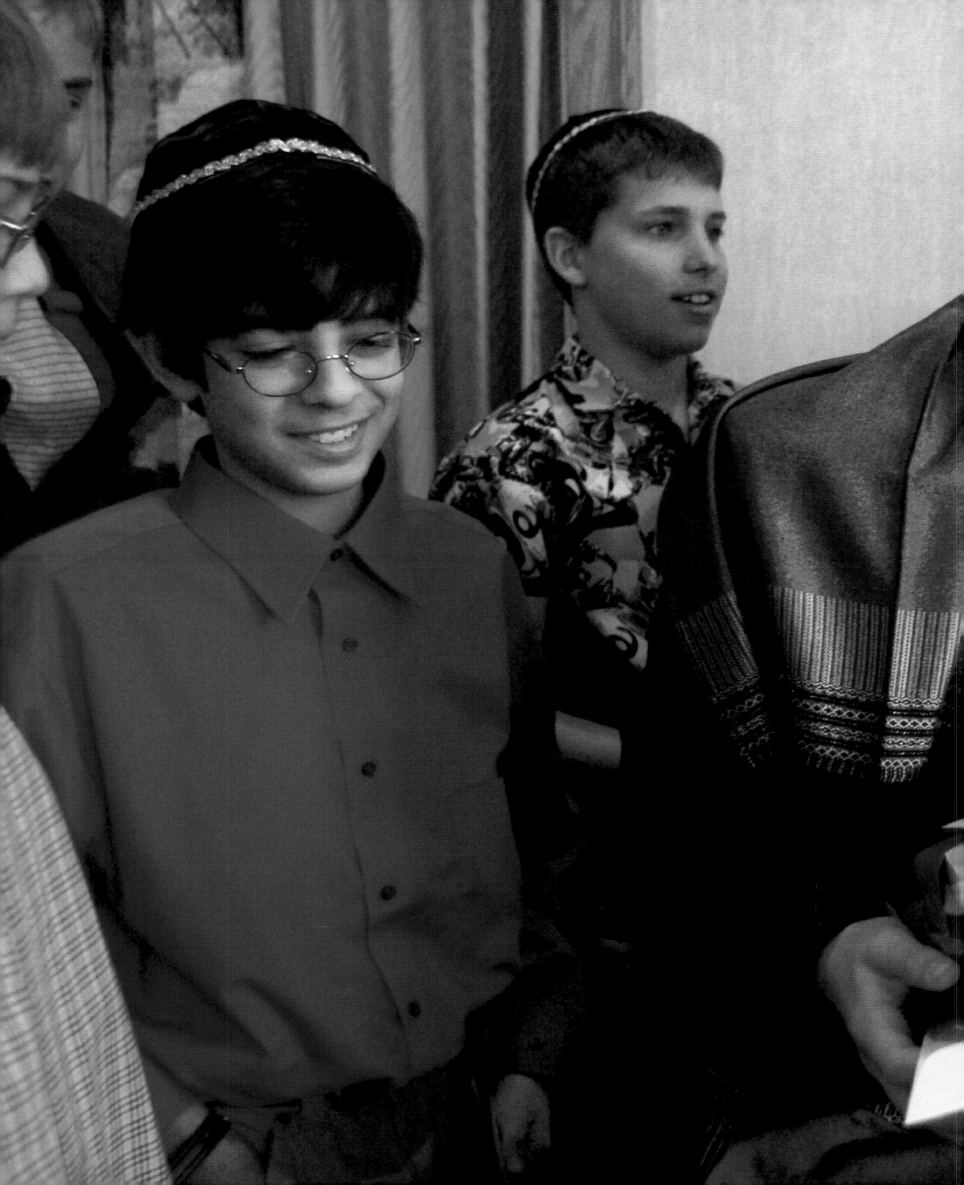

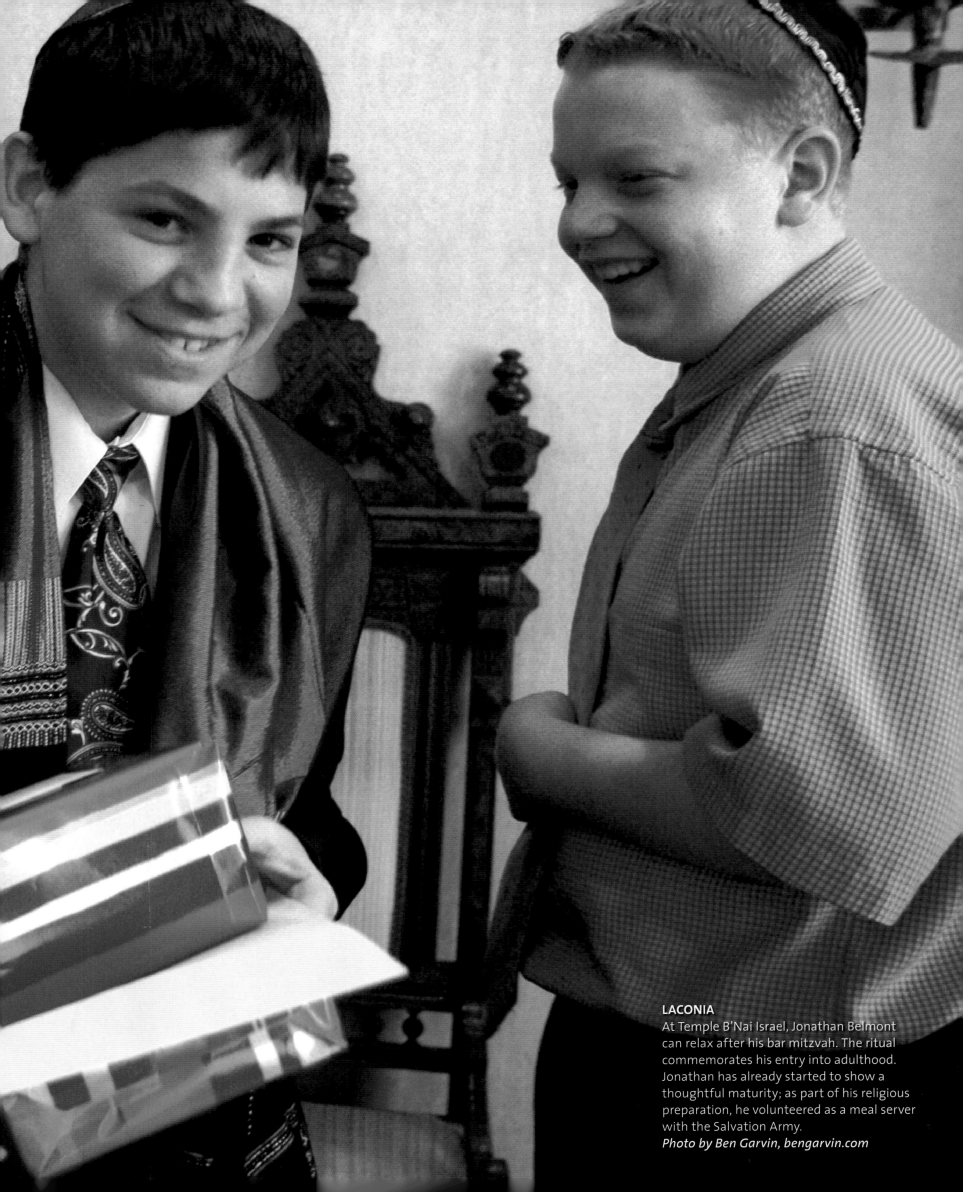

LACONIA
At Temple B'Nai Israel, Jonathan Belmont can relax after his bar mitzvah. The ritual commemorates his entry into adulthood. Jonathan has already started to show a thoughtful maturity; as part of his religious preparation, he volunteered as a meal server with the Salvation Army.
Photo by Ben Garvin, bengarvin.com

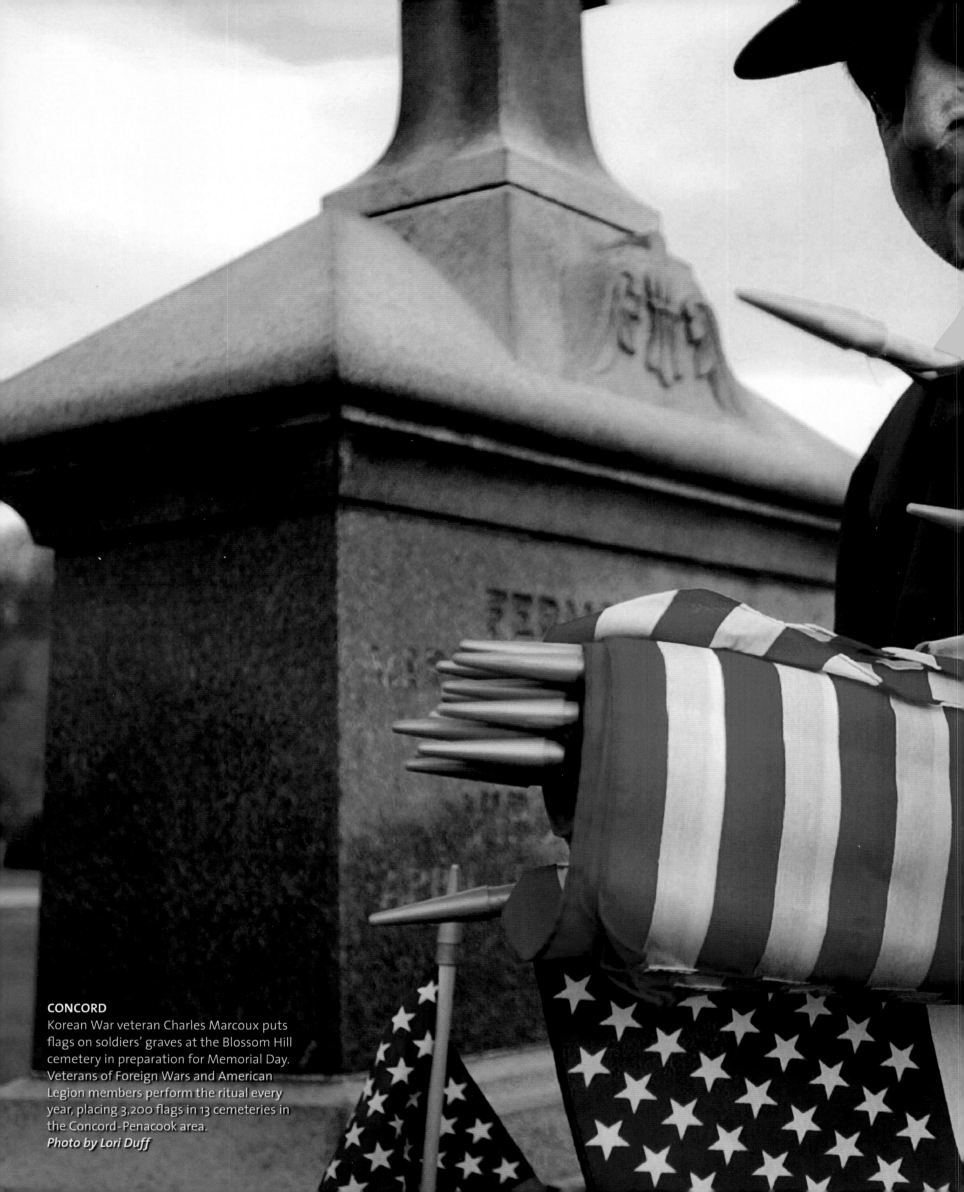

CONCORD

Korean War veteran Charles Marcoux puts flags on soldiers' graves at the Blossom Hill cemetery in preparation for Memorial Day. Veterans of Foreign Wars and American Legion members perform the ritual every year, placing 3,200 flags in 13 cemeteries in the Concord-Penacook area.

Photo by Lori Duff

CANTERBURY

Built in the early 1800s, the village schoolhouse is one of 25 original Shaker structures still standing in Canterbury. The village, now a museum, offers demonstrations of innovative Shaker techniques in crafts including furniture and soap making, rug weaving, and embroidery. The Shaker belief in celibacy eventually snuffed out the sect; the last resident of the village died in 1992 at the age of 96.
Photo by Bill Finney

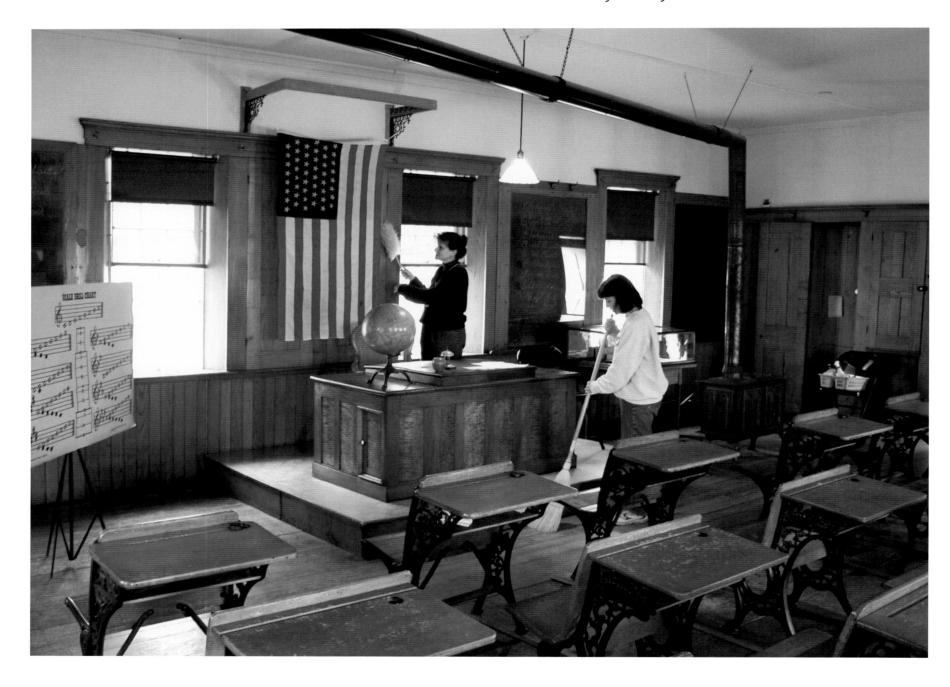

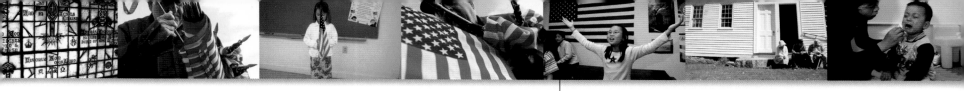

NASHUA

The Chinese Bible Church of Greater Nashua was founded in 2003 so that Nashua's Chinese population would no longer have to travel to the Chinese church in Lowell, Massachusetts. Adult services are conducted in Chinese, but Sunday school, attended by 20 first-generation Chinese-Americans, is taught in English. Hannah Wang opens her arms in song.

Photo by Kathy Seward MacKay

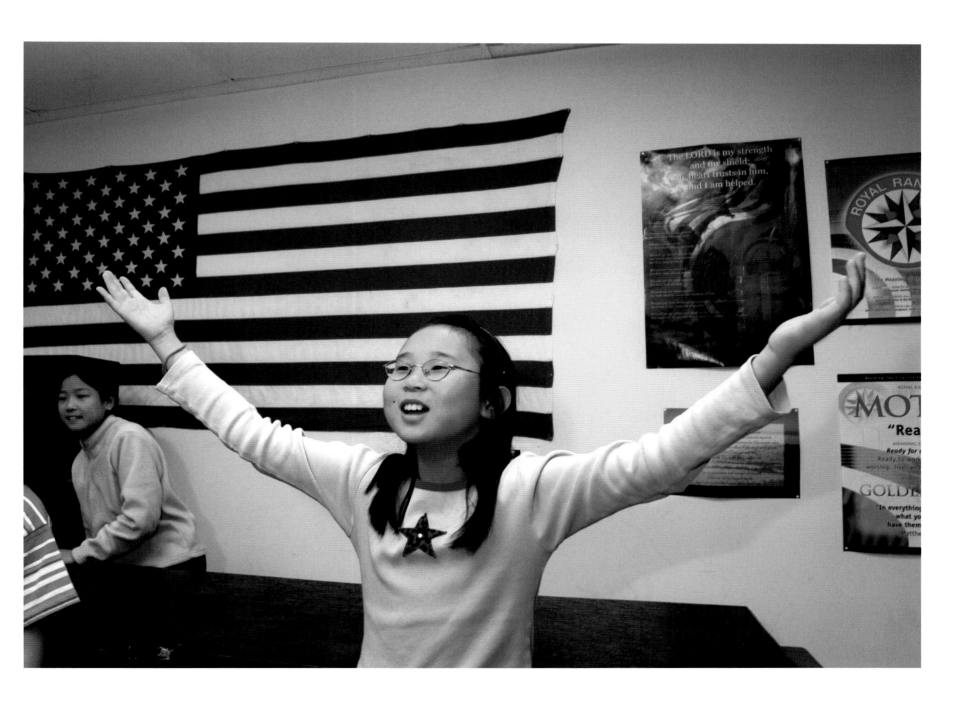

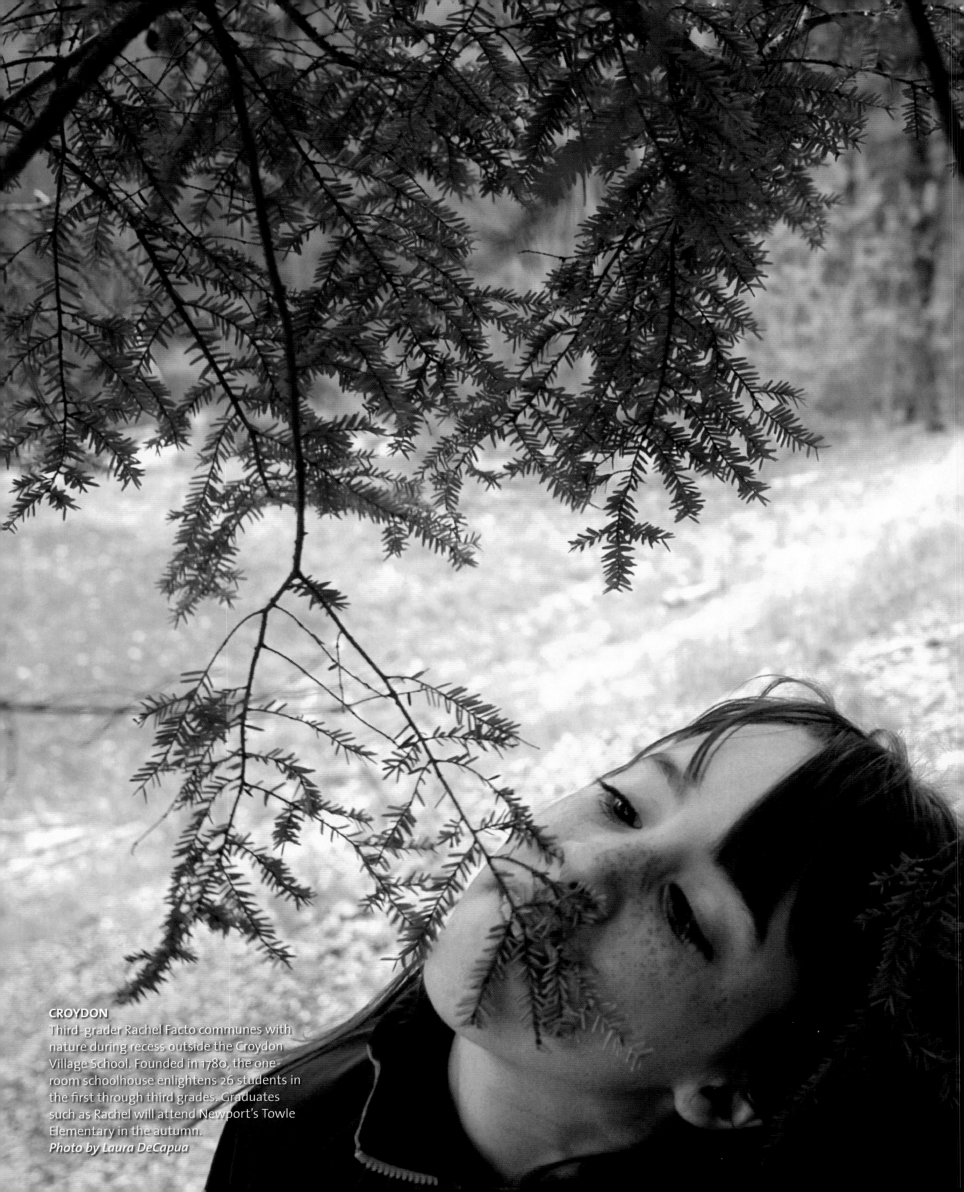

CROYDON
Third-grader Rachel Facto communes with nature during recess outside the Croydon Village School. Founded in 1780, the one-room schoolhouse enlightens 26 students in the first through third grades. Graduates such as Rachel will attend Newport's Towle Elementary in the autumn.
Photo by Laura DeCapua

Our Town

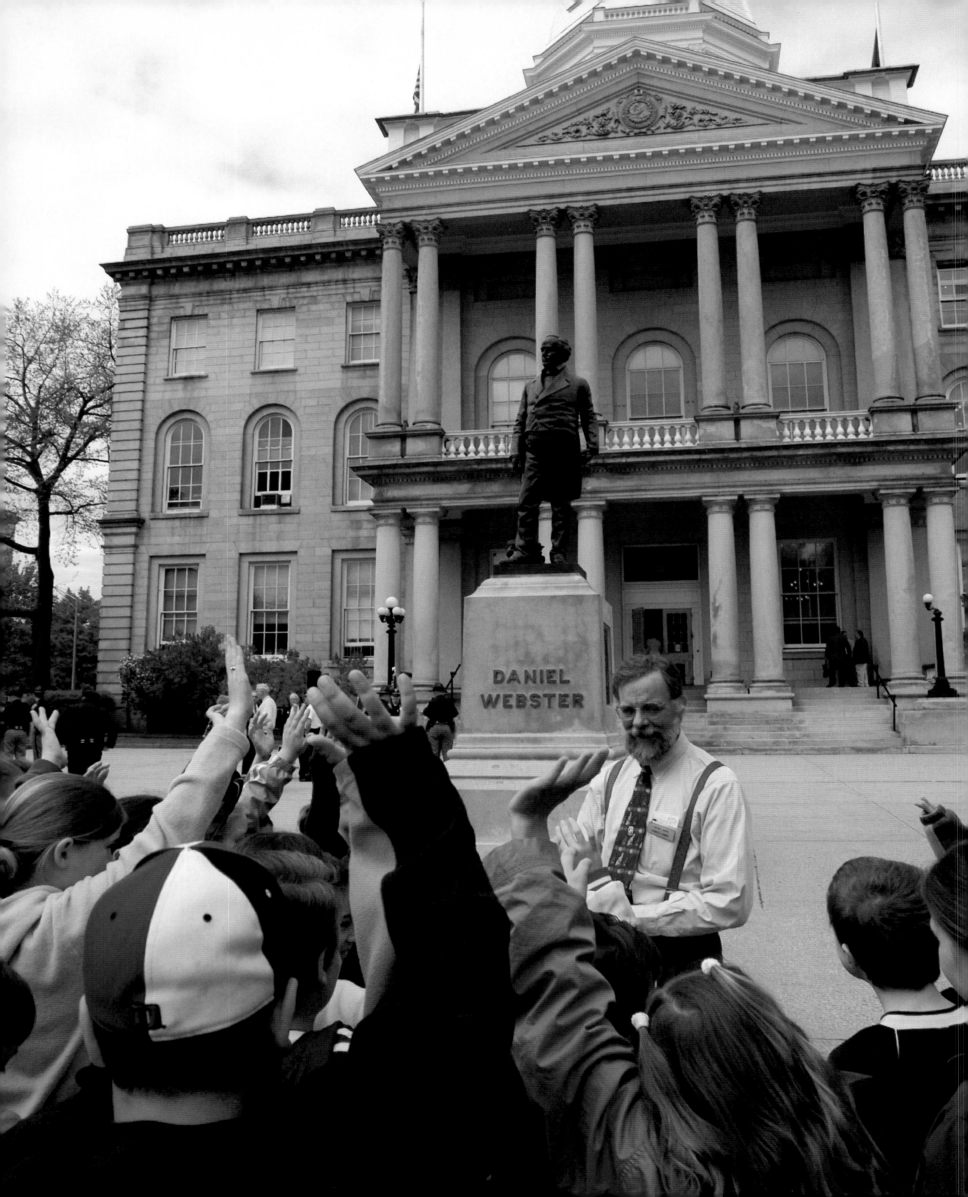

CONCORD

Students from Marston Elementary School in Hampton pepper tour guide Ken Leidner with questions during their field trip to the State House. The statue behind Leidner honors legislator, lawyer, and orator Daniel Webster, born in New Hampshire in 1782.
***Photos by Dan Habib,
The Concord Monitor***

CONCORD

Students ogle a case of swords used in the Battle of Gettysburg at the State House. Above are portraits of three Civil War heroes: nurse Harriet Dame, Colonel Edward Cross, and Colonel Evarts Farr. The building houses more than 200 historic portraits.

CONCORD

New Hampshire's State House, built in 1819, is the oldest continuously operating state capitol in America and home to the country's largest state legislative body. The House of Representatives, often called the "citizen's legislature," has 400 members, or about one for every 3,100 residents.

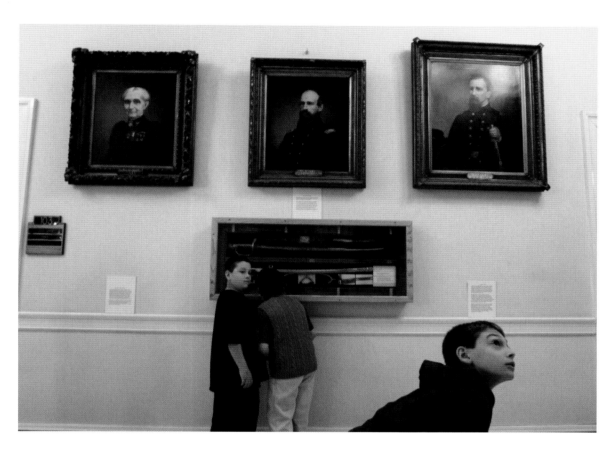

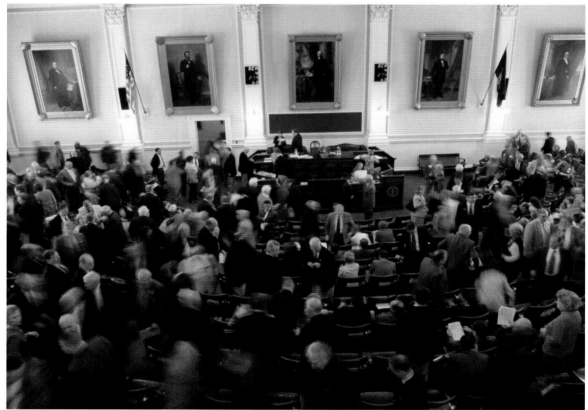

CONCORD

It all looks yummy to 3-year-old Nicholas Briccetti. Franz Andlinger opened the Bread and Chocolate bakery (named for an Italian film) in 1993, after emigrating from Austria. "Baking is a highly regarded craft in Austria," he says. "I apprenticed with some of the best." His specialties include black-and-white chocolate mousse cake and fresh fruit tarts.

Photo by Dan Habib, The Concord Monitor

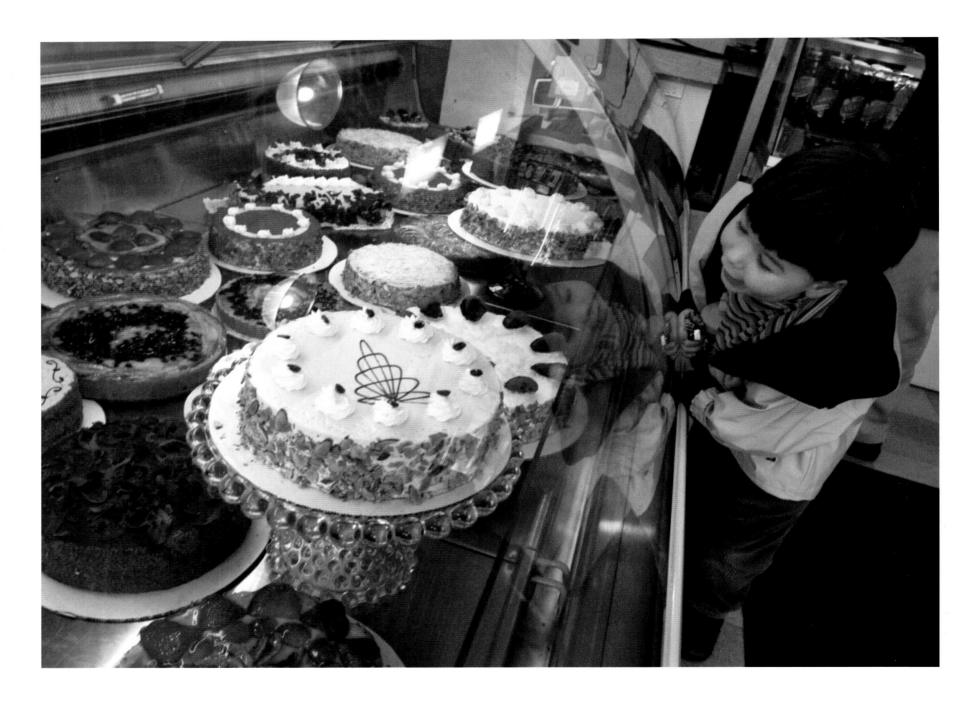

MANCHESTER

"Sometimes it feels like the fish are looking at *you*," says Brandon Hammerstrom (left) during a visit to the Amoskeag Fishways Learning and Visitors Center. Brandon and his parents visit the center every spring to watch migratory fish such as river herring, American shad, and sea lamprey traverse a 54-step ladder to bypass the Amoskeag Hydroelectric Dam.

Photo by Bob Hammerstrom

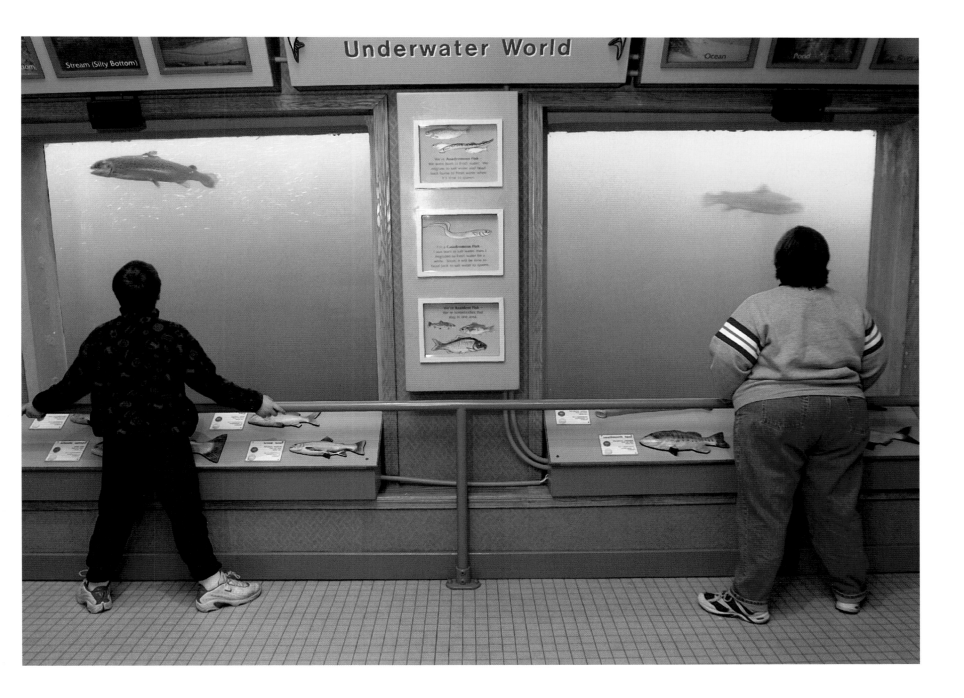

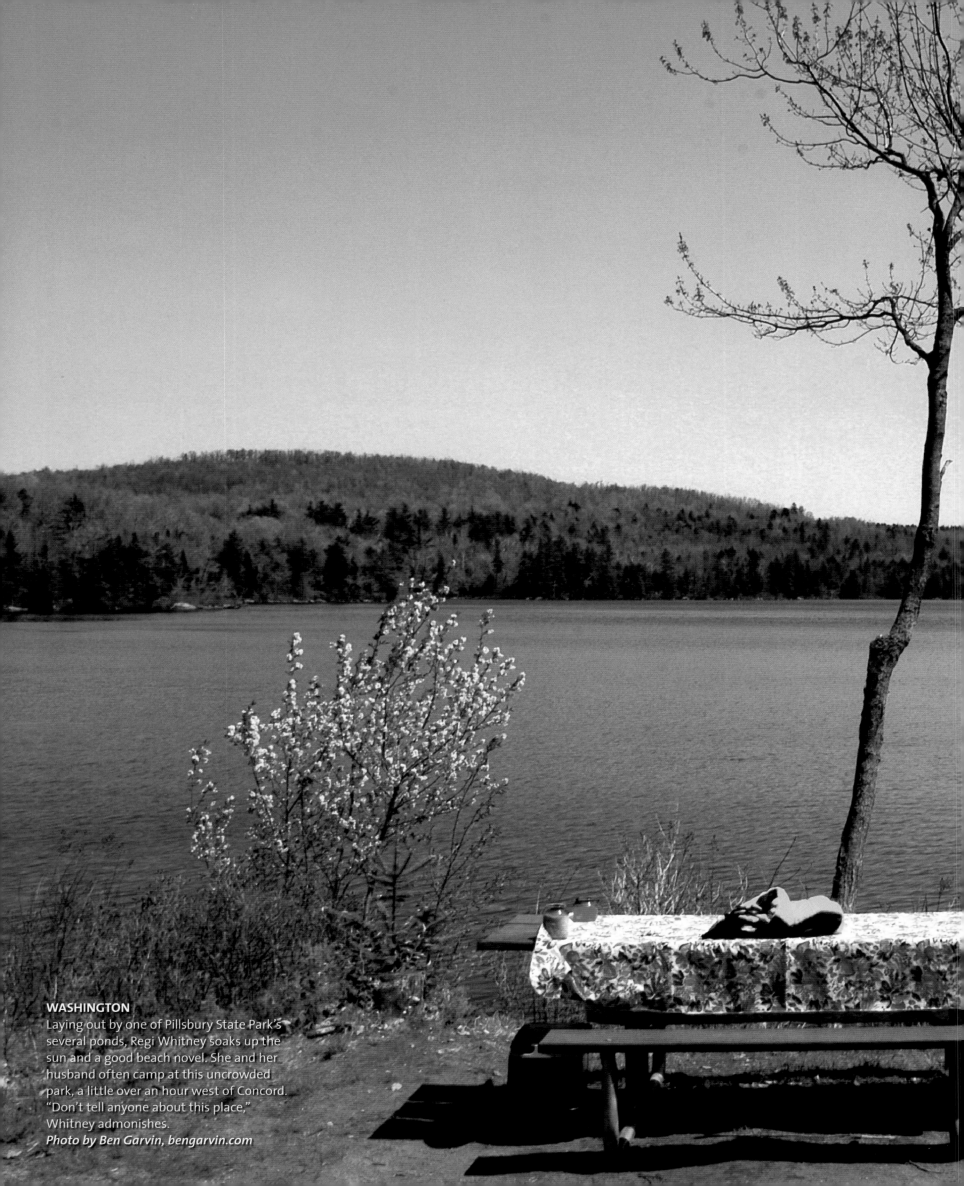

WASHINGTON
Laying out by one of Pillsbury State Park's several ponds, Regi Whitney soaks up the sun and a good beach novel. She and her husband often camp at this uncrowded park, a little over an hour west of Concord. "Don't tell anyone about this place," Whitney admonishes.
Photo by Ben Garvin, bengarvin.com

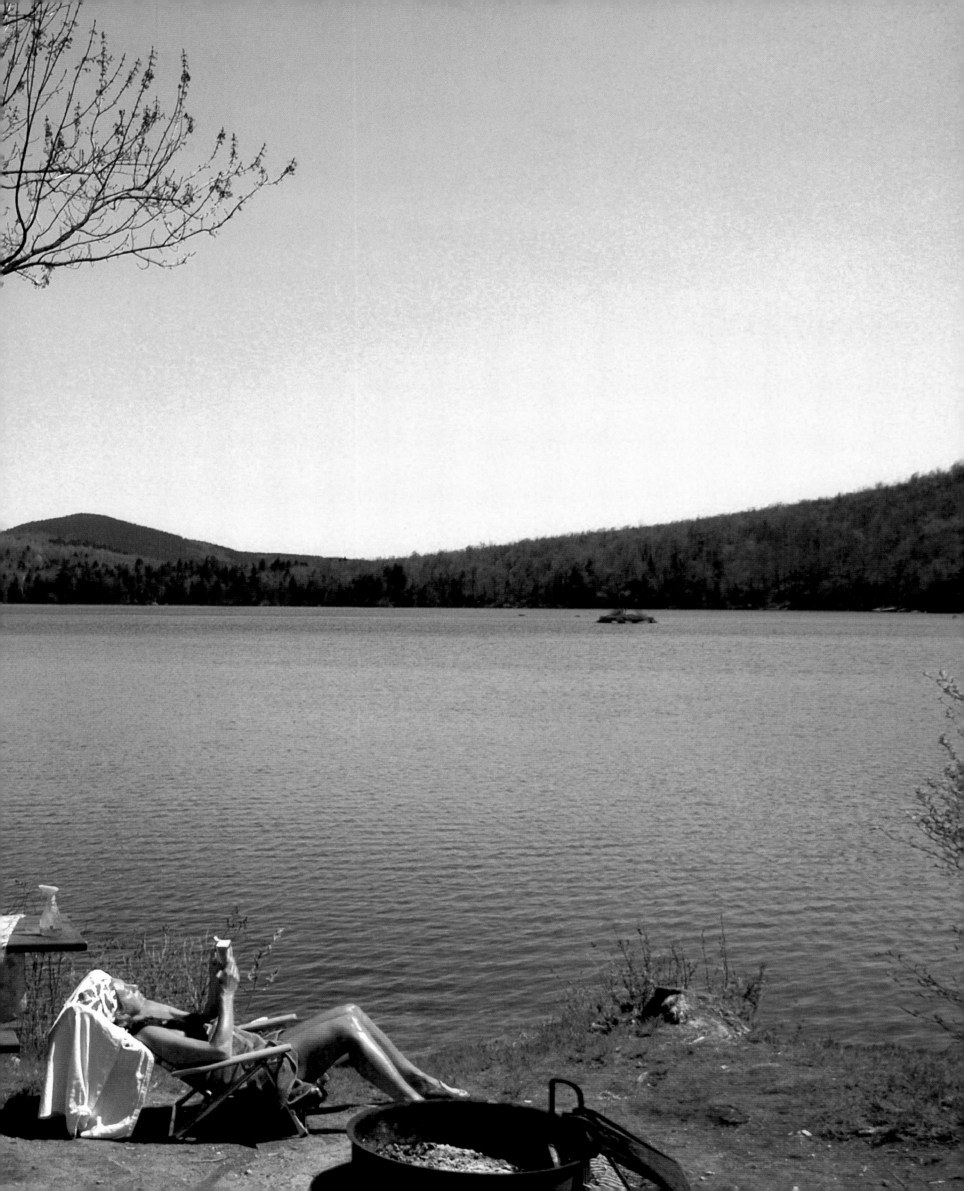

BOSCAWEN

Martha and Bruce Crete use a harrow disk on their cornfield. The Cretes run Highway View Farm, one of 174 dairy farms in the state (down from 1,350 in 1956). To feed their 225 cows, they grow 700 acres of hay and "cow corn," a tougher and less tasty corn than that grown for human consumption.

Photo by Bob LaPree, The Union Leader

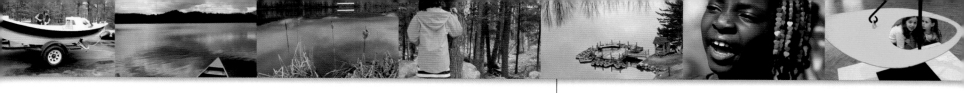

LINCOLN

Paddleboats sit idle on Shadow Lake at the Indian Head Resort in the White Mountains. With more than 1,000 miles of hiking and walking trails in the area, as well as lakes and other attractions, the White Mountains have been a favorite family vacation destination for more than 100 years.

Photo by Jamie Gemmiti, Cross Road Studio

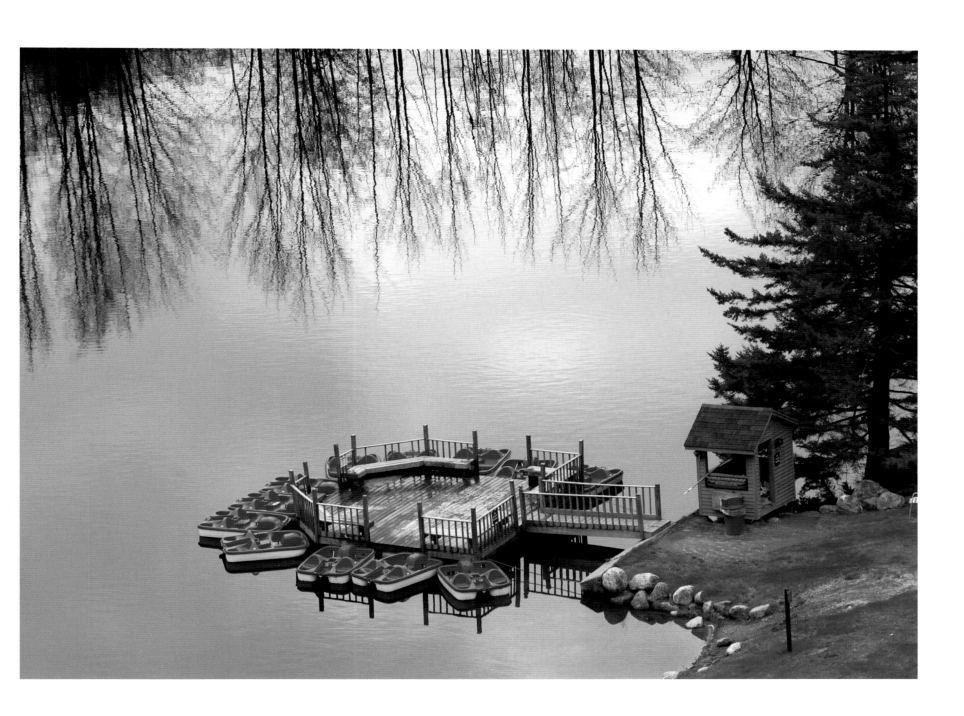

WARREN

The Redstone missile, first deployed in 1958, was officially retired in 1964. Two locals retrieved one from an Alabama arsenal and trucked it here to honor New Hampshire native Alan B. Shepard, Jr. (who was boosted into space by a Redstone rocket in 1961), and to help teach residents about the space program. The 8-ton rocket rises 70 feet over the center of town.

Photo by John Waiveris

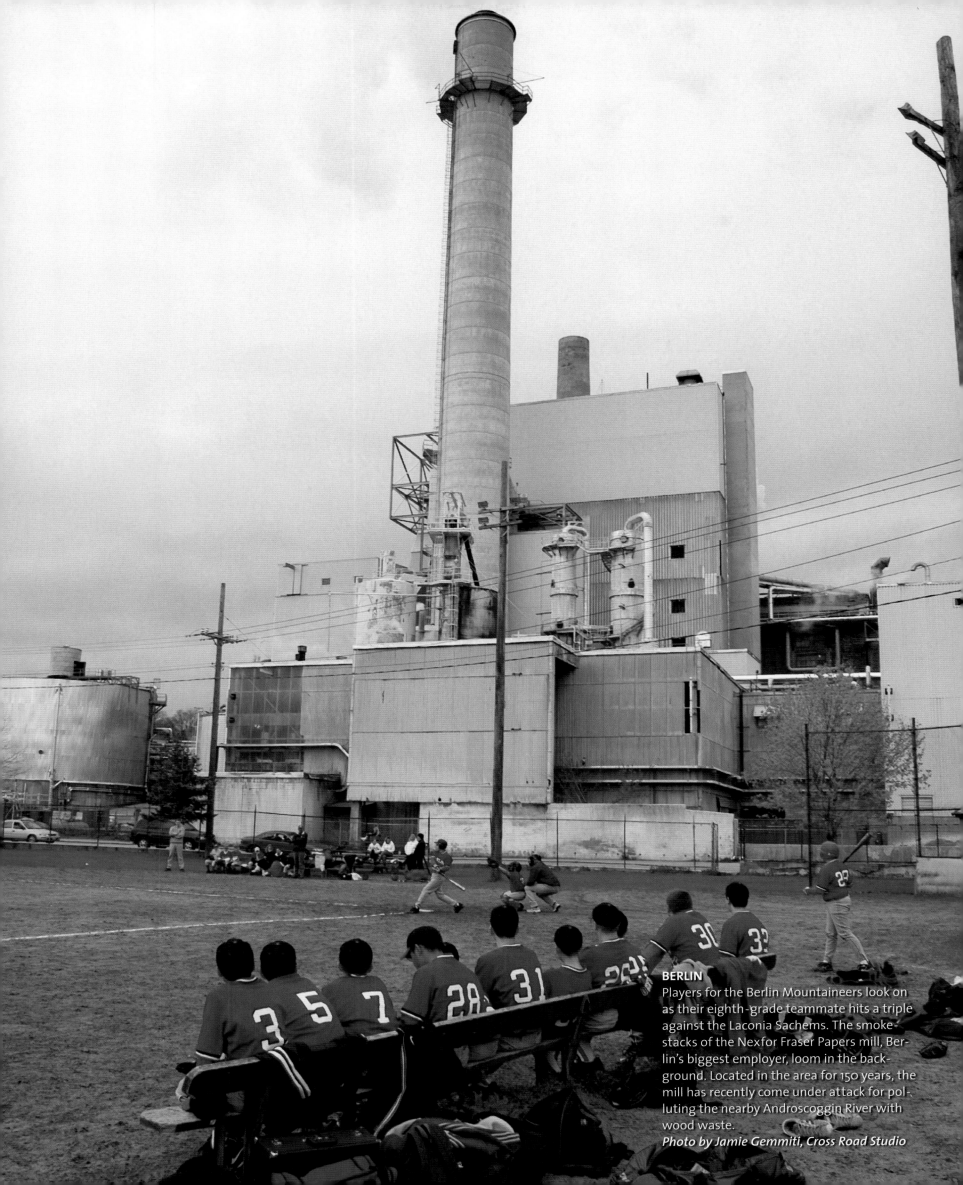

BERLIN

Players for the Berlin Mountaineers look on as their eighth-grade teammate hits a triple against the Laconia Sachems. The smoke-stacks of the Nexfor Fraser Papers mill, Berlin's biggest employer, loom in the back-ground. Located in the area for 150 years, the mill has recently come under attack for pol-luting the nearby Androscoggin River with wood waste.

Photo by Jamie Gemmiti, Cross Road Studio

NEW CASTLE

Artist Walter Liff created his interactive steel sculpture, *Beauty, The Common Denominator*, as a memorial to his painter friend Tom Quinn. The 31-acre Great Island Common park is the recreational centerpiece of New Castle, New Hampshire's smallest town at just under one-tenth of a square mile.

Photos by Rick Bouthiette

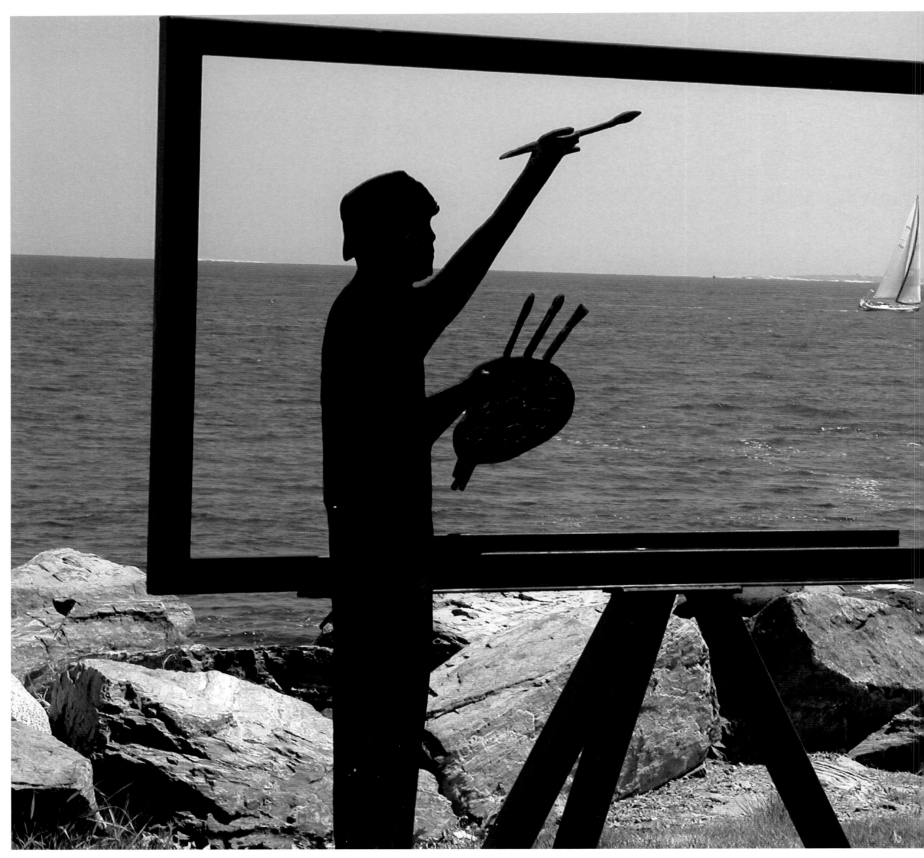

BRETTON WOODS

Built in 1902 by 250 Italian craftsmen, the Mount Washington Hotel has felt the footfalls of Winston Churchill, Thomas Edison, and Babe Ruth in its halls. At the Bretton Woods International Monetary Conference, held in the hotel's Gold Room in 1944, delegates from 44 nations convened to create the World Bank and the International Monetary Fund.

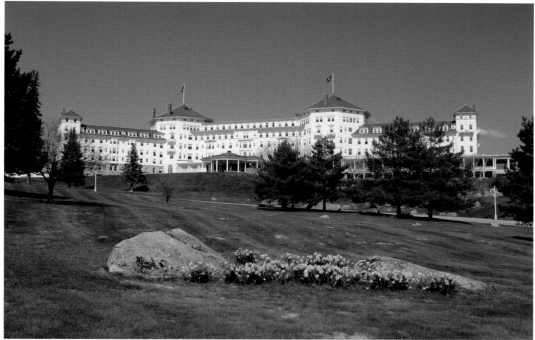

RYE

Lobster buoys decorate a wall at Ray's Lobster Pound, a seafood restaurant on Rye Harbor. The floats, each with a different color scheme to identify its owner, are tied to lobster cages to mark their locations off the rocky coast.

Photo by Bob Hammerstrom

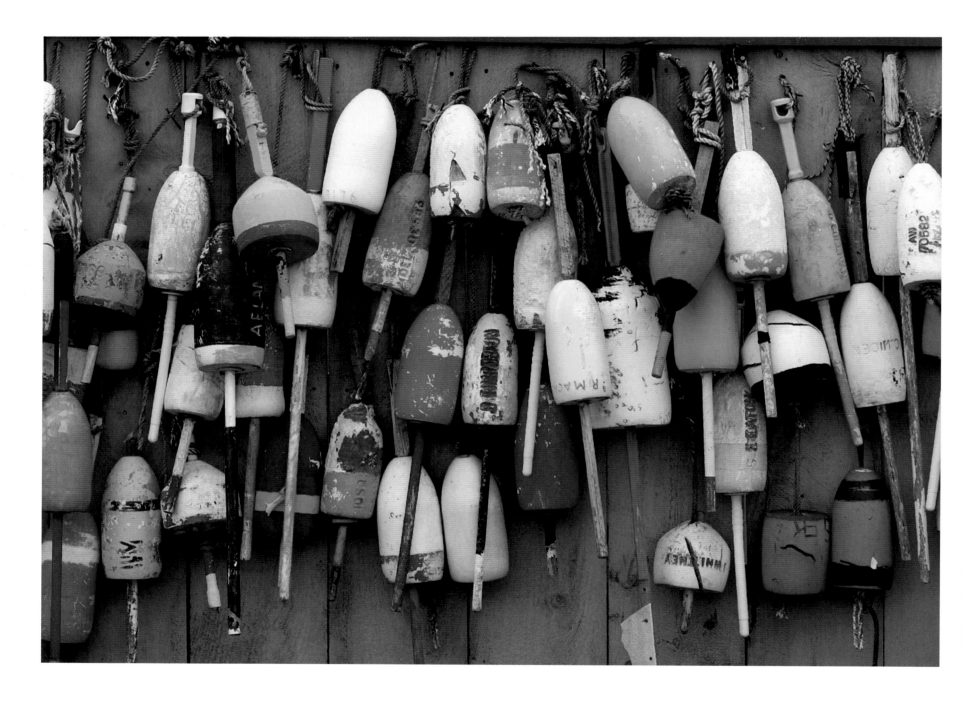

MANCHESTER

In 1810, the Amoskeag Manufacturing Company opened its first cotton mill on the banks of the Merrimack River. By 1915, the mill had become the world's largest textile plant, with 8 million square feet and 17,000 employees. The company closed in 1935, and most of the buildings have been given new life as apartments, offices, restaurants, and art galleries.

Photo by Lori Duff

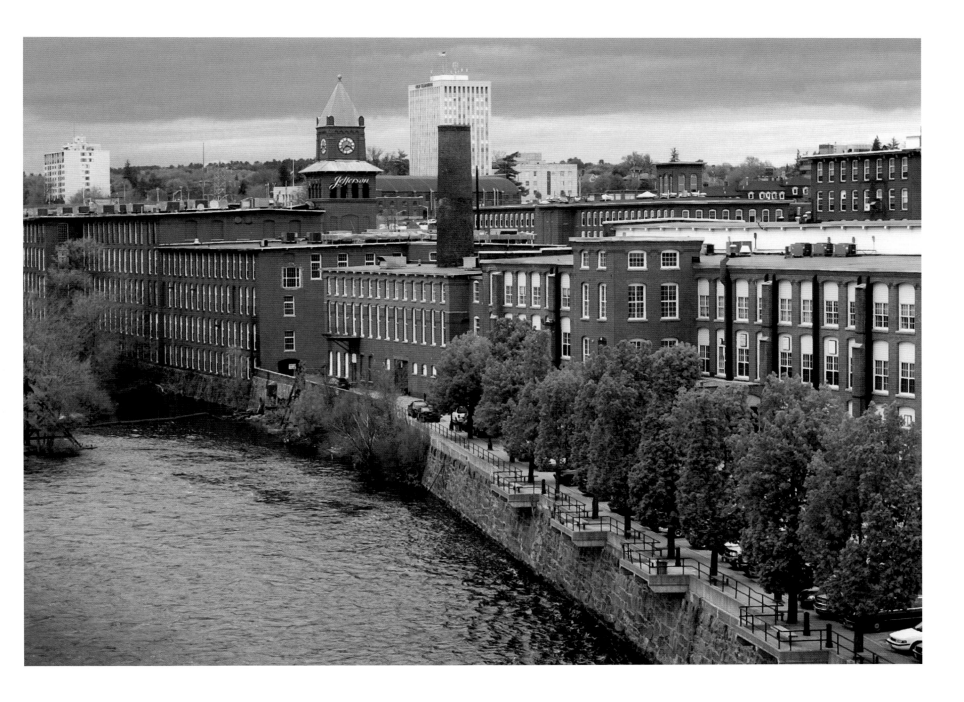

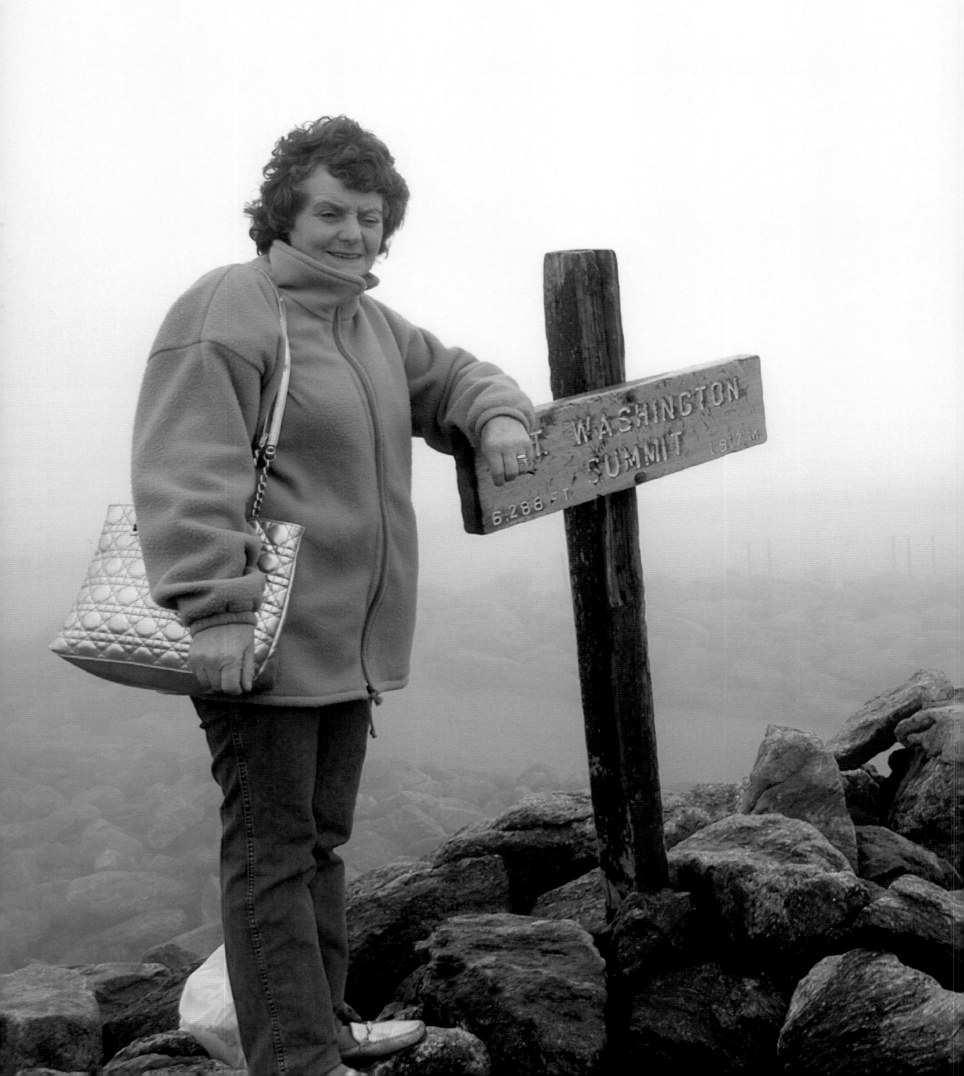

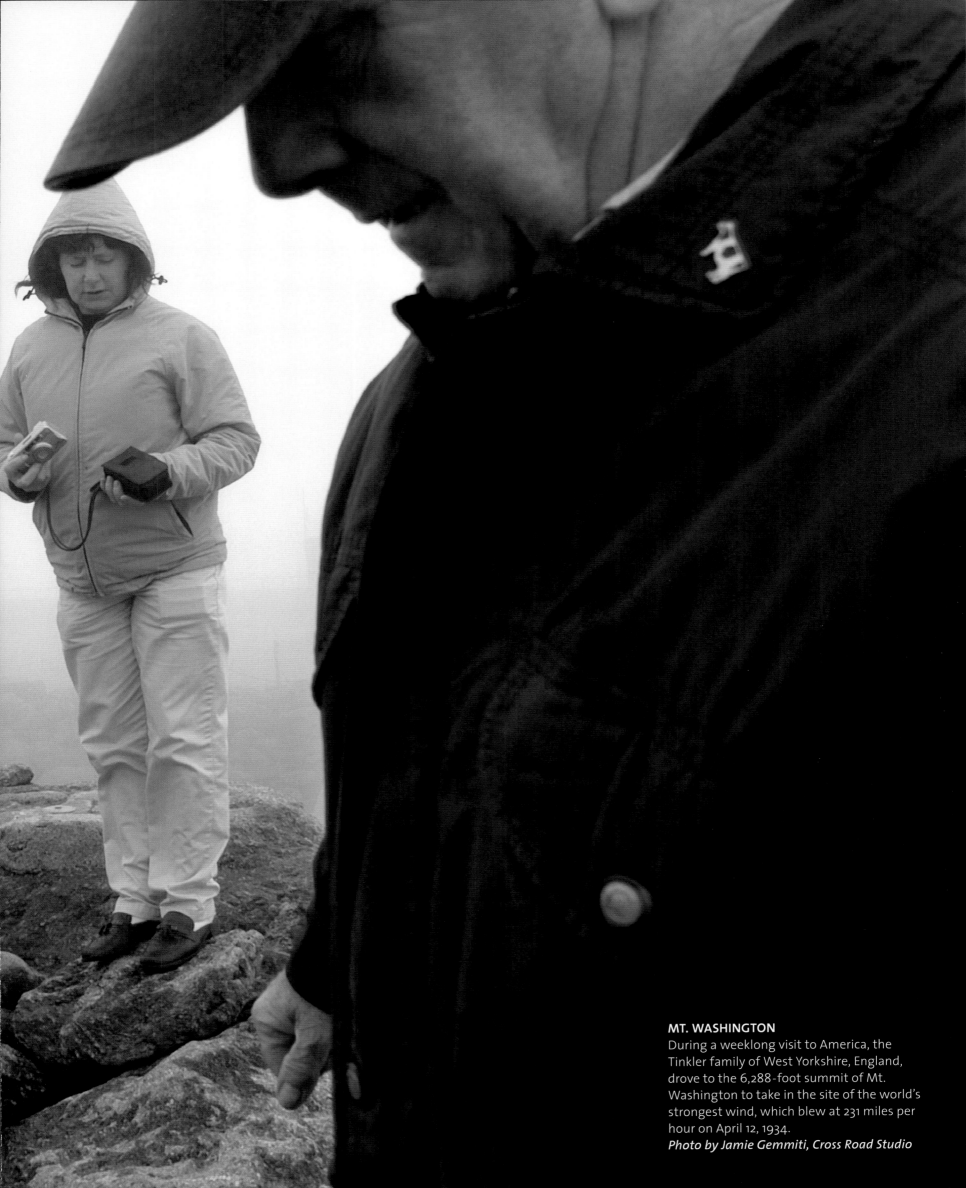

MT. WASHINGTON

During a weeklong visit to America, the Tinkler family of West Yorkshire, England, drove to the 6,288-foot summit of Mt. Washington to take in the site of the world's strongest wind, which blew at 231 miles per hour on April 12, 1934.

Photo by Jamie Gemmiti, Cross Road Studio

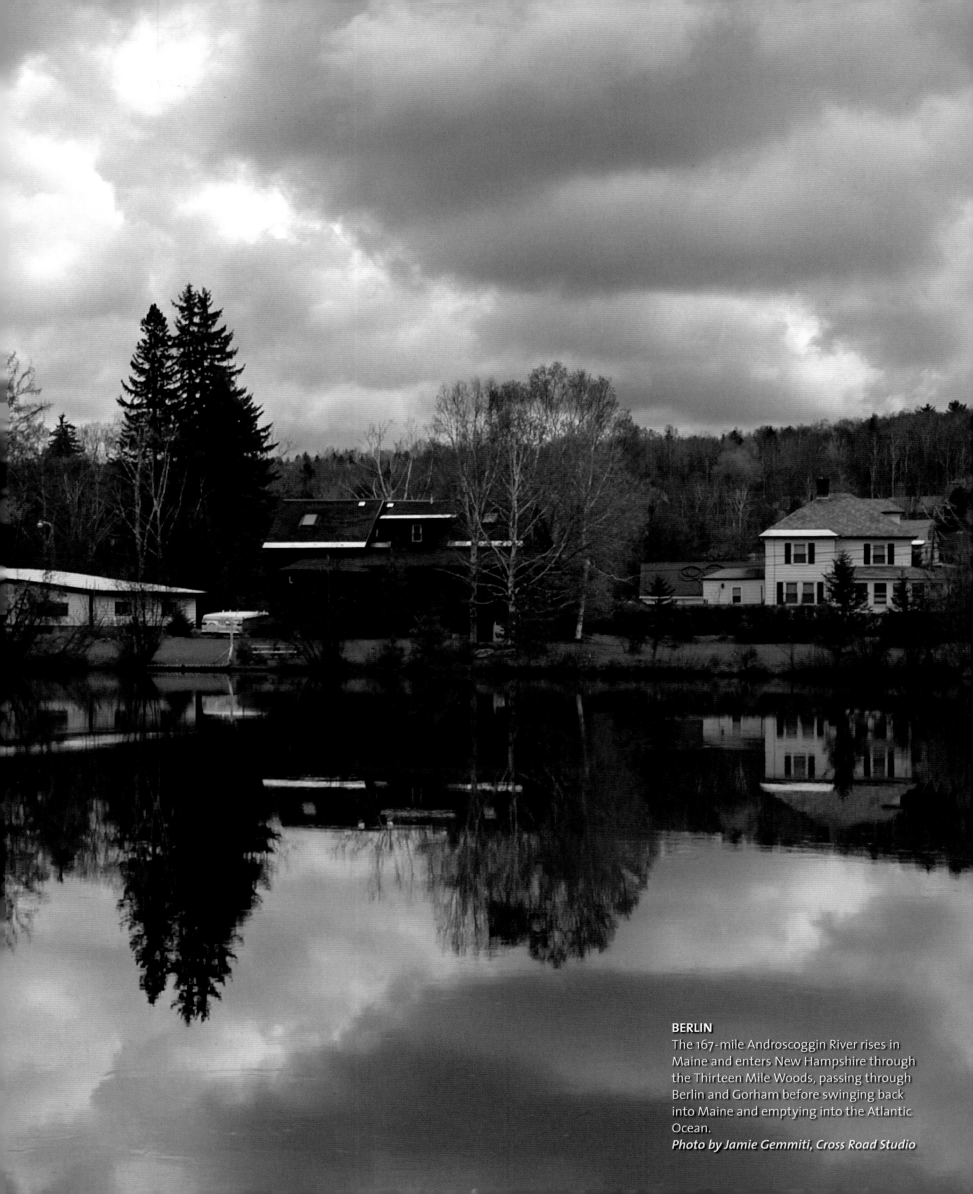

BERLIN
The 167-mile Androscoggin River rises in Maine and enters New Hampshire through the Thirteen Mile Woods, passing through Berlin and Gorham before swinging back into Maine and emptying into the Atlantic Ocean.
Photo by Jamie Gemmiti, Cross Road Studio

CONCORD
Another New Hampshire day comes to a
close as the sun sinks behind the gentle
landscape of Carter Hill Orchard.
Photo by Ben Garvin, bengarvin.com

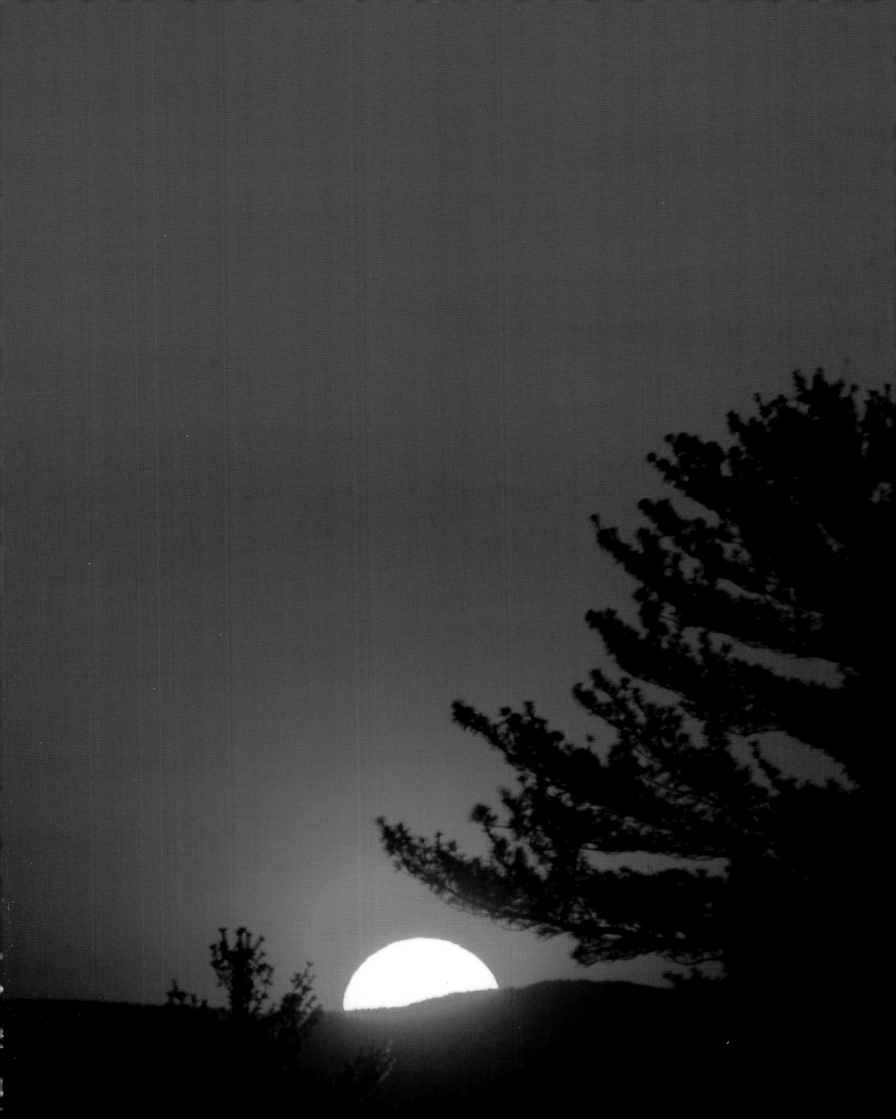

ne week of May 12-18, 2003, more than 25,000

professional and amateur photographers spread out

ss the nation to shoot over a million digital photographs

the goal of capturing the essence of daily life in America.

The professional photographers were equipped with

be Photoshop and Adobe Album software, Olympus

050 digital cameras, and Lexar Media's high-speed

pact flash cards.

he 1,000 professional contract photographers plus

ther 5,000 stringers and students sent their images via

(file transfer protocol) directly to the *America 24/7*

site. Meanwhile, thousands of amateur photographers

aded their images to Snapfish's servers.

At *America 24/7*'s Mission Control headquarters, located

NET in San Francisco, dozens of picture editors from the

on's most prestigious publications culled the images

n to 25,000 of the very best, using Photo Mechanic by

era Bits. These photos were transferred into Webware's

veMedia Digital Asset Management (DAM) system,

ch served as a central image library and enabled the

gners to track, search, distribute, and reformat the images

he creation of the 51 books, foreign language editions,

and magazine syndication, posters, and exhibitions.

Once in the DAM, images were optimized (and in some

s resampled to increase image resolution) using Adobe

oshop. Adobe InDesign and Adobe InCopy were used to

n and produce the 51 books, which were edited and

wed in multiple locations around the world in the form

obe Acrobat PDFs. Epson Stylus printers were used for

o proofing and to produce large-format images for

bitions. The companies providing support for the

ica 24/7 project offer many of the essential components

nyone building a digital darkroom. We encourage you to

SHOOT

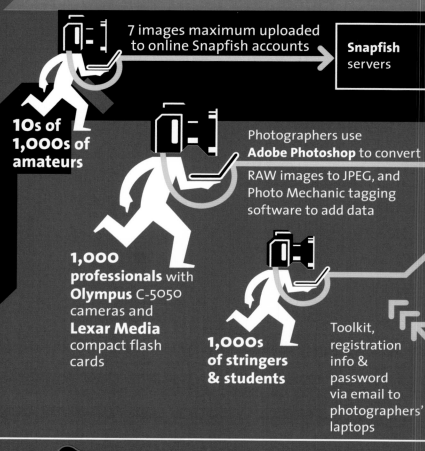

7 images maximum uploaded to online Snapfish accounts → **Snapfish** servers

10s of 1,000s of amateurs

Photographers use **Adobe Photoshop** to convert RAW images to JPEG, and Photo Mechanic tagging software to add data

1,000 professionals with **Olympus** C-5050 cameras and **Lexar Media** compact flash cards

1,000s of stringers & students

Toolkit, registration info & password via email to photographers' laptops

InDesign layouts output via **Acrobat** to PDF format

 Printer

5 graphic design and production teams

51 books: one national, 50 states

Produced by 24/7 Media, published by DK Publishing

50 state posters designed by 50 AIGA member firms

DESIGN & PUBLISH

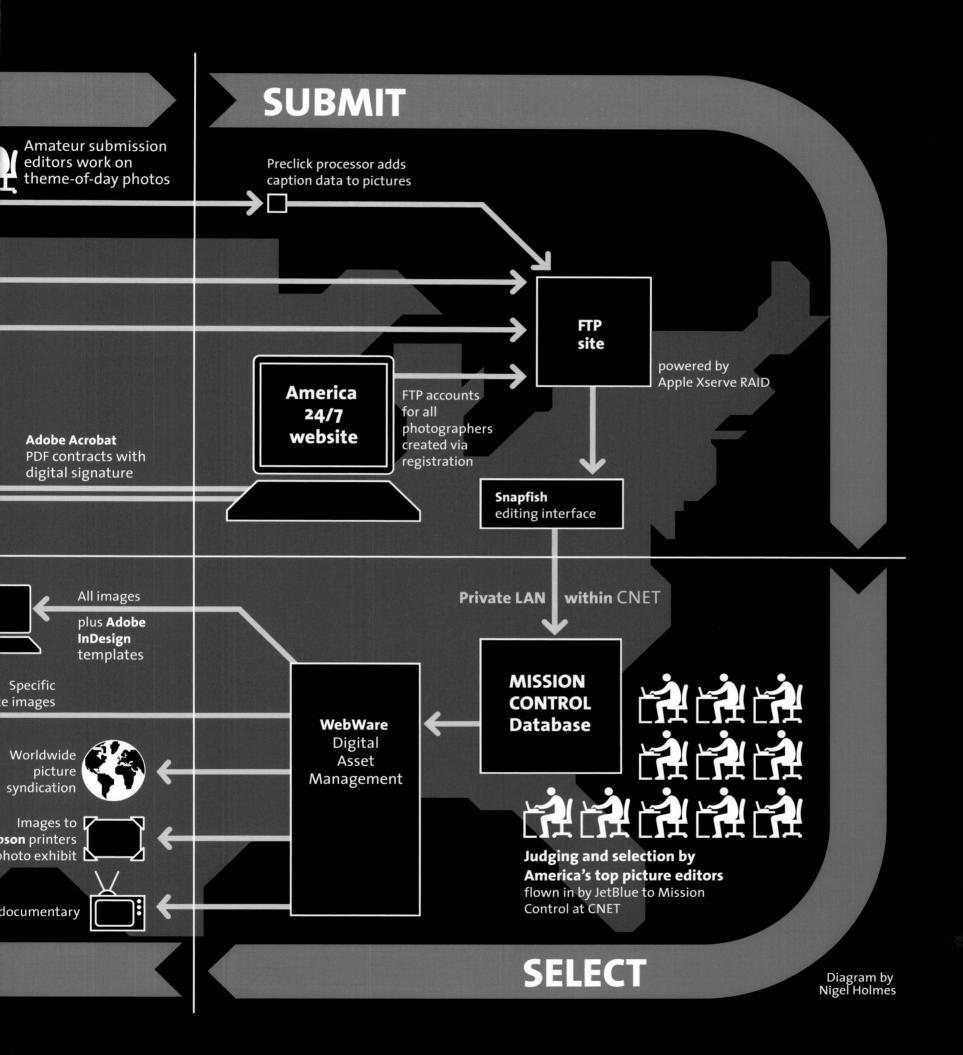

SUBMIT

Amateur submission editors work on theme-of-day photos

Preclick processor adds caption data to pictures

Adobe Acrobat PDF contracts with digital signature

America 24/7 website

FTP accounts for all photographers created via registration

FTP site

powered by Apple Xserve RAID

Snapfish editing interface

All images

plus **Adobe InDesign** templates

Specific te images

Worldwide picture syndication

Images to son printers hoto exhibit

documentary

WebWare Digital Asset Management

Private LAN **within** CNET

MISSION CONTROL Database

Judging and selection by America's top picture editors flown in by JetBlue to Mission Control at CNET

SELECT

Diagram by Nigel Holmes

About Our Sponsors

America 24/7 gave digital photographers of all levels the opportunity to share their visions of what it means to live in the United States. This project was made possible by a digital photography revolution that is dramatically changing and improving picture-taking for professionals and amateurs alike. And an Adobe product, Photoshop®, has been at the center of this sea change.

Adobe's products reflect our customers' passion for the creative process, be it the photographer, graphic designer, layout artist, or printer. Adobe is the Publishing and Imaging Software Partner for *America 24/7* and products such as Adobe InDesign®, Photoshop, Acrobat®, and Illustrator® were used to produce this stunning book in a matter of weeks. We hope that our software has helped do justice to the mythic images, contributed by well-known photographers and the inspired hobbyist.

Adobe is proud to be a lead sponsor of *America 24/7,* a project that celebrates the vibrancy of the American spirit: the same spirit that helped found Adobe and inspires our employees and customers to deliver the very best.

Bruce Chizen
President and CEO
Adobe Systems Incorporated

Olympus, a global technology leader in designing precision healthcare solutions and innovative consumer electronics, is proud to be the official digital camera sponsor of *America 24/7.* The opportunity to introduce Americans from coast to coast to the thrill, excitement, and possibility of digital photography makes the vision behind this book a perfect fit for Olympus, a leader in digital cameras since 1996.

For most people, the essence of digital photography is best grasped through firsthand experience with the technology, which is precisely what *America 24/7* is about. We understand that direct experience is the pathway to inspiration, and welcome opportunities like this sponsorship to bring the power of the digital experience into the lives of people everywhere. To Olympus, *America 24/7* offers a platform to help realize a core mission: to deliver and make accessible the power of the digital experience to millions of American photographers, amateurs, and professionals alike.

The 1,000 professional photographers contracted to shoot on the America 24/7 project were all equipped with Olympus C-5050 digital cameras. Like all Olympus products, the C-5050 is offered by a company well known for designing, manufacturing, and servicing products used by professionals to perform their work, every day. Olympus is a customer-centric company committed to working one-

to-one with a diverse group of professionals. From biomedical researchers who use our clinical microscopes, to doctors who perform life-saving procedures with our endoscopes, to professional photographers who use cameras in their daily work, Olympus is a trusted brand.

The digital imaging technology involved with *America 24/7* has enabled the soul of America to be visually conveyed, not just by professional observers, but by the American public who participated in this project—the very people who collectively breath life into this country's existence each day.

We are proud to be enabling so many photographers to capture the pictures on these pages that tell the story of who we are as a nation. From sea to shining sea, digital imagery allows us to connect to one another in ways we never dreamed possible.

At Olympus, our ideas have proliferated as rapidly as technology has evolved. We have channeled these visions into breakthrough products and solutions to meet the demands of our changing world-products like microscopes, endoscopes, and digital voice recorders, supported by the highly regarded training, educational, and consulting services we offer our customers.

Today, 83 years after we introduced our first microscope, we remain as young, as curious, and as committed as ever.

Lexar Media has grown from the digital photography revolution, which is why we are proud to have supplied the digital memory cards used in the America 24/7 project. Lexar Media's high-performance memory cards utilize our unique and patented controller coupled with high-speed flash memory from Samsung, the world's largest flash memory supplier. This powerful combination brings out the ultimate performance of any digital camera.

Photographers who demand the most from their equipment choose our products for their advanced features like write speeds up to 40X, Write Acceleration technology for enabled cameras, and Image Rescue, which recovers previously deleted or lost images. Leading camera manufacturers bundle Lexar Media digital memory cards with their cameras because they value its performance and reliability.

Lexar Media is at the forefront of digital photography as it transforms picture-taking worldwide, and we will continue to be a leader with new and innovative solutions for professionals and amateurs alike.

Snapfish, which developed the technology behind the *America 24/7* amateur photo event, is a leading online photo service, with more than 5 million members and 100 million photos posted online. Snapfish enables both film and digital camera owners to share, print, and store their most important photo memories, at prices that cannot be equaled. Digital camera users upload photos into a password-protected online album for free. Users can also order film-quality prints on professional photographic paper for as low as 25¢. Film camera users get a full set of prints, plus online sharing and storage, for just $2.99 per roll.

Founded in 1995, eBay created a powerful platform for the sale of goods and services by a passionate community of individuals and businesses. On any given day, there are millions of items across thousands of categories for sale on eBay. eBay enables trade on a local, national and international basis with customized sites in markets around the world.

Through an array of services, such as its payment solution provider PayPal, eBay is enabling global e-commerce for an ever-growing online community.

JetBlue Airways is proud to be *America 24/7's* preferred carrier, flying photographers, photo editors, and organizers across the United States.

Winner of Condé Nast Traveler's Readers' Choice Awards for Best Domestic Airline 2002, JetBlue provides friendly service and low fares for travelers in 22 cities in nine states across America.

On behalf of JetBlue's 5,000 crew members, we're excited to be involved in this remarkable project, and for the opportunity to serve American travelers each and every day, coast to coast, 24/7.

Digital Pond has been a leading creator of large graphic displays for museums, corporations, trade shows, retail environments and fine art since 1992.

We were proud to bring together our creative, print and display capabilities to produce signage and displays for mission control, critical retouching for numerous key images for the book, and art galleries for the New York Public Library and Bryant Park.

The Pond's team and SplashPic® Online service enabled us to nimbly design, produce and install over 200 large graphic panels in two NYC locations within the truly "24/7" production schedule of less than ten days.

WebWare Corporation is pleased to be a major sponsor of the America 24/7 project. We take pride in being part of a groundbreaking adventure that is stretching the boundaries—and the imagination—in digital photography, digital asset management, publishing, news, and global events.

Our ActiveMedia Enterprise™ digital asset management software is the "nerve center" of *America 24/7*, the central repository for managing, sharing, and collaborating on the project's photographs. From photo editors and book publishers to 24/7's media relations and marketing personnel, ActiveMedia provides the application support that links all facets of the project team to the content worldwide.

WebWare helps Global 2000 firms securely manage, reuse, and distribute media assets locally or globally. Its suite of ActiveMedia software products provide powerful media services platforms for integrating rich media into content management systems marketing and communication portals; web publishing systems; and e-commerce portals.

Google's mission is to organize the world's information and make it universally accessible and useful.

With our focus on plucking just the right answer from an ocean of data, we were naturally drawn to the America 24/7 project. The book you hold is a compendium of images of American life distilled from thousands of photographs and infinite possibilities. Are you looking for emotion? Narrative? Shadows? Light? It's all here, thanks to a multitude of photographers and writers creating links between you, the reader, and a sea of wonderful stories. We celebrate the connections that constitute the human experience and are pleased to help engender them. And we're pleased to have been a small part of this project, which captures the results of that interaction so vividly, so dynamically, and so dramatically.

Special thanks to additional contributors: FileMaker, Apple, Camera Bits, LaCie, Now Software, Preclick, Outpost Digital, Xerox, Microsoft, WoodWing Software, net-linx Publishing Solutions, and Radical Media. The Savoy Hotel, San Francisco; The Pan Pacific, San Francisco; Four Seasons Hotel, San Francisco; and The Queen Anne Hotel. Photography editing facilities were generously hosted by CNET Networks, Inc.

Participating Photographers

Coordinator: Ben Garvin, bengarvin.com

John Blais
Rick Bouthiette
Victoria Bush
Deb Cram, *Portsmouth Herald*
Laura DeCapua
Alice Dodge
Jack Donahue
Lori Duff
Bill Finney
Ben Garvin, bengarvin.com
Jamie Gemmiti, Cross Road Studio
Dan Habib, *The Concord Monitor*
Bob Hammerstrom
Jennifer Hauck
Don Himsel, *The Telegraph*
Steve Hooper

Nancy G. Horton
Lloyd E. Jones, *The Conway Daily Sun*
Ronald Kimball
Jim Korpi
Bob LaPree, *The Union Leader*
Kathy Seward MacKay
Michael Moore
Howard S. Muscott
Carrie Niland
Bruce Preston, *The Salem Observer*
Tom Rettig
Evan Richman, *The Boston Globe*
Ron Risman
John Waiveris
Ken Williams, *The Concord Monitor*
Jake Wyman

Thumbnail Picture Credits

Credits for thumbnail photographs are listed by the page number and are in order from left to right.

18 Jamie Gemmiti, Cross Road Studio
Kathy Seward MacKay
Nancy G. Horton
Bob LaPree, *The Union Leader*
Lori Duff
Kathy Seward MacKay
Bob LaPree, *The Union Leader*

19 Nancy G. Horton
Kathy Seward MacKay
Nancy G. Horton
Kathy Seward MacKay
Bob LaPree, *The Union Leader*
Bob LaPree, *The Union Leader*
Bob LaPree, *The Union Leader*

22 Kathy Seward MacKay
Kathy Seward MacKay
Kathy Seward MacKay
Nancy G. Horton
Ken Williams, *The Concord Monitor*
Bill Finney
Bob LaPree, *The Union Leader*

26 Ben Garvin, bengarvin.com
Jamie Gemmiti, Cross Road Studio
Nancy G. Horton
Nancy G. Horton
Nancy G. Horton
Nancy G. Horton
Nancy G. Horton

27 Nancy G. Horton
Ben Garvin, bengarvin.com
Bob LaPree, *The Union Leader*
Nancy G. Horton
Nancy G. Horton
Nancy G. Horton
Nancy G. Horton

28 Don Himsel, *The Telegraph*
Carrie Niland
Ken Williams, *The Concord Monitor*
Carrie Niland
Carrie Niland
Ben Garvin, bengarvin.com
Don Himsel, *The Telegraph*

29 Don Himsel, *The Telegraph*
Ben Garvin, bengarvin.com
Ken Williams, *The Concord Monitor*
Nancy G. Horton
Ken Williams, *The Concord Monitor*
Nancy G. Horton
Rick Bouthiette

32 Dylan Gamache
Dylan Gamache
Dylan Gamache
Ben Garvin, bengarvin.com
Rick Bouthiette
Dylan Gamache
Don Himsel, *The Telegraph*

33 Lloyd E. Jones, *The Conway Daily Sun*
Jim Korpi
Nancy G. Horton
Nancy G. Horton
Jamie Gemmiti, Cross Road Studio
Rick Bouthiette
Rick Bouthiette

34 Michael Moore
Dan Habib, *The Concord Monitor*
Dan Habib, *The Concord Monitor*
Dan Habib, *The Concord Monitor*
Dan Habib, *The Concord Monitor*
Dan Habib, *The Concord Monitor*
Dan Habib, *The Concord Monitor*

35 Dan Habib, *The Concord Monitor*
Dan Habib, *The Concord Monitor*
Dan Habib, *The Concord Monitor*
Dan Habib, *The Concord Monitor*
Dan Habib, *The Concord Monitor*
Laura DeCapua
Dan Habib, *The Concord Monitor*

37 Dan Habib, *The Concord Monitor*
Kathy Seward MacKay
Michael Silverwood
Kathy Seward MacKay
Bob LaPree, *The Union Leader*
Bob LaPree, *The Union Leader*
Kathy Seward MacKay

38 Laura DeCapua
Lloyd E. Jones, *The Conway Daily Sun*
Lori Duff
Laura DeCapua
Jennifer Hauck
Jennifer Hauck
Laura DeCapua

39 Nancy G. Horton
Laura DeCapua
Laura DeCapua
Jennifer Hauck
Rick Bouthiette
Laura DeCapua
Rick Bouthiette

50 Lloyd E. Jones, *The Conway Daily Sun*
Bob Hammerstrom
Howard S. Muscott
Jamie Gemmiti, Cross Road Studio
Jamie Gemmiti, Cross Road Studio
Lloyd E. Jones, *The Conway Daily Sun*
Jim Korpi

51 Lloyd E. Jones, *The Conway Daily Sun*
John Waiveris
Lloyd E. Jones, *The Conway Daily Sun*
Lloyd E. Jones, *The Conway Daily Sun*
Lloyd E. Jones, *The Conway Daily Sun*
Steve Hooper
Lloyd E. Jones, *The Conway Daily Sun*

54 Lloyd E. Jones, *The Conway Daily Sun*
Ben Garvin, bengarvin.com
Ken Williams, *The Concord Monitor*
Jamie Gemmiti, Cross Road Studio
Deb Cram, *Portsmouth Herald*
Ben Garvin, bengarvin.com
Lloyd E. Jones, *The Conway Daily Sun*

55 Lloyd E. Jones, *The Conway Daily Sun*
Jamie Gemmiti, Cross Road Studio
Deb Cram, *Portsmouth Herald*
Lori Duff
Ben Garvin, bengarvin.com
Lloyd E. Jones, *The Conway Daily Sun*
Nancy G. Horton

56 Bill Finney
Ben Garvin, bengarvin.com
Kathy Seward MacKay
Jamie Gemmiti, Cross Road Studio
Jim Korpi
Kathy Seward MacKay
Ben Garvin, bengarvin.com

57 Kathy Seward MacKay
Ben Garvin, bengarvin.com
Kathy Seward MacKay
Kathy Seward MacKay
Jim Korpi
Bill Finney
Kathy Seward MacKay

58 Carrie Niland
Ben Garvin, bengarvin.com
Tom Rettig
Steve Hooper
Carrie Niland
Jacob Silberberg
Carrie Niland

59 Tom Rettig
Tom Rettig
Carrie Niland
Steve Hooper
Tom Rettig
Ben Garvin, bengarvin.com
Ben Garvin, bengarvin.com

64 Bob Hammerstrom
Bob Hammerstrom
Ben Garvin, bengarvin.com
Bob Hammerstrom
Jamie Gemmiti, Cross Road Studio
Bob Hammerstrom
Jamie Gemmiti, Cross Road Studio

65 Bill Finney
Jamie Gemmiti, Cross Road Studio
Bill Finney
Bob Hammerstrom
Carrie Niland
Bill Finney
Steve Hooper

67 Jim Korpi
Bob Hammerstrom
Nancy G. Horton
Bob LaPree, *The Union Leader*
Jim Korpi
Bill Finney
Steve Hooper

74 Ben Garvin, bengarvin.com
Dan Habib, *The Concord Monitor*
Ben Garvin, bengarvin.com
Ben Garvin, bengarvin.com
Ben Garvin, bengarvin.com
Ben Garvin, bengarvin.com
Ben Garvin, bengarvin.com

75 Michael Moore
John Waiveris
Kathy Seward MacKay
Dan Habib, *The Concord Monitor*
Jamie Gemmiti, Cross Road Studio
Lori Duff
Kathy Seward MacKay

76 Dan Habib, *The Concord Monitor*
Laura DeCapua
Carrie Niland
Dan Habib, *The Concord Monitor*
Dan Habib, *The Concord Monitor*
Jamie Gemmiti, Cross Road Studio
Jamie Gemmiti, Cross Road Studio

77 Steve Hooper
Jamie Gemmiti, Cross Road Studio
Jim Korpi
Lori Duff
Jim Korpi
Jamie Gemmiti, Cross Road Studio
Lori Duff

78 Bob Hammerstrom
Bob Hammerstrom
Ben Garvin, bengarvin.com
Lori Duff
Bob Hammerstrom
Rick Bouthiette
Lori Duff

82 Jamie Gemmiti, Cross Road Studio
Steve Hooper
Jennifer Hauck
Steve Hooper
Jennifer Hauck
Lori Duff
Jennifer Hauck

86 Ben Garvin, bengarvin.com
Ben Garvin, bengarvin.com
Bob Hammerstrom
Bruce Preston, *The Salem Observer*
Bob Hammerstrom
Ben Garvin, bengarvin.com
Lloyd E. Jones, *The Conway Daily Sun*

87 Roger Marcoux Photography
Michael Moore
Roger Marcoux Photography
Bob Hammerstrom
Michael Moore
Jamie Gemmiti, Cross Road Studio
Lloyd E. Jones, *The Conway Daily Sun*

88 Bob Hammerstrom
Bruce Preston, *The Salem Observer*
Dan Habib, *The Concord Monitor*
Ben Garvin, bengarvin.com
Don Himsel, *The Telegraph*
Don Himsel, *The Telegraph*
Deb Cram, *Portsmouth Herald*

89 Deb Cram, *Portsmouth Herald*
Jamie Gemmiti, Cross Road Studio
Lloyd E. Jones, *The Conway Daily Sun*
Deb Cram, *Portsmouth Herald*
Lloyd E. Jones, *The Conway Daily Sun*
Deb Cram, *Portsmouth Herald*
Laura DeCapua

92 Lloyd E. Jones, *The Conway Daily Sun*
Bob LaPree, *The Union Leader*
Ben Garvin, bengarvin.com
Dan Habib, *The Concord Monitor*
Kathy Seward MacKay
Dan Habib, *The Concord Monitor*
Lori Duff

93 Dan Habib, *The Concord Monitor*
Ben Garvin, bengarvin.com
Roger Marcoux Photography
Don Himsel, *The Telegraph*
Bob LaPree, *The Union Leader*
Don Himsel, *The Telegraph*
Dan Habib, *The Concord Monitor*

96 Dan Habib, *The Concord Monitor*
Ben Garvin, bengarvin.com
Dan Habib, *The Concord Monitor*
Ben Garvin, bengarvin.com
Jamie Gemmiti, Cross Road Studio
Dan Habib, *The Concord Monitor*
Lloyd E. Jones, *The Conway Daily Sun*

97 Lloyd E. Jones, *The Conway Daily Sun*
Roger Marcoux Photography
Roger Marcoux Photography
Ben Garvin, bengarvin.com
Steve Hooper
Steve Hooper
Michael Moore

102 Ben Garvin, bengarvin.com
Bruce Preston, *The Salem Observer*
Carolyn L. Stoddard
Ben Garvin, bengarvin.com
Ken Williams, *The Concord Monitor*
Jamie Gemmiti, Cross Road Studio
Bruce Preston, *The Salem Observer*

103 Dan Habib, *The Concord Monitor*
Bill Finney
Bruce Preston, *The Salem Observer*
Kathy Seward MacKay
Lori Duff
Kathy Seward MacKay
Bill Finney

104 Ben Garvin, bengarvin.com
Evan Richman, *The Boston Globe*
Steve Hooper
Lori Duff
Caitlin M. Fitzgerald
Lori Duff
Dan Habib, *The Concord Monitor*

105 Bill Finney
Bill Finney
Lori Duff
Bill Finney
Bill Finney
Bill Finney
Lori Duff

108 Kathy Seward MacKay
Lori Duff
Bill Finney
Bill Finney
Ken Williams, *The Concord Monitor*
Lori Duff
Bill Finney

109 Bill Finney
Bill Finney
Ben Garvin, bengarvin.com
Lori Duff
Bill Finney
Bill Finney
Bill Finney

114 Kathy Seward MacKay
Kathy Seward MacKay
Kathy Seward MacKay
Kathy Seward MacKay
Bill Finney
Kathy Seward MacKay
Kathy Seward MacKay

115 Bill Finney
Lori Duff
Lori Duff
Lori Duff
Kathy Seward MacKay
Lori Duff
Kathy Seward MacKay

119 Carolyn L. Stoddard
Dan Habib, *The Concord Monitor*
Nancy G. Horton
Dan Habib, *The Concord Monitor*
Steve Hooper
Dan Habib, *The Concord Monitor*
Ben Garvin, bengarvin.com

120 Bob Hammerstrom
Ben Garvin, bengarvin.com
Dan Habib, *The Concord Monitor*
Don Himsel, *The Telegraph*
Don Himsel, *The Telegraph*
Ben Garvin, bengarvin.com
Dan Habib, *The Concord Monitor*

121 Deb Cram, *Portsmouth Herald*
Jamie Gemmiti, Cross Road Studio
Deb Cram, *Portsmouth Herald*
Bob Hammerstrom
Jim Korpi
Jamie Gemmiti, Cross Road Studio
Jamie Gemmiti, Cross Road Studio

124 Ben Garvin, bengarvin.com
Carolyn L. Stoddard
Caitlin M. Fitzgerald
Bob LaPree, *The Union Leader*
Howard S. Muscott
Lloyd E. Jones, *The Conway Daily Sun*
Jamie Gemmiti, Cross Road Studio

125 Jamie Gemmiti, Cross Road Studio
Laura DeCapua
Jim Korpi
Laura DeCapua
Jamie Gemmiti, Cross Road Studio
Michael Moore
Bob LaPree, *The Union Leader*

128 Bob Hammerstrom
Rick Bouthiette
Howard S. Muscott
Rick Bouthiette
Rick Bouthiette
Rick Bouthiette
Rick Bouthiette

129 Rick Bouthiette
Rick Bouthiette
Rick Bouthiette
Rick Bouthiette
Rick Bouthiette
Bob LaPree, *The Union Leader*
Bob LaPree, *The Union Leader*

130 Ben Garvin, bengarvin.com
Bob Hammerstrom
Carolyn L. Stoddard
Caitlin M. Fitzgerald
Caitlin M. Fitzgerald
Jamie Gemmiti, Cross Road Studio
Bob Hammerstrom

131 Jim Korpi
Lori Duff
Jamie Gemmiti, Cross Road Studio
Jennifer Hauck
Jennifer Hauck
Jamie Gemmiti, Cross Road Studio
Ken Williams, *The Concord Monitor*

Staff

The *America 24/7* series was imagined years ago by our friend Oscar Dystel, a publishing legend whose vision and enthusiasm have been a source of great inspiration.

We also wish to express our gratitude to our truly visionary publisher, DK.

Rick Smolan, Project Director
David Elliot Cohen, Project Director

Administrative
Katya Able, Operations Director
Gina Privitere, Communications Director
Chuck Gathard, Technology Director
Kim Shannon, Photographer Relations Director
Erin O'Connor, Photographer Relations Intern
Leslie Hunter, Partnership Director
Annie Polk, Publicity Manager
John McAlester, Website Manager
Alex Notides, Office Manager
C. Thomas Hardin, State Photography Coordinator

Design
Brad Zucroff, Creative Director
Karen Mullarkey, Photography Director
Judy Zimola, Production Manager
David Simoni, Production Designer
Mary Dias, Production Designer
Heidi Madison, Associate Picture Editor
Don McCartney, Production Designer
Diane Dempsey Murray, Production Designer
Jan Rogers, Associate Picture Editor
Bill Shore, Production Designer and Image Artist
Larry Nighswander, Senior Picture Editor
Bill Marr, Sarah Leen, Senior Picture Editors
Peter Truskier, Workflow Consultant
Jim Birkenseer, Workflow Consultant

Editorial
Maggie Canon, Managing Editor
Curt Sanburn, Senior Editor
Teresa L. Trego, Production Editor
Lea Aschkenas, Writer
Olivia Boler, Writer
Korey Capozza, Writer
Beverly Hanly, Writer
Bridgett Novak, Writer
Alison Owings, Writer
Fred Raker, Writer
Joe Wolff, Writer
Elise O'Keefe, Copy Chief
Daisy Hernández, Copy Editor
Jennifer Wolfe, Copy Editor

Infographic Design
Nigel Holmes

Literary Agent
Carol Mann, The Carol Mann Agency

Legal Counsel
Barry Reder, Coblentz, Patch, Duffy & Bass, LLP
Phil Feldman, Coblentz, Patch, Duffy & Bass, LLP
Gabe Perle, Ohlandt, Greeley, Ruggiero & Perle, LLP
Jon Hart, Dow, Lohnes & Albertson, PLLC
Mike Hays, Dow, Lohnes & Albertson, PLLC
Stephen Pollen, Warshaw Burstein, Cohen, Schlesinger & Kuh, LLP
Rick Pappas

Accounting and Finance
Rita Dulebohn, Accountant
Robert Powers, Calegari, Morris & Co. Accountants
Eugene Blumberg, Blumberg & Associates
Arthur Langhaus, KLS Professional Advisors Group, Inc.

Picture Editors
J. David Ake, Associated Press
Caren Alpert, formerly *Health* magazine
Simon Barnett, *Newsweek*
Caroline Couig, *San Jose Mercury News*
Mike Davis, formerly *National Geographic*
Michel duCille, *Washington Post*
Deborah Dragon, *Rolling Stone*
Victor Fisher, formerly Associated Press
Frank Folwell, *USA Today*
MaryAnne Golon, *Time*
Liz Grady, formerly *National Geographic*
Randall Greenwell, *San Francisco Chronicle*
C. Thomas Hardin, formerly *Louisville Courier-Journal*
Kathleen Hennessy, *San Francisco Chronicle*
Scot Jahn, *U.S. News & World Report*
Steve Jessmore, *Flint Journal*
John Kaplan, University of Florida
Kim Komenich, *San Francisco Chronicle*
Eliane Laffont, *Hachette Filipacchi Media*
Jean-Pierre Laffont, *Hachette Filipacchi Media*
Andrew Locke, MSNBC
Jose Lopez, *The New York Times*
Maria Mann, formerly AFP
Bill Marr, formerly *National Geographic*
Michele McNally, *Fortune*
James Merithew, *San Francisco Chronicle*
Eric Meskauskas, *New York Daily News*
Maddy Miller, *People* magazine
Michelle Molloy, *Newsweek*
Dolores Morrison, *New York Daily News*
Karen Mullarkey, formerly *Newsweek, Rolling Stone, Sports Illustrated*
Larry Nighswander, Ohio University School of Visual Communication
Jim Preston, *Baltimore Sun*
Sarah Rozen, formerly *Entertainment Weekly*
Mike Smith, *The New York Times*
Neal Ulevich, formerly Associated Press

Website and Digital Systems
Jeff Burchell, Applications Engineer

Television Documentary
Sandy Smolan, Producer/Director
Rick King, Producer/Director
Bill Medsker, Producer

Video News Release
Mike Cerre, Producer/Director

Digital Pond
Peter Hogg
Kris Knight
Roger Graham
Philip Bond
Frank De Pace
Lisa Li

Senior Advisors
Jennifer Erwitt, Strategic Advisor
Tom Walker, Creative Advisor
Megan Smith, Technology Advisor
Jon Kamen, Media and Partnership Advisor
Mark Greenberg, Partnership Advisor
Patti Richards, Publicity Advisor
Cotton Coulson, Mission Control Advisor

Executive Advisors
Sonia Land
George Craig
Carole Bidnick

Advisors
Chris Anderson
Samir Arora
Russell Brown
Craig Cline
Gayle Cline
Harlan Felt
George Fisher
Phillip Moffitt
Clement Mok
Laureen Seeger
Richard Saul Wurman

DK Publishing
Bill Barry
Joanna Bull
Therese Burke
Sarah Coltman
Christopher Davis
Todd Fries
Dick Heffernan
Jay Henry
Stuart Jackman
Stephanie Jackson
Chuck Lang
Sharon Lucas
Cathy Melnicki
Nicola Munro
Eunice Paterson
Andrew Welham

Colourscan
Jimmy Tsao
Eddie Chia
Richard Law
Josephine Yam
Paul Koh
Chee Cheng Yeong
Dan Kang

Chief Morale Officer
Goose, the dog